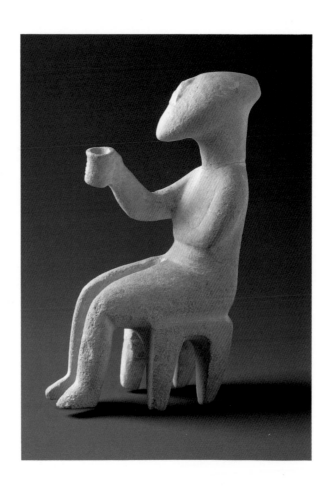

C'est dans ta coupe aussi que j'avais bu l'ivresse,

Et dans l'éclair furtif de ton oeil souriant,

Quand aux pieds d'Iacchus on me voyait priant,

Car la Muse m'a fait l'un des fils de la Grèce.

GÉRARD DE NERVAL, *Myrtho*

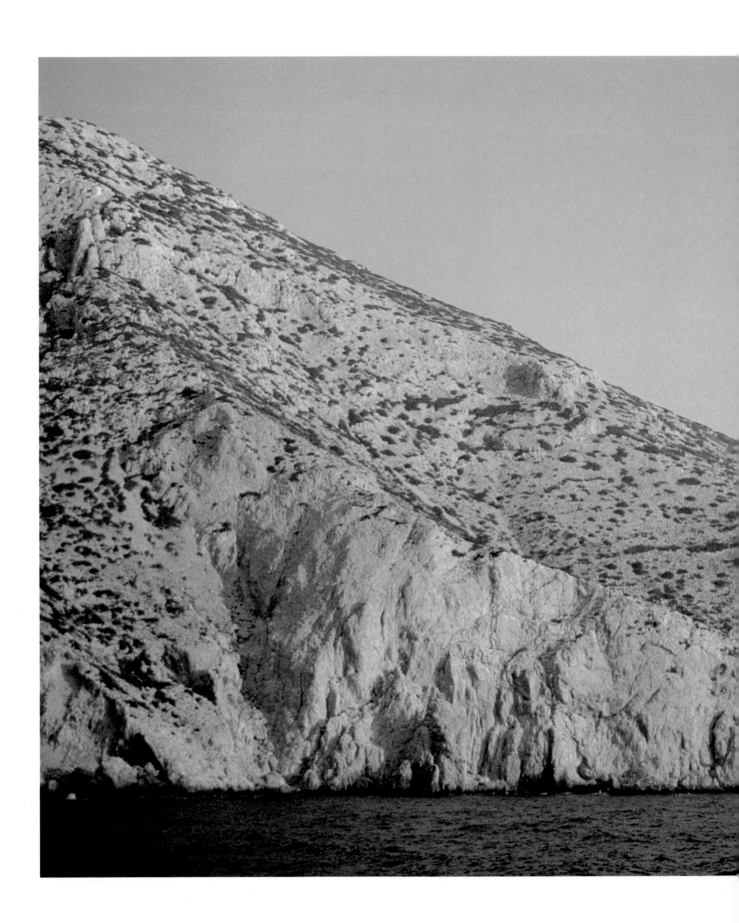

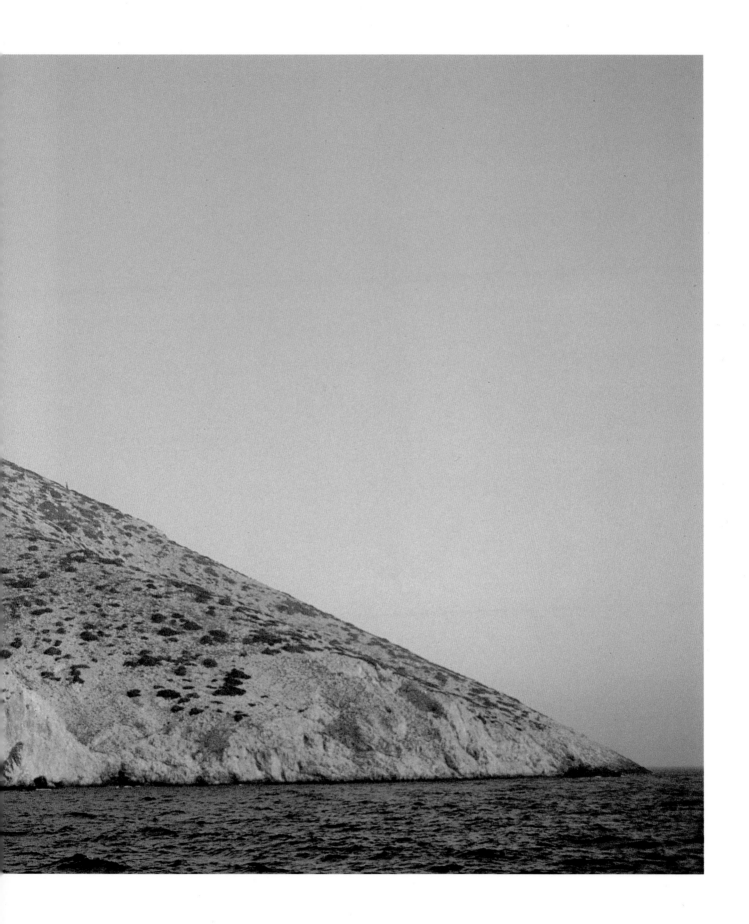

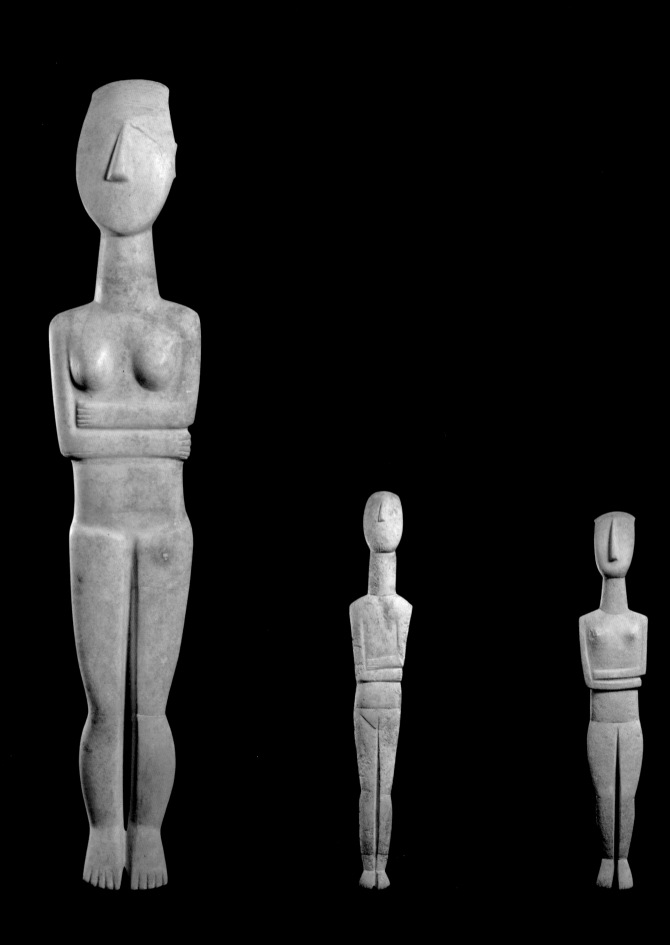

THE CYCLADIC SPIRIT

Masterpieces from the Nicholas P. Goulandris Collection

Colin Renfrew

Introduction by Christos Doumas

Photographs by

John Bigelow Taylor

Harry N. Abrams, Inc., New York

in association with the

Nicholas P. Goulandris Foundation

Museum of Cycladic Art

Athens

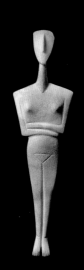
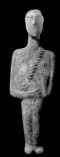
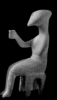
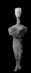

Lemnos

ANATOLIA

THESSALY

Lesbos

Skyros

BOEOTIA EUBOIA
• Manika

Chios

Lithares •

Marathon •

ATTICA

CORINTHIA

Samos

• Mycenae
Aegina • Lavrion

ARGOLIS

Lerna •

Iasos

CYCLADES

LACONIA

Kos
Giali
Nisyros

Rhodes

Crete

Knossos •
• Archanes
Mochlos •
• Aghia Photia
Platanos •
Myrtos •
Lebena • • Koumasa

Figure 1

THE AEGEAN

See figure 2, page 36, for a map
of the Cyclades

0 120

miles

ACKNOWLEDGMENTS

THE MASTERPIECES OF EARLY Cycladic sculpture discussed here have been chosen principally from the Nicholas P. Goulandris Collection, formed over the past thirty years through the energy and enthusiasm of Mrs. Dolly Goulandris. But for her initiative, many would have left Greece and found their way onto the international art markets of Switzerland, London, and New York. Instead they remain in Athens and will be displayed permanently in the Nicholas P. Goulandris Foundation–Museum of Cycladic Art.

All the photographs from the Goulandris Collection have been specially taken by John Bigelow Taylor. To complete the picture and to illustrate the discussion, a number of Early Cycladic works from other museums are depicted here, generally in black and white. For comparative purposes a number of works from later periods are also illustrated: they do not form part of the Goulandris Collection. Most of these photographs have also been taken specially for this book.

My first debt is to Mrs. Dolly Goulandris, a friend of more than twenty years standing, at whose invitation the present book has been written. Over the years I have benefited both from her generous hospitality, and from the unhesitatingly free access to her wonderful collection. I have happy memories of staying with my wife, Jane, in the summer of 1967 in Dolly's apartment in King George II Street in Athens where the collection was at that time displayed in the drawing room, and of creeping out from the adjoining bedroom (creeping from a wish not to disturb rather than to avoid discovery), armed with a flashlight, to examine the sculptures by night in a different and more personal perspective than by the direct light of day. On a much later occasion, I recall being shown, in the company of Christos Doumas, the extraordinary life-sized figure now in the Museum of Cycladic Art (plate 103) not long after its acquisition. To have seen the development over the years of the Museum of Cycladic Art has been a particular pleasure.

My second debt, in the context of this book, is to John Bigelow Taylor, so ably partnered and assisted by Dianne Dubler, for his collaboration in its preparation. It has indeed been a collaborative work, and John's enormous care in producing the right image to the best effect is evident in the photographs here. The book has also been aided greatly by his own tireless itinerary of travel, which has brought him to all the museums from which further photographs were desirable.

And my third debt is to my old friend and *koumbaros,* Christos Doumas, for his lifelong companionship in Cycladic studies, for his own work on the Goulandris Collection, in whose formation he played so significant a role, and for his kindly consenting to contribute a chapter to this book.

COLIN RENFREW

THE

CYCLADIC

WORLD

The southwest coast of Amorgos,
looking north toward Keros and the
small island of Kisiri

CHAPTER I

PROLOGUE: THE CYCLADIC SPIRIT

MORE THAN FOUR THOUSAND years ago in the Cycladic islands of Greece, something quite remarkable happened. In that sparse and rather unpromising environment, in the small-scale societies of what scholars have come to call the Bronze Age, local craftsmen were able to create special objects — marble sculptures, pottery vessels, other goods of metal and stone — that possess a breathtaking simplicity of form that delights the modern eye.

Many communities, at different times and places in the world, have produced works of arresting vitality with the power to command the attention and respect of the modern viewer. A visit to the Musée de l'Homme in Paris to look at the so-called "ethnic arts" of Africa or to the National Museum in Mexico City to see the Pre-Columbian collection reminds us that great art did not begin with Classical Greece, nor is it found only in those territories influenced by the European Renaissance. But the products of the early Cyclades have a surpassing quality, not altogether easy to define but easy enough to recognize once you have truly felt it. The greatest of them achieve a simplicity of form that can be altogether breathtaking. Sometimes they seem to come closer to the essence of that extraordinary and mysterious act, the making in an inert material of an artifact whose form seems to carry great meaning for us, than any other works made by human hand at any place or time.

I felt this to be so when, as an undergraduate, I first traveled to Greece and visited the National Museum in Athens, where in a single long gallery, amply illuminated by natural light, some of the finest works from the prehistoric Cyclades are displayed. As a boy I had seen such "stylized" marble figures in the British Museum and as a student in Paris, before going to university, I had spent days in the Louvre and admired there that remarkable Cycladic head, which still seems to me one of the most satisfying portrayals in the history of art (plate 124). But not until that summer's day in 1961, after some weeks assisting in the excavation of an early prehistoric site in northern Greece, had I seen a major collection, an assemblage, of these remarkable sculptures. As isolated works some of them are indeed memorable, individual "works of art" (if one may use an anachronistic term drawn from more recent Western aesthetics). But taken together they are no longer seen as oddities, unexpectedly fortunate successes by craftsmen experimenting with a promising material at the dawn of civilization. They have a coherence, a quiet confidence, a tranquillity of style that speaks to us of great art, not merely of beginner's luck. Early in date they may be, and precocious in the history of human creativity, but they appeal to us today as quite astonishing achievements.

It was not always so. A century ago, when these products of a still forgotten past were first coming to light, they were seen as mere curiosities, as incompetent representations of the human form, stiff and immobile, created by an inept and barbarous people incapable of doing better. Today, with a century of archaeological research behind us, we still place them at the dawn of civilization, before the time of the palaces of Minoan Crete or of Mycenaean Greece and see them as the contemporaries of Old Kingdom Egypt, fashioned within a few centuries of the building of the pyramids. But our appreciation of art has changed. The

3
CANONICAL FIGURE
Keros-Syros culture, c. 2500 B.C.
Marble, height 25 13/16"

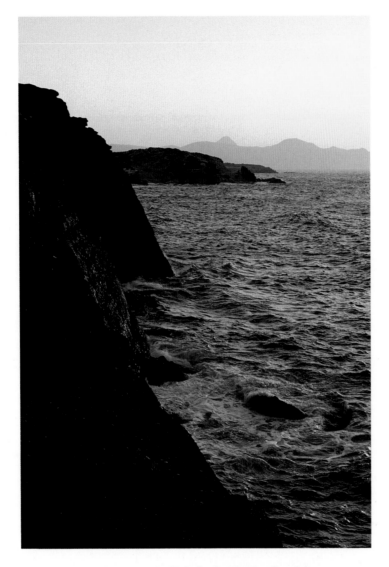

In Memory of Nicholas P. Goulandris

The coast of Melos
at Phylakopi

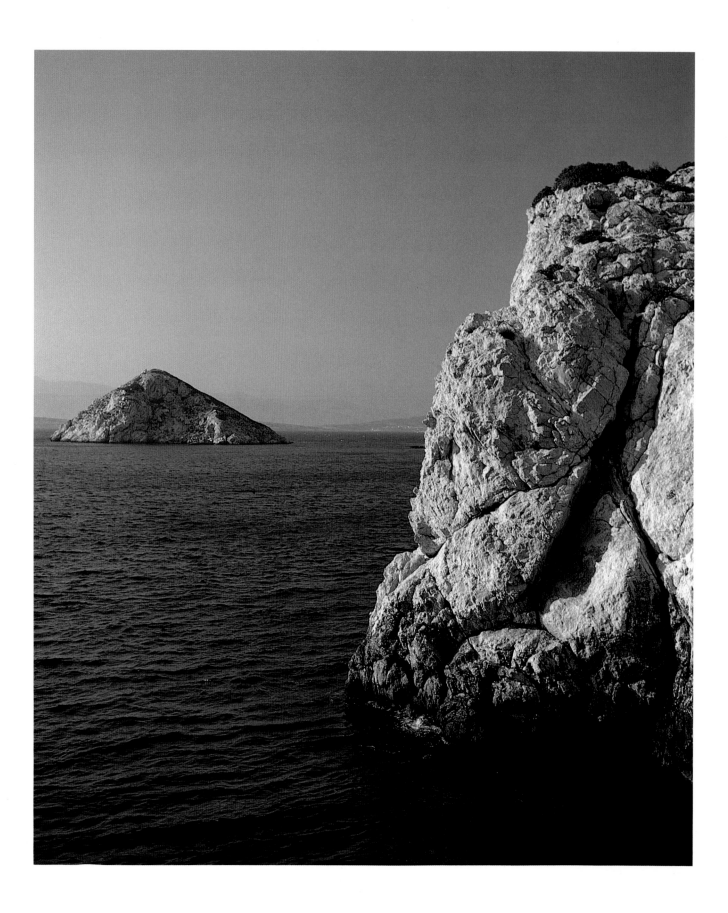

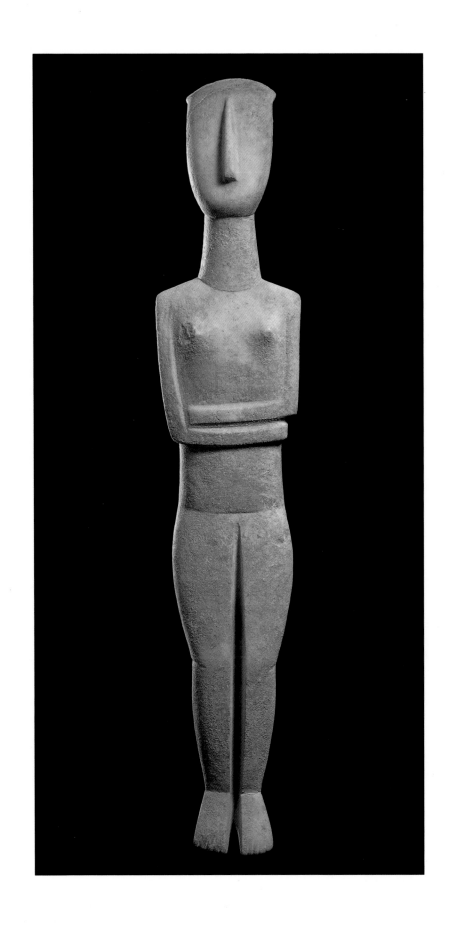

modern movement in the early years of this century taught us to admire and value the process of abstraction. What once seemed uncouth is now recognized as profound in its simplicity.

A marble cup from the Cyclades, with its poise and balance, its clarity of line, is no longer in our eyes the work of a peasant who could do no better (plate 4). Its quiet authority now speaks to us. Its elegant form holds for us today, in our own experience, some echo of Chinese porcelain, of the celadon wares of the Sung dynasty perhaps, although of course these were created some three thousand years later.

A footed pottery vessel achieves its own economical completeness, the concave curvature of the neck contrasting with the globular outline of the body and this again with the concave curvature of the pedestaled foot (plate 5). The potters of our own time have rediscovered only with considerable labor the knack of allowing such simple curves to speak plainly for themselves, accompanied by only a minimum of decoration.

An eyeless head set upon an elongated neck, with timeless, polished features, no longer seems to us barbarous (plate 6). With its reduction to essentials, its avoidance of the superfluous, it is more sophisticated, more accomplished than the elaborate and sometimes fussy works of the Victorian era so much admired by the early critics of Cycladic art.

Above all, a handsome standing figure, with quiet, unassertive rhythms and balanced proportions, achieves one of the most compelling early statements of the human form (plate 3). As Henry Moore, a master of these qualities in our own century, put it: "I love and admire Cycladic sculpture. It has such great elemental simplicity."[1]

The text that follows is intended as a discussion of Cycladic art, not of the archaeology of the Cycladic Early Bronze Age, for which other, lengthier accounts can be consulted.[2] The Goulandris Collection itself has been well described by Christos Doumas.[3] For Early Cycladic sculpture a number of substantial accounts that raise many of the main archaeological and interpretive issues are available.[4] None, however, has set out in any systematic way to consider the aesthetic questions involved: why we admire so much today these works that, a century ago, were considered barbaric. That is the central enigma that underlies this book. Its investigation requires a fresh consideration of that misleadingly simple concept of the "work of art," which while evident enough to us in some of its implications, may have held little meaning for the makers of these works or indeed for the makers of most "works of art" in other cultural traditions than our own.

I am well aware that the adequate discussion or "deconstruction" of the concept would imply the resolution of many of the central and timeless questions of aesthetics: What is beauty? How much of the enjoyment of an object is due to the beholder, how much inherent in the work? To what extent is the operation of a work to be regarded as the consequence of the intention and the sensibilities of its original maker? Needless to say, no claim is made here to settle such questions, for

which any answer must be rooted in the context of its time and place and the perspective of the individual responding. My hope is simply that the reflections of one who has looked long and hard at the works and who is familiar with the archaeological background may make some further contribution to the definition and appreciation of the Cycladic spirit.

Those questions, not quite so explicitly formulated, came into my mind nearly thirty years ago, when I first stood in the Cycladic room of the National Museum in Athens. It dawned on me then that little was known of the archaeology of the early Cyclades and that little progress had been made since the early days of the century in reconstructing their history and culture. And it was then that I first saw that the Early Cycladic cultures — the cultures of the Cycladic Early Bronze Age, to use the appropriate terminology — might amply repay further research. Over the next year, my last as an undergraduate, I considered carefully whether this period might form an appropriate subject for a doctoral dissertation, the necessary first step for someone contemplating a career in academic life, perhaps as a university teacher. In weighing the pros and cons, the image of these remarkable sculptures several times tipped the balance. And they have continued to do so ever since, whenever the minutiae of archaeological detail — the hours spent in the elaboration of ceramic typologies or the compilation of excavation reports — or the sometimes petty discourtesies of academic disputation have proven tiresome.

The investigation of the Early Cycladic "cultures" — that is to say of the material remains of the life of the early islanders that have come down to us and of the inferences that can be made from those remains about Cycladic society — has led on to many wider problems. The relations and contacts between the Cyclades and the rest of Europe involve a whole tangle of issues bearing upon the wider interpretation of European prehistory.[5] The cultural and linguistic background of the islanders, as discussed by earlier scholars, brought one up against the whole vexed question of the origins of the Indo-European languages (although one might have thought that linguistic questions would be remote from the proper understanding of a region that was to be without any form of writing for a further thousand years).[6] These discussions and controversies have at least cleared the decks for a more adequate consideration of the Early Cycladic cultures in their own right, without the need for assumptions and presuppositions about matters that once loomed large among archaeologists, such as "the Orient and Europe," "pre-Greeks," or "proto–Indo-Europeans." Of course our knowledge today is based firmly upon the achievements of the scholars of yesterday, and we can only contemplate the past with the self-critical awareness that our beliefs and conclusions are rooted in our own experience as well as in the light of those earlier achievements. But we do not have to take those achievements on trust: One of the lessons of the New Archaeology of recent decades has been that we ourselves must take the responsibility for the account that we now offer of the past.

There is a less happy thread to our story. As Professor Doumas recounts in Chapter II, on the history of Cycladic research, the first archaeological investiga-

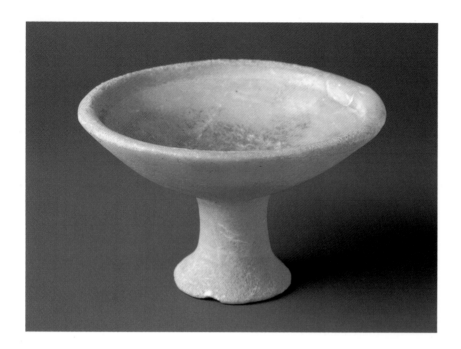

4
FOOTED CUP
Keros–Syros culture, c. 2500 B.C.
Marble, height 2⅝"

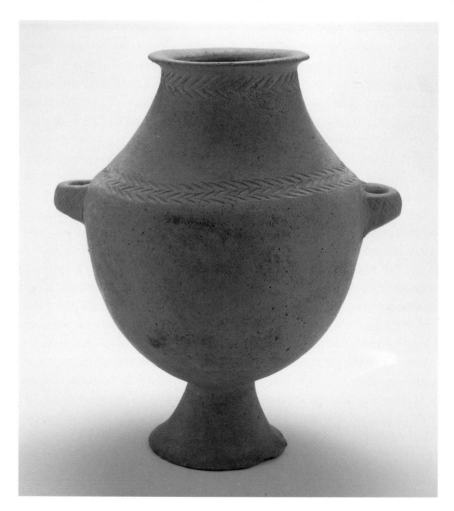

5
FOOTED VESSEL
Keros–Syros culture, c. 2400 B.C.
Pottery, height 10⅛"

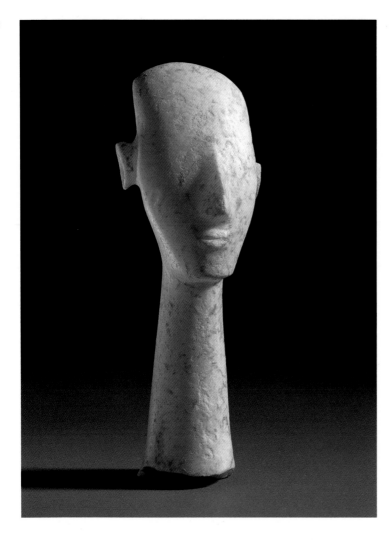

tions in the Cyclades more than a century ago were, by the standards of the time, very ably executed. In particular, the Greek archaeologist Christos Tsountas excavated a number of Early Cycladic cemeteries at the end of the last century and found Cycladic sculptures within some of the graves. Since his time, alas, the cemeteries have been extensively looted. The illicit excavators, the *archaiokapiloi*, operate largely by night: In the richest of the islands, Naxos, they have discovered and destroyed entire cemeteries. On the small island of Keros they discovered a site (now termed Dhaskaleio Kavos) in the 1950s so rich that even the fragments that they left behind constitute the most important assemblage of Early Cycladic finds known to archaeology. The damage is irreparable, the loss incalculable.

In order to understand these works of art properly we need to know how they were used. Were they made exclusively for the grave, as accoutrements for the deceased? Or did they have some central role in the religious beliefs and practices in the daily life of the time? To the modern archaeologist these are not — or should not be — empty speculations. From later prehistoric periods in the Aegean, sanctuaries have been found in the course of controlled excavations

where the nature of the finds and their contexts allows much to be inferred about the belief systems of the time.[7] If the Keros site had been properly excavated when the first finds were uncovered we should have known whether it was a sanctuary or a burial site.[8] We might have known if the life-sized Cycladic figures (plates 103 and 104) were made for use in sanctuaries, possibly as the effigies of a divinity, or were manufactured simply for the grave. Yet it is the lamentable reality that not one of the several life-sized sculptures now known comes from a properly documented excavation. Each has been ripped from its archaeological context and separated from the accompanying finds that might have given it meaning for us and that would have allowed careful interpretation.

The looting of antiquities — whether from the Etruscan tombs of Italy, the Mayan temples of Yucatán, or the early cemeteries and Christian churches of Cyprus — to supply the art markets of the Western world is one of the saddest expressions of our time. But perhaps nowhere else than in the Cyclades has so much, that is to say so high a proportion of what was once there, been lost to archaeological research and hence to the common understanding, to our shared knowledge and experience of the human past.

There is one school of thought that holds that no museum should purchase any looted antiquity: No object that lacks a respectable provenance should, however desirable or fascinating in itself, be acquired from the antiquities market. By the same light it can be argued that no responsible archaeologist should, by describing or publishing, or authenticating unprovenanced works, subscribe to the system responsible for creating that very market that ultimately finances and rewards the activities of looters.

But for a contemporary archaeologist, by a self-imposed vow of silence, to avoid mention of entire categories of material would be to adopt an inappropriate solution. The sculptures of the Cyclades represent one of the great moments of human achievement, and it is one that the historian can ill afford to ignore. Moreover the Nicholas P. Goulandris Foundation–Museum of Cycladic Art has ensured that the many important objects within it shall remain in Greece, available to scholars and to the public in perpetuity. They have escaped the international art market. While regretting their lack of archaeological context, we may be thankful for this and for the impetus that the museum has given to Cycladic studies.

The situation does, however, leave with us a second enigma beyond the aesthetic one posed earlier, namely the question of the function and meaning of these ancient objects. It is a melancholy reflection that the modern appreciation that these are works of supreme beauty has led, almost directly, to so high a commercial valuation (where appraisals and sales are now measured in millions of dollars[9]) that they continue to be torn, in secret, from the context of discovery, which alone would allow their function to be interpreted.

This book, then, is not only a celebration of the Cycladic spirit that created these works and an attempt to investigate its subtleties: It is also an elegy for a lost world whose traces we have insufficiently respected and whose reality is consequently remote to us.

THE

DISCOVERY

OF

EARLY

CYCLADIC

CIVILIZATION

CHRISTOS DOUMAS

THE ESSENTIALLY ANTHROPOCENTRIC CHARACTER of Aegean civilization is manifest in virtually all fields of human activity. It is the human scale that dominates, not least in its architecture and art. The Aegean was never home to structures like the massive temples and tombs of the East, which by virtue of sheer size imposed the presence of the deity, or his earthly representative — the dynast — on the individual. Public buildings and private dwellings were built to accommodate man, not to overawe him. In art too the principal form is man, and wherever animals or plants appear it is to serve him, to beautify his environment. And this because the anthropocentric element is seminal to Aegean man's thinking and ideology. As G. S. Kirk has said, "There is no real confusion in the Greek mythical world between men and animals as such," which is why theriomorphic tendencies in Greek mythology are rather the exception than the rule.[1] Even in the Neolithic period, for the inhabitants of the Aegean "animals became tools, not masters, and the proto-Greeks started on that long process of humanism, of placing man at the center of the universe, that distinguished them from the Egyptians with their interminable tradition of dreary crocodile-gods and the like."[2] Indeed, it could be said that in the Aegean man was deified or the godhead humanized. The idea crystallized in the maxim "Man is the measure of all things" has deep roots, penetrating back into the very early history of the Aegean.

Tangible manifestations of this Aegean ideal are the Cycladic figurines — whether they portray gods or men — that for almost one thousand years, throughout the third millennium B.C., constituted the main artistic expression in the Aegean area. Only after years of research by several generations of scholars has this artistic creation of the Cycladic islanders and the significance of Cycladic culture been recognized. Until quite recently, the mid-nineteenth-century view of Cycladic art, epitomized in Thiersch's description of the figurine nowadays housed in the Karlsruhe Museum, "from a strange barbarian gestalt" ("von ganz eigenthumlicher barbarischer Gestalt"),[3] unfortunately prevailed.

However, despite this general opinion of Cycladic art, interest in Cycladic culture and its creations began to be expressed by enlightened travelers in the early nineteenth century. In 1818, R. Walpole published a marble figurine, which he called "sigillarium." He interpreted it as a depiction of a deity and, moreover, judging "from its stiff and inexpressive form," dated it to before the mythical Daidalos from Sikyon, in his opinion about 700-600 B.C.[4] Sporadic references, mainly to figurines and occasionally to other Cycladic objects, continued throughout the nineteenth century, sometimes confined to descriptive presentations, sometimes accompanied by explanations, and sometimes with an attempted attribution to specific ethnic groups.[5]

Though somewhat superficial, these isolated approaches to Cycladic civilization may be included within the general historical and scientific inquiries of nineteenth century Europe, which gave impetus to prehistoric research and established archaeology as a discipline.[6] For it is these approaches that, on the one hand, made known the existence of a most ancient culture in the Cyclades and, on the other, focused attention on more systematic study and investigation. By the closing decades of the last century there was a spurt

of archaeological activity. In 1884, two European scholars were involved with research into Cycladic civilization: the British traveler Theodore Bent, who excavated and published Early Cycladic graves on Antiparos, and the German archaeologist U. Köhler, who published an account of the then known prehistoric finds from the Cyclades.[7] Just two years later, in 1886, another German scholar, F. Duemmler, excavated and published Early Cycladic graves on Amorgos, while the British School at Athens commenced archaeological investigations on Melos.[8] In his evaluation of the finds recovered from the cemetery at Pelos, C. C. Edgar once again revealed nineteenth-century views on the art and culture of the Cyclades. He wrote of the marble vases found there that these may be considered "most characteristic of the primitive island culture."[9]

As the nineteenth century drew to a close, Greece's greatest archaeologist, Christos Tsountas, rightly dubbed the father of Greek prehistory, came to the fore. His extensive and systematic excavations on behalf of the Archaeological Society of Athens, on the islands of Syros, Paros, Amorgos, Antiparos, Siphnos, and Despotikon, brought to light hundreds of Early Cycladic graves and important settlements. In his reconstitution of the archaeological data, this Greek scholar was the first to attempt a picture of Early Cycladic society.[10] In acknowledgment of the singularity of his finds, he introduced the term Cycladic Culture.

During the early years of the present century there was considerable archaeological activity in the Cyclades. The Archaeological Society of Athens continued its researches, headed by the physical anthropologist Klon Stephanos. Dozens of Early Cycladic cemeteries were excavated on Naxos, and hundreds of graves were revealed. Alas, Stephanos did not prove a worthy successor to Tsountas, and his consideration of the finds is restricted to his brief annual reports.[11] Alongside the work of the Archaeological Society, the British continued their excavations on Melos.[12] The stratigraphical study of the phases at Phylakopi, by the collaborator of Sir Arthur Evans in Knossos, Duncan Mackenzie, laid the foundations of Cycladic chronology: comparison of finds indicated that the first city at Phylakopi was contemporary, at least in part, with the second city at Troy.[13]

In the ensuing decades there was a lull in archaeological research on the islands though not, it would seem, in scholarly interest. A small yet important excavation of a few graves at Kampos on Paros, by I. Varoucha, proved to be most significant.[14] The pottery types recovered from this cemetery were later recognized as a distinct group, characteristic of the transitional phase from Early Cycladic I to Early Cycladic II.[15] In 1928, part I of the first volume of the *Catalogue of Sculpture in the British Museum* was published, in which a small number of Cycladic figurines is included. Even in this tome the persistence of nineteenth-century perspectives on Cycladic art is apparent, despite the progress made in scholarship. Entitling the relevant chapter "Primitive Idols," the compiler of this section, F. N. Pryce, writes: "The small representations of the human form, generally feminine and identified as types of the Mother God-

dess, which are found over the Aegean area from Neolithic times, are of greater anthropological than artistic interest."[16] The conception that only the creations of the Greek Classical period may rightfully be regarded as works of art is implicit. It is perhaps due to this same conception that the highly important discovery of Neolithic and Early Cycladic remains at Grotta on Naxos, by Gabriel Welter, was not systematically pursued and indeed virtually ignored.[17] Nevertheless, archaeological investigations on the periphery of the Cycladic world increasingly demonstrated its external relations. In particular, excavations in Crete and on the Greek mainland brought to light pottery, marble figurines, and other artifacts of indisputable Cycladic origin.[18]

The first systematic study of the art of the Cyclades was undertaken by the Polish scholar K. Majewski in 1935.[19] This important work, written in Polish, is almost completely unknown in the international bibliography.

After World War II a period of sustained and vital interest in the study of Cycladic culture commenced. In 1949, even before the wounds of the two conflicts that devastated Greece — World War II and the Civil War — had healed, the then Ephor of the Cyclades, Nikolaos Kontoleon, began digging one of the most important centers of Early Cycladic culture on Naxos, the site of Grotta. This excavation, which he continued after his appointment as Professor of Archaeology in the University of Athens, brought to light — unfortunately in waterlogged circumstances as it is below sea level — the prehistoric settlement and its cemetery on the adjacent site of Aplomata.[20] Kontoleon's successor as Ephor of the Cyclades, Nikolaos Zapheiropoulos, continued investigations in the islands and excavated Early Cycladic I and II graves on Despotikon.[21] He also located the Neolithic settlement on the islet of Saliagos, between Paros and Antiparos, that was actually excavated by the British School of Archaeology at Athens and constitutes a landmark in Cycladic research: What are still the earliest traces of permanent settlement in the Cyclades were revealed there.[22] Later investigations by the American School of Classical Studies, at Kephala and Aghia Irini on Kea, have shown that Early Cycladic culture was not transplanted to the islands from elsewhere but constitutes the natural evolution of the local Late Neolithic.[23]

In the post-war years discoveries continued to be made on the periphery of the Cyclades too, confirming the islands' contacts with Crete, the Peloponnese, and Attica.[24] This revival of interest was not restricted to excavation. Articles and monographs began to appear, the most important publication being Christian Zervos's monumental volume L'Art des Cyclades.[25]

By the early 1960s Cycladic culture had firmly staked its claim to a place among the major civilizations and its study became increasingly thorough. Excavations continued on the islands, producing more and more evidence and enriching the museums with precious exhibits.[26] Most of these operations were rescue digs and only a few had been planned beforehand. The latter include the continuing project at Grotta on Naxos, the resumption of the excavation at Kastri on Syros, that of Saliagos near Antiparos, and Kephala and Aghia Irini on Kea.[27]

Cycladic figurines, moreover, had been acknowledged as great works of art and there was a growing demand for them in the international market. Their striking similarity to modern works of art attracted the interest not only of art lovers but also of art dealers with an eye to profit. As a consequence there was an upsurge in illicit digging activities during the 1960s, which attained the dimensions of a scourge and caused inestimable damage. Thousands of Early Cycladic graves were rifled and invaluable information on the beliefs and concepts of the creators of this exceptional art lost forever.

Museums and individuals all over the world began forming collections of Cycladic art, thus further increasing demand in the international market. And as the supply of pieces from clandestine excavations did not suffice, there was a parallel development of a veritable industry producing fakes. Entire collections were assembled, made up almost exclusively of counterfeit marble figurines, probably from artists' ateliers in Paris or other centers in the international art market. Could this infiltration of fakes into private collections perhaps be considered divine retribution of the works themselves for the humiliation they have suffered in being reduced to objects of commercial exchange?

During the 1960s archaeological research outside the Cyclades continued to widen the geographical limits of its sphere of cultural influence. New discoveries in Crete and the Peloponnese confirmed the relations between the Cyclades and these regions, while the discovery of the Tsepi cemetery at Marathon in Attica yielded the first substantive indications of a truly Cycladic settlement on the Greek mainland.[28] It would seem that the cemetery discovered at Iasos in Karia represents a comparable settlement, judging from the affinity of funerary customs and similarity of grave goods to those of the Cyclades, even though the finds have been interpreted as proof of the Karian provenance of the Cycladic islanders.[29] These discoveries not only enriched museums and collections with works of Cycladic art, they revealed the important role the islands played in the formation of Aegean civilization as a whole.

Notable among the activities of the 1960s was the founding of the Nicholas P. Goulandris Collection in Athens, which enabled a significant number of Cycladic artifacts to be assembled under one roof, at the same time preventing their dispersal outside Greece.

The publication of catalogues, both of systematic excavations and private collections and museums, considerably augmented the material available for study, thus facilitating the advancement of research.[30] As a consequence articles appeared dealing with the relations between the islands and the outside world and their contribution to the development of technology and trade.[31] It was also possible from the published material to confront such issues as distinguishing phases within Cycladic culture, their chronological sequence, the evolution of Cycladic art, and the meaning of the figurines.[32] Colin Renfrew's typological and chronological classification of Cycladic figurines became the basis for subsequent more detailed research and the quest for

"master" sculptors.[33] Another field of Cycladic artistic creativity, additional to sculpting, was discovered at this time: rock art.[34]

The past two decades (1970s and 1980s) may be characterized as the era in which Cycladic studies matured and Cycladic art achieved full recognition. Possibly the wide diffusion of fakes subdued the demand for figurines, a repercussion of which was the decline in illegal digging on the islands. On Naxos, which was one of the chief centers of such activities, a collection was established in the village of Apeiranthos and villagers were encouraged to add their finds to it.

The excavations conducted over the last twenty years have still mainly been rescue operations. Certainly their finds have enriched the museums of the Cyclades, Crete, and mainland Greece, but none have challenged established opinions on the nature of Cycladic culture.[35] On the contrary, these have been reinforced. The resumption of excavations at Phylakopi on Melos by the British School of Archaeology confirmed the existence of early phases in that settlement and helped clarify its stratigraphy.[36] Likewise, the major excavation at Akrotiri, on Thera, the most important phase of which is undoubtedly the Late Cycladic, has brought to light considerable evidence to show that this extensive city evolved from a small, existing settlement of the Early Cycladic, and even the Late Neolithic period.[37]

The discovery of the extensive cemetery at Aghia Photia near Siteia in eastern Crete, with burial habits, grave architecture, and grave goods displaying such close affinity — in some cases identical — with their counterparts in the Cyclades, could be regarded as the most important indication to date of the existence of a Cycladic colony on Crete.[38] As a consequence of a building boom in the region of Chalkis on Euboia, excavations were, of necessity, resumed at Manika.[39] A very extensive Early Helladic settlement has been uncovered, estimated to cover an area of some 123 acres.[40] Though neither the settlement nor cemetery at Manika is Cycladic in character, they nevertheless reveal close contacts with the Cyclades.[41] Similar close relations are evident from investigations in the Corycian Cave on Mt. Parnassos, and the excavation of the Early Helladic settlement at Lithares in Boeotia.[42]

The organization of a major exhibition of Cycladic art at the Badisches Landesmuseum in Karlsruhe in Germany, in 1976, was a landmark in the history of Cycladic research. Pieces were assembled from seventy-nine museums and collections, mainly in Europe and America, and for the first time the scale of the recent worldwide diffusion of works of Cycladic art was made known. The weighty catalogue that accompanied the exhibition constitutes the first venture at a joint international approach to Cycladic culture.[43] The Karlsruhe exhibition sparked off many more. In 1978, the first public exhibition of the Goulandris Collection was organized in Athens.[44] So great was its impact that interest was expressed in transferring it elsewhere, outside Greece. The Collection went on display in the National Gallery of Art, Washington, D.C., in 1979; in the National Museum of Western Art, Tokyo, in the autumn of 1980; and in Kyoto, Japan in the winter of 1981. In the autumn

of that year it once again visited the United States, where it was exhibited in the Museum of Fine Arts, Houston. Between October 1982 and January 1983 it participated in the events organized in connection with the "Europalia-Greece," held in Brussels. From there the exhibition moved to the British Museum, London, where it remained all summer, and from October 1983 until January 1984 it was presented in the Louvre. Three years later (1987) another major exhibition of works of Cycladic art in North American collections and museums was mounted in the United States. This moved from the Virginia Museum of Fine Arts, Richmond, to the Kimbell Art Museum at Fort Worth, and eventually to the Fine Arts Museums of San Francisco.[45] Lastly, Cycladic culture and its development is the subject of an exhibition that opened in October 1990 at the Nicholas P. Goulandris Foundation–Museum of Cycladic Art in Athens, entitled "Naxos in the Third Millennium B.C."[46] Through these exhibitions and their accompanying catalogues, Cycladic art began to captivate the general public, while specialists have been given the opportunity of seeing new material.

In the field of research, a host of young scholars came to the fore during the 1970s and 1980s. Concentrating specifically on Cycladic culture, they have contributed dozens of publications to the relevant bibliography. Renfrew was the first to deal with the early history of the Cyclades as a phenomenon of world civilization, in his monumental monograph *The Emergence of Civilization*.[47] He does not confine himself to a descriptive presentation of the archaeological data, but proceeds to their critical analysis within a theoretical framework based on data from similar phenomena elsewhere on earth. A less global approach is adopted in other monographs examining the culture of the Cyclades, whether as a whole or in its partial aspects.[48] There is also a plethora of scientific articles dedicated to art, technology, and chronology.[49]

The increase in scholarly interest in the early history of the Cyclades is indicated, inter alia, by the relative frequency of symposia, seminars, or other scientific meetings organized by diverse scholarly institutions. In many cases these have resulted in the publication of collective works, including contributions by several specialists.[50]

It would be remiss indeed to conclude this survey of the last two decades without mentioning the establishment of the Museum of Cycladic Art in Athens, in which the Goulandris Collection has found its definitive home, as well as the founding of the Nicholas P. Goulandris Foundation with the exclusive aim of promoting Cycladic studies. The Foundation's lectures, scientific meetings, exhibitions, and publications not only exemplify its great contribution but promise even more.

It has taken almost a century to gain, little by little, what knowledge we have of those anonymous fishermen and farmers who lived in the Cyclades in the third millennium B.C. Thanks to continuing research into their material culture, these humble folk, though still anonymous, have been brought closer to us. So close indeed that we are able to feel their spirit, the Cycladic spirit.

THE CYCLADIC WORLD

31 THE CYCLADIC WORLD HAS a timeless quality. Its basic elements have not changed in the past five thousand years. In the photographs of John Taylor some of the immanent features of the land, which even as travelers in the islands we sometimes fail to appreciate, are brought out and revealed deliberately to our attention.

The locus of our study is this beautiful group of islands, set in the Aegean Sea, that have such a distinguished place in early Greek history. The ancient Greeks called these islands the *kyklades,* imagining them as scattered in a *kyklos,* or circle, around the great holy island and sanctuary of Apollo, Delos.

Marble is a dominant feature of the Cycladic landscape. Many of the islands are literally made of marble, sometimes gray and rough, sometimes of a dazzling white, for which the quarries of Paros in particular were renowned. Its crystalline quality is not always apparent in the rough hills, which are covered in scrub and by the characteristic thin reddish soil. At moments the light will catch some outcrop and define its shape with a special radiance.

The gray limestone and marble cliffs often fall sheer to the sea, which is the second reality of Cycladic life. Sometimes pale, sometimes "wine dark," as Homer had it (for wine in Homer's day was neither stored nor served in glass containers but drunk from pottery or metal cups), the sea divides what is in fact a submerged mountain landmass. What seem islands are in fact the peaks of this lost landscape.

In rough weather Cycladic insularity is a stark reality: Storms spring up with great suddenness. Many is the voyager lost in what promised to be a short and easy crossing. But the sea unites as much as it divides, and the seaways are open to merchants and travelers who have braved its dangers for well over ten thousand years. The earliest traders in the world voyaged from the Greek mainland to the island of Melos before 10000 B.C. to collect obsidian.[1] Obsidian, a volcanic glass, was prized as a material for chipped stone tools, and these early seafarers in seeking it established the seaways that later generations followed.

The four elements played a significant role in early Greek thought, and Christos Doumas has recently suggested an early Cycladic origin for this concept in pre-Socratic philosophy.[2] If Earth and Water form the Cycladic landscape, Air and Fire, the sky and the sun, combine to endow it with the particular clarity that forms so fundamental a component of the Cycladic spirit. By day there is a brilliant interplay of blue sea and white marble that must have been an inspiration to the Early Cycladic sculptors as much as to their successors in Naxos and Paros in the archaic period of the art of ancient Greece.

But man does not live by sun alone, and the first settlers in the islands, certainly as early as 5000 B.C., brought with them the basic ingredients of the farming life: grain and livestock. From that time on, Cycladic fields have been dominated by cereals; first barley, and in second place wheat.[3] The rhythms of daily life as described by Hesiod in his *Works and Days* date from in the islands at that time, and Cycladic agriculture has changed little since then. On many islands the grain is still threshed by the hooves of animals and winnowed by throwing it into the air with wooden shovels for the wind to disperse the chaff.

The typical Cycladic animal is the goat, well suited to the sparse hills. But from the first, sheep have been kept as well — the spindle whorls used for spinning wool (plate 9) give visible proof. Cattle and pigs were known, but the equids (horses, donkeys, mules) only became a feature of the Cyclades in the Later Bronze Age, some centuries after the period we are considering.[4]

Two other plants completed the triad for our Cycladic islanders: the olive and the vine. Domesticated grape vines have been found elsewhere in Greece from this period, and other evidence, including the widespread use of jugs and drinking cups, suggests that wine was known.[5] There is evidence too that the olive was known, although it may not have come into intensive production until the Later Bronze Age.[6] Both are well adapted to the semi-arid environment of the islands, and we may imagine the silvery green of the olive tree contrasting already with the straw yellow of the ripening grain.

The produce of the sea has always supplemented that of the land — fish, shellfish, lobster, octopus, sea urchin. For thousands of years fishermen in the Cyclades have pursued their catch with line and with spear, and sometimes with net.[7] The simple forms of shellfish, along with the skeletons of sea urchins, entered early on into the visual repertoire of Cycladic objects. The slap of the octopus, fresh from the sea, beaten upon the rock to tenderize it, has long been a familiar sound.

All these are part of the world of every islander. It is a world that has not changed greatly since it was established more than five thousand years ago.

Previous pages

Page 32, top
View of Amorgos from
the site of Minoa above the town
of Katapola

Page 32, bottom
South coast of Amorgos

Page 33, top
Wheat field on Naxos

Page 33, bottom
Olive tree on Paros

OUR PICTURE OF THE life of the early islanders, played out against the elements of earth and water, marble and sea, is far from a complete one. The looters have pillaged the cemeteries, and the archaeologists have not yet excavated many of the settlements, sometimes much eroded, that have been discovered. But despite this some clear outlines can be sketched. For the archaeologist, or anyone seeking a clear perception of the Cycladic past, the first question is one of date.

CHAPTER IV

FROM
THE
SPARSE
EARTH:
EARLY
CYCLADIC
LIFE
AND
SOCIETY

THE TIME DIMENSION

The Cycladic cemeteries that came to light in the late nineteenth century are the key to our present understanding of the Early Cycladic period. From them came most of the objects described in the next two chapters, and probably nearly all of the finds illustrated in this book.

The wealth of material owes its preservation to the remarkable care that the early islanders took of their dead. These were frequently buried in graves in the form of "cists"—that is to say in boxes typically rather more than three feet long by about two feet wide made of flat slabs of schist or marble. There would be one slab for each of the four sides, sometimes one more for a floor, and always one for a cover, making a neat marble box, in effect a durable time capsule. In it the dead person was buried along with his or her grave goods. Variant forms exist in form and construction, but in each case the objects buried were effectively packaged to survive for more than four millennia until our own century. Sometimes the same cist grave was used several times, probably as a sort of vault for the successive dead within a single family. Groups of such graves form cemeteries which in many cases were set near settlements. The largest cemetery known, at Chalandriani on Syros, contained at least 600 graves; that at Aphendika on Naxos at least 170. Most were very much smaller.

When these cemeteries were first discovered, their date was not at all clear, although it was obvious to archaeologists that they were "prehistoric"—that is to say prior to the first millennium B.C. (1000 B.C. to A.D. 1), the period of the Classical Greeks. The situation became clearer, however, with the excavations on the island of Melos, at the important prehistoric settlement of Phylakopi. Duncan Mackenzie, who supervised the digging for the British School of Archaeology at Athens, realized that the site contained the stratified remains of three successive towns or "cities," of which the third and latest was the contemporary of the great citadel at Mycenae, investigated in the 1880s by Heinrich Schliemann.[1] The "Mycenaean" period third city at Phylakopi was thus much older than the Classical Greek period.

Beneath these three cities were pockets of material that Mackenzie realized were comparable to recent finds from the early Cycladic cemetery at Pelos on Melos.[2] It was evident, therefore, that the Cycladic cemeteries dated from quite an early period. It was not yet possible to say how early. Discoveries on Crete, one hundred miles to the south of Melos, were soon to give further insights.

When Sir Arthur Evans began his excavations at the great site of Knossos on Crete in 1900, he soon realized that his finds were, apart from those on the uppermost layers of the mound, earlier than the period of Classical Greek

Figure 2

The Cyclades

Kea: 1 Kephala
 2 Aghia Irini
Melos: 1 Phylakopi
 2 Pelos
Syros: 1 Chalandriani
Delos: 1 Mt. Kynthos
Paros: 1 Plastiras
 2 Paroikia
 3 Kampos
 4 Pyrgos
 5 Drios
 6 Glypha
Naxos: 1 Akrotiri
 2 Aplomata
 3 Grotta
 4 Apeiranthos
 5 Aghioi Anargyroi
 6 Aphendika
 7 Louros
 8 Lakkoudes
 9 Panormos
 10 Spedos
Keros: 1 Dhaskaleio Kavos
Amorgos: 1 Kapsala
 2 Dokathismata
 3 Markiani
Ios: 1 Skarkou
Thera: 1 Akrotiri

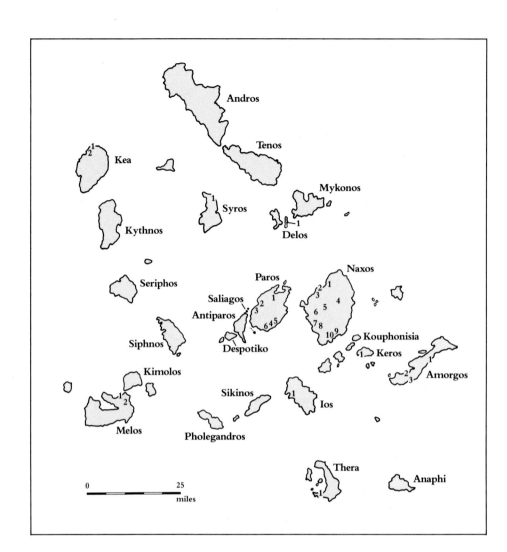

civilization. The major palace that he discovered there, with its frescoes and its archive of clay tablets, evidently belonged in its entirety to an earlier age, which Evans termed "Minoan." It was contemporary in part with the discoveries that Heinrich Schliemann had made at Mycenae, including the burial circle of the Mycenaean princes with its golden treasures. (The Mycenaean civilization had come to an end well before 1000 B.C.)

In order to make some sense out of the great series of stratified deposits at Knossos, Evans borrowed an important idea from the so-called "northern antiquaries." For in Denmark in the early years of the nineteenth century a useful classificatory scheme, the "Three Age system," had been developed. There the "Stone Age" was followed by the "Bronze Age," which was in turn followed by the "Iron Age," each defined by the presence or absence of the relevant technology. The Classical Greeks of the first millennium B.C. enjoyed the use of iron: that was therefore the "Iron Age" of Greece. Their predecessors at Knossos at the time of the successive palaces, like those at Mycenae, had no iron but made frequent use of copper and bronze. That was therefore the "Bronze Age." And beneath the

Bronze Age levels at Knossos were no fewer than twenty-six feet of stratified deposits going back to an early period when bronze was not known. This was the "Stone Age." More specifically this was termed the "New Stone Age," or Neolithic period, to distinguish it from the far earlier "Old Stone Age," or Paleolithic period, already familiar from finds in France (including the painted caves) but not represented on Crete.

Evans dubbed his great complex of buildings at Knossos "the palace of Minos," after the legendary ruler of Crete whose deeds are recorded in Classical Greek traditions. And he termed the brilliant civilization that he recovered there "Minoan," proceeding to subdivide the Minoan Bronze Age into three phases: Early, Middle, and Late. (With systematic and perhaps rather ponderous logic he further subdivided each of these periods into three, so that Cretan archaeologists now speak of "Early Minoan I," "Early Minoan II," "Early Minoan III," "Middle Minoan I," and so forth.[3] The phases of the mainland Helladic Bronze Age have similarly been divided up.) Through the contacts that Crete enjoyed with the early civilization of Egypt, Evans was able to use the datings for the reigns of the successive pharaohs of early Egypt as the basis for his Minoan chronology. All of this was a considerable achievement: The prehistoric civilization of Crete had not only been brought to light, but it had been securely dated as well. Today, using this system and aided by radiocarbon dating, the Early Minoan period can be set between about 3500 B.C. and 2050 B.C.[4]

Evans's work in Crete provided the key to the proper dating of the Cycladic cemeteries and of the earliest levels of the settlement at Phylakopi in Melos. From these cemeteries come the splendid marble figures with the arms folded across the chest, which have also been found in Crete in contexts of Early Minoan II and Early Minoan III date. These and other comparisons allow the Cycladic cemeteries to be assigned to the Cycladic Early Bronze Age or Early Cycladic period.

A careful analysis of all the properly excavated Cycladic cemeteries allows their division into two major groups, an earlier and a later phase, both with some sub-groupings.[5] The early phase takes its name from the early cemetery at Pelos on Melos. In 1965 I suggested that the settlement material that could be equated with the Pelos graves was that found in the earliest levels at Phylakopi and also in the earliest materials from the important settlement at Grotta on Naxos.[6] I therefore proposed the term Grotta-Pelos culture for this early phase, which some scholars prefer to designate as Early Cycladic I, adopting the system used by Evans at Knossos.[7] The Grotta-Pelos culture, or Early Cycladic I, is broadly contemporary with Early Minoan I, and I would date it from about 3300 B.C. to about 2700 B.C.[8]

The mature phase in the early Cyclades, which I have termed the Keros-Syros culture, takes its name from the Chalandriani cemetery on the island of Syros and from the crucially important but sadly looted site called Dhaskaleio Kavos on Keros.[9] (Some scholars prefer to term this phase Early Cycladic II.) It may be dated from about 2700 B.C. to 2400 or 2300 B.C.

Various sub-groupings may be recognized among the Cycladic cemeteries. For the archaeologist they are of very considerable interest, and the details of

Cycladic chronology (and terminology) have been the subject of lively discussion. Here it is probably sufficient to note that between the early (Grotta-Pelos or Early Cycladic I) phase and the mature (Keros-Syros or Early Cycladic II) phase there may lie a transitional, or Kampos, phase to be dated around 2800 to 2700 B.C.

It is not clear precisely when the Cycladic cemeteries went out of use, but there are very few preserved graves with grave finds after the mature, Keros-Syros phase.[10] A new pottery assemblage is seen in the northern Cyclades following the heyday of the Keros-Syros culture. It has been named the Kastri group, after the defensive fort of Kastri near Chalandriani on Syros where much of it has been found.[11] Comparable finds have been made on an analogous defensive position on Mt. Kynthos on the holy island of Delos.[12] And at the important Bronze Age township excavated in the 1960s by Professor J. L. Caskey at Aghia Irini on the Cycladic island of Kea, Kastri group material was found that dates well prior to the first fortified settlement of the Middle Cycladic period.[13] (The Kastri phase is taken by some scholars to represent Early Cycladic III.)[14] Whatever the minutiae of terminology, it seems that the production of marble vessels and those splendid marble sculptures that are the particular focus of this book ended by about 2300 B.C., and by 2000 B.C. the Cycladic Early Bronze Age was at an end.

Thus the broad chronological framework for our study has been established. Using the useful Cretan comparisons and others with the Early Helladic cultures of mainland Greece (as well as calibrated radiocarbon dates from the Aegean) we may date the early phase (the Grotta-Pelos culture; Early Cycladic I) from c. 3300 B.C. to c. 2700 B.C. The mature phase (the Keros-Syros culture; Early Cycladic II), during which most and indeed probably all of the "canonical" or folded-arm figures were produced may be dated from c. 2700 B.C. to c. 2400 B.C.

Figure 3
Chronological table of
Early Cycladic cultures

THERA	MELOS	PAROS ANTIPAROS	NAXOS SIPHNOS	AMORGOS	SYROS MYKONOS	KEA	AEGEAN	CALENDAR DATES
MIDDLE MINOAN PHYLAKOPI II	PHYLAKOPI II	PHYLAKOPI II	MIDDLE BRONZE AGE	?	MIDDLE BRONZE AGE	MIDDLE BRONZE AGE	MIDDLE BRONZE AGE	
								c. 2000 B.C.
PHYLAKOPI I	PHYLAKOPI I	PHYLAKOPI I	PHYLAKOPI I	AMORGOS GROUP	KASTRI GROUP	KASTRI/ LEFKANDI I GROUP	EARLY BRONZE AGE 3	
			KEROS-SYROS					c. 2400/ 2300 B.C.
KEROS-SYROS	? KEROS-SYROS			KEROS-SYROS		KORAKOU	EARLY BRONZE AGE 2	
		KAMPOS + PLASTIRAS GROUP	LOUROS GROUP		KEROS-SYROS			c. 2700 B.C.
GROTTA-PELOS	GROTTA-PELOS	GROTTA-PELOS		GROTTA-PELOS			EARLY BRONZE AGE 1	
			GROTTA-PELOS					c. 3300 B.C.
						KEPHALA	FINAL NEOLITHIC	

For many years it was thought that the Early Cycladic inhabitants of the islands were the first settlers, incomers from Anatolia arriving perhaps around 3500 B.C. Cemeteries like Pelos on Melos and settlements such as Grotta on Naxos or the earliest finds at Phylakopi on Melos offered an indication of their material culture: their pottery, stone tools, and so forth.

With the discovery of the Neolithic settlement at Saliagos on the tiny island of Saliagos near Antiparos, however, that impression has been revised.[15] We know now that farmers — and they were also fishermen — were active in Antiparos, as well as on Melos, Mykonos, Naxos, and other islands, from about 5000 B.C. (The date is based upon radiocarbon determinations of samples of charcoal, bone, and shell from the Saliagos settlement.)

Where these first settlers came from is a matter for speculation. Indeed it is possible that earlier Neolithic finds will be discovered in the islands, since Melos was already being visited by voyagers seeking obsidian to make stone tools as early as 8000 B.C.[16] But so far no convincing evidence has been found for settlement in the Cyclades prior to the occupation of Saliagos.[17] The pottery of the first Saliagos settlers, much of it decorated with white paint, should give us some clue as to their origins. At present however it is not clear whether they arrived from the east — from Anatolia — or from the west, from mainland Greece. In any case the first farmers of mainland Greece appear themselves to have arrived at a very much earlier date (shortly after 7000 B.C.), with their cereals and their livestock, from western Anatolia. In consequence the first Cycladic farmers will have been related, however distantly, to their contemporaries to the east and to the west. They may have spoken a language related to those spoken by these contemporaries, perhaps an early proto–Indo-European language.[18] But this is mere speculation, since we have no direct evidence in the form of written texts from these early periods, and none that we can read and understand from the Aegean until the Linear B tablets from Crete and Mycenaean Greece around 1300 B.C.

Saliagos was a small and probably permanent settlement, situated upon a promontory by the sea. The site, today partly submerged, is now an island of about 330 by 250 feet. The finds show that its inhabitants grew barley and wheat. Heavy stone querns were used to grind the grain into flour to make bread. There is no evidence from Saliagos for the use of the olive or the vine and these plants may not yet have been domesticated in the Neolithic period. Their livestock were mainly sheep and goats, but cattle and pigs were also kept and deer still ran wild in the islands and were occasionally hunted.[19]

The Saliagos farmers were also great fishermen: Numerous bones of tunny fish have been found along with those of other species. The tips of their fishing spears, made of carefully worked obsidian, are also a frequent find.

Broken pottery, on this as on most early sites, are the most abundant finds, particularly bowls, jars, and other containers. The fine wares were handsomely decorated in white paint. Spindle whorls indicate that the inhabitants were spinning the wool from their sheep and presumably weaving it as well. Their tools and artifacts were of bone and stone and probably of wood, which has not

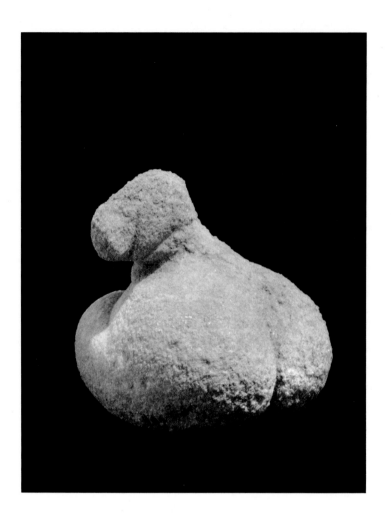

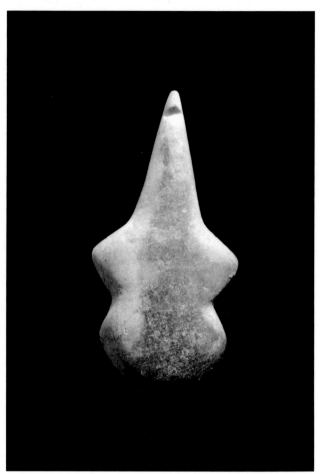

7

THE FAT LADY OF SALIAGOS

Saliagos, c. 5000 B.C.

Marble, height 2⁵⁄₁₆″

Archaeological Museum, Paros

8

SCHEMATIC MARBLE FIGURE

Saliagos, c. 5000 B.C.

Marble, height 2⅝″

Archaeological Museum, Paros

survived. Neat axes, probably for woodworking, were made from emery, a hard stone imported from the nearby island of Naxos. The obsidian used was also imported, from the island of Melos to the south. But more distant contacts are documented by the find of a few fragments of a different kind of obsidian from a source near Nisyros, north of Rhodes.

The settlement remains at Saliagos are not well enough preserved to allow one to estimate its original size with any confidence. It is just conceivable, to take a minimal view, that a single family of six or seven persons could have occupied a small homestead there. On the other hand it takes no great act of imagination to conceive of a village of up to ten such families and a population of sixty persons. Only part of the available area has been excavated and there is no reliable way of deciding. My guess is that a population of twenty-five would not be too far out. There is nothing to suggest that this small society contained persons of special wealth or prominence. The cemetery, if there was one, has not been found: There is no way of evaluating the personal possessions of one person against those of another, although a few attractive stone beads and pendants have been found, and two fragments of marble bowls.

These people were, however, already accomplished sculptors in stone — or at least, either the best of their craftsmen were or they were obtaining the products of such craftsmen through exchange. For it is of great significance to our story that there were, at Saliagos, hardly any of those little human representations in terra-cotta that are a common feature of early Neolithic sites in many parts of Greece, including Crete and Thessaly, and that, as we shall see, survived into the final Neolithic period of the Cyclades at Kephala on Kea. Saliagos yielded a single torso of baked clay (the preserved height is about two and a half inches) and three terra-cotta legs that may have been the supports for pottery vessels. But it yielded instead several very significant finds of marble. One is a little seated figure of a woman, today unfortunately headless and lacking the right shoulder (plate 7). The preserved height is about two and a quarter inches. She is agreeably plump, and the legs are folded with the hands meeting at the waist. Her most prominent feature, therefore, is the well rounded buttocks. The form is known from other finds in the Cycladic islands, none alas from a well-stratified context, and from elsewhere in the Aegean.[20] So the Fat Lady of Saliagos, as she has been called, ranks as the earliest known Cycladic sculpture, standing at the head of that fine succession that we shall be reviewing here.

The fairly "naturalistic" style of the Fat Lady of Saliagos, with her rounded form, contrasts strikingly with the other marble figures from the site (plate 8). Their forms are instantly recognizable to us from the "violin figurines" (plate 21) seen in the early phase of the Early Cycladic cemeteries but they precede by some 1,500 years those Early Bronze Age examples. The one complete one is only two and a half inches high. The neck of a comparable sculpture, a thicker and heavier schematic marble figure, and the head and neck of a another schematic figurine have also been found.[21]

What is interesting here is that we see, at about the same time, two differing artistic tendencies, which we might have imagined to be conflicting ones. The

first is the representational figurative approach (which does not exclude an attractive simplicity of rounded forms). This we see in the Fat Lady of Saliagos. The second is the schematic, abstract tendency, seen in the little "fiddle figurine." There is, however, no doubt that this was conceived as representing the human form: The head is separated from the neck by a distinct notch.

The original function of these little human representations is not clear to us. Some scholars have assumed that they are indications of some kind of fertility cult; others are skeptical. This general question will be further discussed in Chapter VIII.

Neolithic finds in the islands are still rather rare, although systematic site survey on the island of Melos revealed no fewer than seven sites of the Saliagos period. John Cherry has suggested that these were not permanent settlements like Saliagos itself. They may have been merely "short-term, probably seasonal, stopovers in the quest for marine food sources, possibly by true hunter-gatherers, but perhaps more likely by people who were already farming in other areas."[22] One site of particular interest, however, has been found at Kephala, a promontory on the northwestern coast of the northern island of Kea, which lies twelve miles off the coast of Attica: It belongs to the Final Neolithic period, dating from shortly after 4000 B.C. As in many settlements of the succeeding Early Cycladic period, the houses were set on a peninsula overlooking a fine sheltered harbor.[23]

The cemetery, set on the slopes below the settlement, is especially notable. For this is the earliest Cycladic cemetery known, indeed the earliest from the Aegean where built tombs are documented. There were some forty graves, mainly built of drystone, oval or rectangular in plan, and about a yard in length. Most preserved the remains of a single individual, but in Grave 7 no fewer than thirteen burials were conserved. The remains of some sixty-five individuals were recovered altogether, and this must be regarded as a minimum figure.

The graves and the settlement yielded abundant pottery, some of it decorated with pattern burnishing. The economy was broadly similar to that at Saliagos, although there are now preserved the impressions of textiles to confirm the earlier inference of their existence. Kephala, however, was a site where simple copper metallurgy was already practiced. There is evidence that copper-rich ore, doubtless from the nearby sources at Lavrion in Attica, was being smelted: Remains of slag, bits of crucibles, chisel fragments, and a copper awl from the cemetery document this.

The graves contained a number of objects of interest. The most impressive was a marble beaker, now in the Kea Museum, very close in form to an example in the Goulandris Collection (plate 24), but with a pointed, not a flat base. It stands six and a half inches high and is the earliest complete marble vessel from the Cyclades. A small marble bowl with pierced lug handles and three other fragments of marble vessels were also found. Kephala had, however, no marble figurines comparable to those of Saliagos, but as noted earlier there were some figurines of terra-cotta. There were five simple body fragments, none more than two and three-quarters inches high, and three heads, of which the largest, a surface find from the settlement, was four and three-quarters inches high. An

interesting feature of these heads is that, although of terra-cotta, they already anticipate the somewhat flat, tilted face, prominent nose, and the lack of other features that are so characteristic of the heads of the marble folded-arm figures of almost a millennium later.

In two important respects, the site of Kephala heralds the new era, the Early Cycladic period, which is to follow. The first is the clear and very early evidence for metal working in the settlement. The second is the social innovation implied by the existence of a cemetery; the first evidence of systematic burial from the Cycladic islands. For the systematic disposal of the remains of the dead in carefully prepared tombs was not a general feature of the Neolithic period of the Aegean, although it became such in most areas during the Early Bronze Age.

This is no mere fashion, no casual shift of convention: It must represent something significant in social terms and perhaps in religious terms as well. The social significance of the considerable investment of effort in the disposal of the dead lies, perhaps, in the use that was being made of the ancestors. All of us have ancestors, but not all societies bother to commemorate them or to look after their remains. One reason for doing so may have been a new preoccupation with inheritance and with property, especially land. For in many early societies, just as in later ones, property rights, including land rights, were passed on from generation to generation. In celebrating the ancestors and in offering in at least one case a magnificent marble vessel for burial in the grave, these Cycladic farmers were also celebrating their descent from their forbears and thus perhaps establishing their own right to the land that they farmed and to the place where they lived.

EARLY CYCLADIC SETTLEMENT AND SOCIETY

We know surprisingly little about life in the Early Cycladic period, and what we know derives largely from the cemetery evidence. Elsewhere in the Aegean at this time our information comes mainly from settlements (although the tombs of Early Minoan Crete are also highly informative). But excavations in Cycladic settlements have hitherto been few.

Two of the most important sites (Phylakopi on Melos and Aghia Irini on Kea) are known principally for the towns there that flourished during the Later Bronze Age. At Phylakopi, prior to the "First City" at the end of the Early Bronze Age, the earlier levels provide little evidence of structures although the pottery and other material uncovered in the soundings are useful in documenting the material culture. At Aghia Irini some rooms of a house have been found in a stratum below the Middle Cycladic fortification wall but again the accompanying pottery tells us more about the chronological succession than it does about the nature of the settlement.[24]

The best investigated and published site is in fact Kastri, the small fort near Chalandriani on Syros. It occupies the summit of a hill overlooking the sea and is only 230 feet across.[25] The pottery found there, characteristic of the Kastri group, indicates that it should be set rather late in the Early Cycladic period, after the flowering of the Keros-Syros culture and perhaps after the production of the

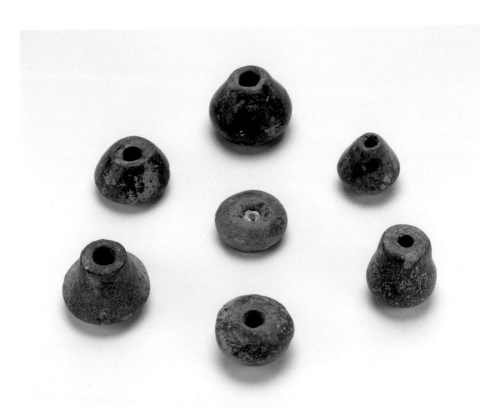

9

SPINDLE WHORLS
Third millennium B.C.
Terra-cotta, diameter c. 1″

marble sculptures had ended, although this is not certain. The tiny (it is only seventy-five feet in diameter) fort of Panormos on Naxos is assigned to the same period by its excavator.[26] Excavations are currently underway at the hilltop settlement of Markiani on Amorgos, where the most densely occupied portion occupies an area of about half an acre. There is clear evidence that this was fortified during the mature Early Cycladic period, and the fortifications, which include a bastion, may in fact go back to the early phase (although further study of the pottery will be needed before this can be established).

The finds from all these sites are certainly sufficient to establish that the subsistence economy drew upon the resources already documented in the Late and Final Neolithic periods at Saliagos and Kephala respectively. Spindle whorls again attest the existence of spinning and therefore weaving (plate 9). In addition viticulture was probably practiced, although this has recently been disputed.[27] The frequent impressions of vine leaves on the bases of pots at Markiani and other sites do however strengthen the case. It has been argued that olive cultivation also developed at this time, although this too has been questioned. The existence in a grave (discussed below) at Spedos on Naxos both of an oil lamp and of a jug containing earth that, on analysis, reportedly showed traces of olive oil does offer supporting arguments, but certainly one would wish to see actual olive pits consistently recovered from settlement excavations before considering the matter settled. All in all, however, a picture of fairly simple mixed farming, not unlike that until recently the traditional pattern in the Cyclades, emerges. It was based

primarily on the cultivation of cereals and the herding of sheep and goats, while cattle, and probably viticulture and olive cultivation, played a secondary role.

As to the density of population, opinions vary about the number and size of settlements. Information about both will gradually emerge from systematic site survey of the kind undertaken by John Cherry on Melos and by Cherry and Jack Davis on Kea.[28] Up to now, however, most estimates have been based upon the number and the size of the Cycladic cemeteries. Most of those excavated have yielded no more than fifty graves, which might argue for no more than two or three families at any one time living at the adjoining settlement. Even the largest known cemetery, at Chalandriani, with its six hundred graves, might represent a population of no more than eight families (about forty people) if a duration of four hundred years is allowed for the settlement.

These calculations are based however on the assumption, which may be erroneous, that all the dead from a community were in fact given burial in those cemeteries that archaeologists have been able to uncover. But they cannot gainsay the fact that no large-scale settlements have been investigated or discovered. It is probably correct therefore to think of a dispersed settlement pattern, with most of the population in homesteads of just two or three families. The Markiani finds and a few others hint that in the mature phase there were settlements of village size, perhaps of fifty to a hundred people, and that some of these were fortified. Certainly in the late, Kastri phase fortifications seem to have become more common. By the end of the Early Cycladic period the settlement pattern seems to have shifted from dispersed to agglomerate, with just one or two townships on each island. By this time the Cycladic cemeteries of cist graves had come to an end.

There is no doubt that, in the technological field, the most significant development of the Early Cycladic period was the growth of a substantial metallurgical industry. Yet despite the indications from Kephala in the Final Neolithic period, the finds from the cemeteries give almost no indications of the use of metal during the early, Grotta-Pelos phase. Instead, decorative objects (beads and pins) of lead and silver make their appearance in the graves of the transitional Kampos phase, and by the mature Keros-Syros culture there are fairly abundant finds of copper, sometimes allied with arsenic to make bronze. True tin bronze, an alloy with 10 percent of tin to 90 percent of copper, with its improved strength and hardness, is not, however, found until the late Kastri phase. In the mature phase, the copper came mainly from the island of Kythnos or in some cases from Lavrion in Attica, as lead isotope analysis has shown, while much of the lead and silver came from Siphnos.[29] Interestingly enough, the copper component of the tin bronzes found at the fort of Kastri on Syros in the late, Kastri phase indicates that they came from the northwest Anatolian region. Kastri phase pottery, which has been compared with that of Troy and of the islands of Lemnos and Lesbos off the northwest Anatolian coast, also suggests trade links between the Cyclades and Anatolia.

Certainly the extent of trade at the time cannot be doubted. Obsidian had been obtained from Melos already for thousands of years by the inhabitants of the mainland and is found at almost every contemporary site within about 120 miles.

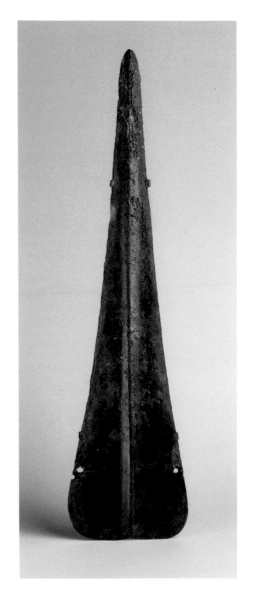

10

DAGGER

Keros-Syros culture

Copper, length 9¹³⁄₁₆″

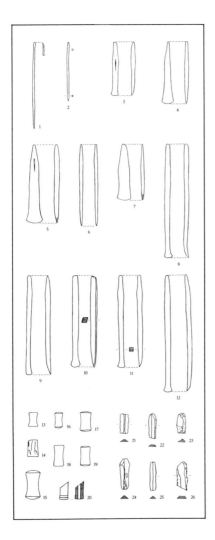

Figure 4
Craftworker's tool kit found at Kastri on
Syros (after Fischer-Bossert). Nos. 1–14
of bronze, 15–19 of stone, 20 of bone,
21–26 of obsidian. Length of no. 8: 5¹³⁄₁₆″.
Archaeological Museum, Syros

Metals were widely traded: The copper and silver of Lavrion in Attica reached 46
Crete as well as the Cyclades, and as we have seen there were Cycladic sources
also. Finished metal objects, notably copper and bronze daggers, were probably
widely traded also (plate 10).

For direct evidence of craftsmen we have to turn again to the site of Kastri on
Syros. But although the finds there are a little later than the mature Keros-Syros
phase, the craft techniques were probably very similar. There is evidence from the
site of clay molds, used for casting copper or bronze tools. And the tool kit of a
craftsman, possibly a lapidary worker, has been found, containing copper awls
and small chisels (figure 4). These, along with obsidian blades and stone rubbers,
may have been the tools used by the early sculptors of the Cyclades (plate 11).

When we turn to social organization, the absence of good settlement evi-
dence certainly presents problems. But the grave goods found in the cemeteries
offer indications of disparities in wealth. In the large cemetery at Chalandriani
there were rich graves as well as poor graves. And in just a few cases, for instance
in Grave 10 at Spedos on Naxos or Grave 14A at Dokathismata on Amorgos, we
catch a glimpse of what seems to be a particularly prominent burial.

For example, Grave 10 at Spedos contained the following objects:[30]

Marble folded-arm figure, height 23″
Marble folded-arm figure, height 17¼″
Marble bowl, diameter 11¾″
Marble bowl, diameter 10¼″
Spouted marble bowl, diameter 4¾″
Marble lamp with three supports for wicks, height 3½″
Painted pottery lamp with three spouted receptacles for oil and wick, height 7½″
Small pottery jug with painted decoration, found containing traces of olive oil, height 3½″
Painted jug, original height about 11″
Painted drinking cup of "sauceboat" shape, height 7¾″
Plain spouted cup, height 5″
Footed pottery jar, height 6½″
Footed pottery jar, height 5″

This is one of the richest Cycladic graves ever recorded. To contain two marble
figures is unusual, although not unparalleled, but the inclusion of other fine
vessels of marble and painted pottery marks this out as the equipment of some
especially prominent individual.

Grave 14A at Dokathismata contained a marble figure as well as a silver
diadem (plate 12), a silver pin with a representation of a sheep or goat at its head, a
small dish of sheet silver, two copper bracelets, a marble bowl, a lump of red
coloring matter, and a pottery jar with a leaf impression upon its base.[31] Silver
vessels have been found at other sites (plate 13).

These observations are certainly enough to suggest that in the Cyclades at
this time some form of personal ranking was emerging, reflected in the quantity
and the quality of the grave goods buried with favored individuals. Now "per-
sonal ranking" smacks of the specialized jargon of the anthropologist. What it
may imply, however, is that, as in many nonurban societies, an office broadly

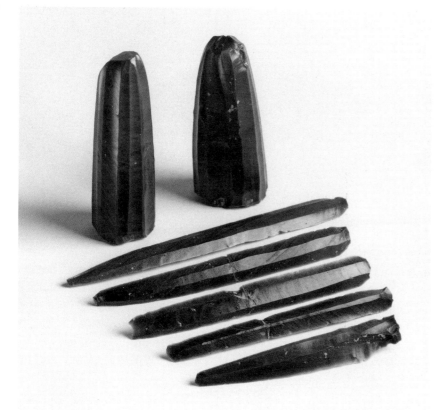

BLADES AND BLADE CORES
Melian obsidian, length (largest core) 3½″
National Museum, Athens

12

DIADEM
Keros-Syros culture
Silver, diameter 6¹³⁄₁₆″
Archaeological Museum, Athens

BOWL
Keros-Syros culture
Silver, diameter 2⁵⁄₁₆″

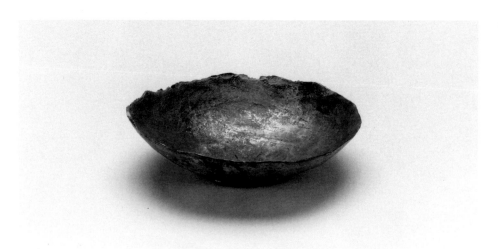

equivalent to that of "chief" had emerged by this time in Cycladic society. Such a chief would be a figure of authority, very possibly over part or all of the island in question, and his authority might be hereditary. He would be a person of high status, capable of exercising a measure of control, and of organizing some aspects of the life of society, not least in times of war. Chiefdom can sometimes represent the equivalent of "kingship" on a modest level. Thus the leaders of society in early Anglo-Saxon England, conventionally referred to as "kings," were in reality chiefs on a scale certainly no grander than in the chiefdoms of Polynesia, two centuries ago, when these were first described by Western travelers. In Africa too it is common to speak of kingdoms and of kings for the holders of the same sort of offices and roles that in Polynesia would be termed chiefs.

Similar comments may be made for some of the developments in mainland Greece at this time and indeed in Crete. There the impression of emerging central power and authority conveyed by some very rich burials at the site of Mochlos is confirmed by the existence, at Aghia Photia, of a large building on a scale hitherto unprecedented that presumably reflects the development of some kind of centralized organization. In some respects the chiefs, if such they were, of the Early Bronze Age in Crete and probably in mainland Greece (for instance at Lerna) and no doubt at Troy, may have been the precursors of the more powerful rulers of Crete in the palace era that was to follow.

For the Cyclades, however, the cemetery evidence is all we have to go on, and it is not really sufficient to sustain the conclusions that the settlement evidence provides for these other areas of the Aegean. If the settlements were really as small as some suggest, then the total population of one of the larger islands would be no more than two hundred or so. I suspect that these figures may be too modest and that the settlements will indeed, when they are investigated, document some concentration of wealth and power in the hands of prominent individuals, whose eminent status is already hinted in the cemeteries. The late fort at Kastri already gives some indications of this, for not only are there indications of metallurgy and other specialized crafts, but the site also yielded up a silver diadem, this time with incised decoration of a possibly symbolic significance (figure 6, page 97).[32]

We may consider the wider social relations of the region on two different spatial scales: relations between the different islands of the Cyclades, and relations between these and their neighboring regions in the Aegean, and indeed beyond.

The term "culture" has been used several times earlier in referring to the Grotta-Pelos culture of the early phase and the Keros-Syros culture of the mature phase in the Cyclades. It is a useful term, for it implies not only a time period, but also some uniformity in material culture extending over a definite area. (All such terms are of course a shade arbitrary, and it is quite possible for one culture to evolve into another over the course of time.) The typical incised pottery vessels of the Grotta-Pelos culture (plate 17), for instance, are found in all the islands where other finds typical of that culture are seen. They resemble each other closely. And no doubt they do so because of close links between the inhabitants of the various islands, whether in terms of common origin or continuing contacts or indeed both.

Mention has already been made of a "trade" in obsidian in Neolithic times, which certainly continued through the Early Bronze Age. Careful research on Melos itself has shown that the quarries there may not have been the base for the specialist craftsmen that some scholars have imagined, craftsmen who would have extracted the raw material and roughed out the obsidian cores ready for exchange.[33] Had they done so they could no doubt have traded these with visitors to Melos or transported the material themselves for exchange in various parts of the Aegean.

The conclusion of a recent study by Robin Torrence was rather that those voyagers who came for Melian obsidian to the island simply went up to the quarries themselves to get it, roughing out the cores themselves from the raw material. In her view there is no evidence for more elaborate craft specialization. And strictly speaking, since there was no actual exchange of goods involved, this was hardly trade at all.

14
SHIP MODELS
Naxos, Keros-Syros culture
Lead, length (largest) 15¹¹⁄₁₆″
Ashmolean Museum, Oxford

Be that as it may, there is no doubt that Melian obsidian was used widely in the Aegean during the Early Bronze Age. Nor need we doubt that the islanders were great seafarers. Their ships are conveniently depicted for us in the form of incisions on a number of carefully decorated vessels found in the cemetery at Chalandriani on Syros (plate 35). Models in lead of these ships, found in an Early Cycladic grave on Naxos (plate 14), have been preserved and confirm the impression made by the representations on the pottery. These were longships, presumably clinker-built, and powered by oarsmen, perhaps as many as forty. They seem to have had no sails, and we have no clear evidence that the sail was used until about the end of the Early Bronze Age, around 2000 B.C.

These craft will have made inter-island travel relatively easy. But Cyprian Broodbank has recently pointed out that not many communities would have been able to provide the crew of forty, or on a more modest estimate perhaps twenty-five, men that would be needed.[34] He suggests a voyage of two weeks (one week out and one back) would give these boats a range of something approaching 200 miles. Metal objects as well, no doubt, as foodstuffs would have been traded. So too perhaps the marble vessels and the sculptures to be described in later chapters.

Nor need commercial motives have been the only ones for the social links between the islands. Many a Cycladic seafarer must have traveled to a neighboring island to visit kinsfolk and ultimately to find a bride. And although we have no evidence that any one island dominated another politically at that time — they were certainly fiercely independent in early Classical times — there may also have been important centers of quite other significance. We shall see in Chapter VIII that there may have been at least one religious center or sanctuary on the islands, for the sadly looted site at Dhaskaleio Kavos on Keros seems likely to have been one of these.

Turning to wider horizons, we may be sure that there were occasional voyages between the islands and Crete, since Cycladic exports have been found in Early Minoan tombs, notably at Archanes and at Aghia Photia. There was certainly contact with mainland Greece also. Cycladic marble figurines are found in both areas (and they were extensively copied in Crete). Moreover, with the widespread development of metallurgy in the Early Bronze II period of the Aegean (the time of the Keros-Syros culture in the Cyclades) something of an "international spirit" developed, with a widespread trade in metal objects, notably daggers and, possibly, in the raw material from Kythnos and Lavrion as well.

Some of the islanders, we may be sure, were intrepid travelers. But there is, at present, no reason to imagine that they voyaged beyond the Aegean Sea. An earlier generation of scholars claimed that developments in the Balkans — in late Neolithic Yugoslavia, Romania, and Bulgaria — were the beneficiaries of visits from Early Cycladic traders and craftsmen. But it has been conclusively shown that the Balkan resemblances are earlier and essentially independent.

Others have argued that Cycladic seafarers ventured far into the western Mediterranean, setting up colonies in what are now Spain and Portugal and perhaps in Italy. Indeed the famous Spanish late Neolithic and Early Bronze Age site of Los Millares has a defensive wall with semi-circular bastions that have been

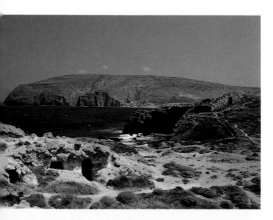

compared with those of Chalandriani.[35] But there are no convincing proofs of direct contact: Much of this was simply diffusionist thinking, based on the assumption that inspiration for prehistoric Europe always came from the Mediterranean world. There is at present no good evidence for contact between the Aegean and the western Mediterranean during the early or mature phases of Early Cycladic culture.

The prosperous Early Cycladic world seems to have suffered setbacks in the later part of the Early Bronze Age from which it never fully recovered. Mention has been made of the fortified site at Kastri near Chalandriani on Syros. The pottery from that site is much like that from the isles of the northeast Aegean and from Troy. And as noted earlier, analysis suggests that the metal used at Kastri came from the same area.[36]

It is not yet clear whether these indications of contact with the northeast, which are seen also in other islands in the northern Cyclades, reflect a strong new orientation in trading patterns or rather the arrival of colonists or immigrants from that direction. It should be noted that similar indications are seen on the island of Euboia and at some sites on mainland Greece. In any case the number of known Cycladic sites diminishes in this late period. This might, of course, simply reflect a change in burial practices, but more probably it indicates a radical shift in settlement pattern, with the small, often undefended settlements uniting into more easily fortifiable strongholds.

It may be that the military potentialities of the new metal weapons now available — daggers, and soon rapiers — were being exploited to the full. Perhaps piracy developed among the islands, as it has certainly done in later periods. In any case the Cycladic spirit suffered a setback from which it did not recover until the Iron Age and the time of the proudly independent city states of archaic Greece.

At about the time of the establishment of the fortified site at Kastri, or perhaps a couple of centuries later, there were significant developments also on Melos.[37] The site of Phylakopi became more important, while the other small settlements and farmsteads on the island came to an end. The pottery and other finds in this, the "First City" at Phylakopi, do not reflect the strong northeast Aegean links seen at Kastri on Syros and at Aghia Irini on Kea. They seem rather to show some continuities in form with the preceding period. But the social implications were much the same. In the succeeding Middle Bronze Age (c. 2050 B.C. to 1600 B.C.), and indeed later, each island in general had a single, well-fortified center of population. The open settlement pattern, with small farmsteads dotted about the countryside, was no more. By 2000 B.C. the Cycladic spirit, as expressed by the remarkable sculptures and marble vessels that we are about to review, was no more than a memory.

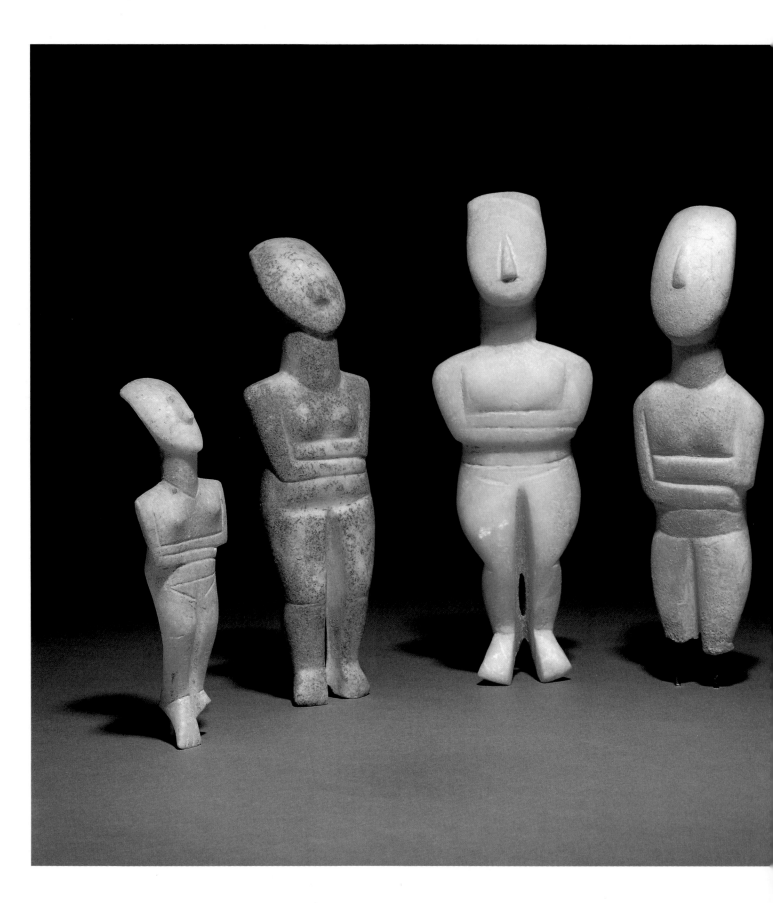

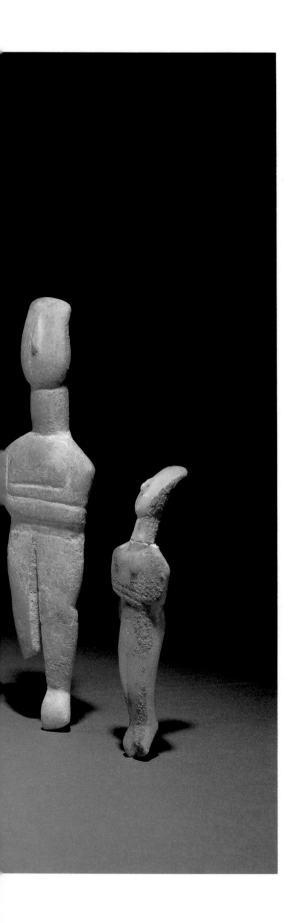

FROM
SOCIETY
TO
SCULPTURE

CHAPTER V

THE
EARLY
PHASE
OF
CYCLADIC
ART:
THE
DEFINITION
OF
FORM

IN THIS CHAPTER we introduce the objects — or artworks, if one prefers that term, or material culture — of the early phase of the Cycladic Early Bronze Age. As already indicated, this has been termed the Grotta-Pelos culture (or Early Cycladic I). It dates from about 3300 B.C. to about 2700 B.C.

We see here the appearance of Cycladic incised pottery and of marble vessels and marble figurines of well-defined types. For one of the most notable qualities of the Cycladic Early Bronze Age is that nearly every object that is found seems to fall within a well-defined category: a type. To some extent, the artifacts produced by any culture may be classified into types, but in the Cyclades these types are exceptionally well-defined. Each type is, in general, represented by many pieces, when we take together all the Cycladic artifacts that are known.

Obsidian is still used as the raw material for knives. There is some evidence for the use of metal, seen already in the Final Neolithic excavations at Kephala on Kea. But very few metal objects have been found in the graves, and what there is seems to have come at the end of the early phase, in the Kampos group, and to have been used for display purposes.

It is perhaps best to let the objects speak for themselves. As we look through them we shall see forms that can be assigned to some of the subgroups within the Grotta-Pelos culture, including the Plastiras and Kampos groups.[1] This last may be dated from about 2800 B.C. to about 2700 B.C., at the end of the early phase (or, as some scholars would prefer to say, at the beginning of the mature Keros-Syros phase).

Of particular interest is the development of, or at least the change in the treatment of, the human body from small "fiddle figurines" to the more detailed Plastiras form and the elegant, stylish, and simple Louros form.

But it is best to look first, and longest, at the objects themselves.

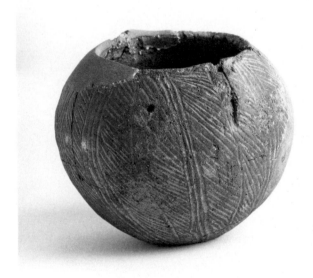

16

SPHERICAL PYXIS
Grotta-Pelos culture
Pottery, height c. 4″
National Museum, Athens

The most typical form of the earliest cemeteries of the beginning of the Early Cycladic I period, first known from the celebrated cemetery of Pelos on Melos, is a cylindrical vessel or *pyxis*, as it is called. It usually has two vertically set tubular lugs and a lid with two matching perforations, probably so that it could be held closed with string.

Typically the pyxides of this time, whether cylindrical or spherical in form, are decorated with light incisions of parallel lines gathered together in zones (plate 16). Often, successive zones have the lines sloping in alternate directions giving a "herringbone" effect. In the example illustrated here, they are arranged vertically, and the lines all run in more or less the same direction.

The modest pyxis in the Goulandris Collection (plate 17) has a pleasing quality, which comes in part from the regularity of the surface decoration as it is applied to the well burnished surface.

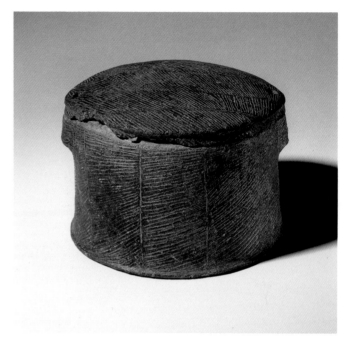

17
CYLINDRICAL PYXIS
Grotta-Pelos culture
Pottery, height 3⅞″

OBSIDIAN BLADES

Obsidian (plate 18) is not only common in the Cyclades (like marble) but has been found in all Cycladic settlements. It is a natural volcanic glass and its distribution in nature is rare, as it comes only from volcanoes of "acid" (that is, silica-rich) composition and geologically recent date. In the Aegean, the most important sources are two deposits on the island of Melos.[2] A third source, on the island of Giali in the Dodecanese, was used principally for special objects (stone vases) in the Later Bronze Age. Obsidian from Melos was the most commonly traded commodity in the Neolithic and Early Bronze Age.

During the Early Bronze Age, the most common use of obsidian was for elegant blades, which possess a hard, glass-like quality. They were struck from specially prepared cylindrical or conical cores, which were themselves carefully prepared from larger rough-outs. Such cores are themselves sometimes found in the graves, and there are indications that they were used as little grinders to pulverize the red-ocher pigment found in some of the marble bowls. The blades, which fracture to a sharp, hard edge, were used as knives and perhaps as razors.

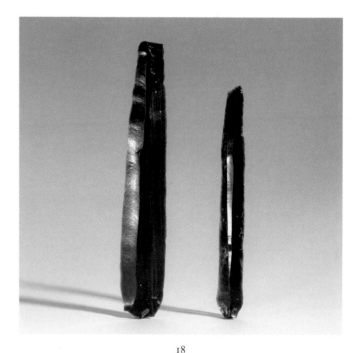

18
BLADES
Grotta-Pelos culture
Obsidian, length 1 3⁄16″

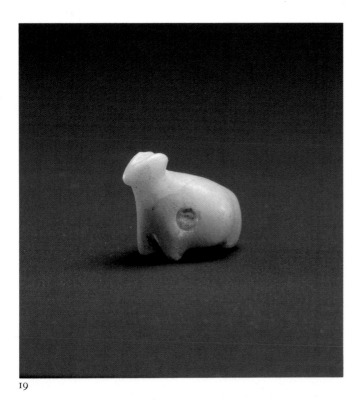

19

STONE BEADS

An exception, perhaps, to the rule that all the Early Cycladic objects of the early phase conform closely to just a few particular types is offered by the stone beads (plates 19 and 20). Most of these, to be sure, are very simple — commonly of cylindrical form, whether short or long. But some are spherical. They are made from stones that are no doubt local to the islands.

There are also, in the early phase, just a few beads that are deliberately carved in the form of birds or of animals. One in the Goulandris Collection is clearly a quadruped. Perhaps it is a sheep. It is carved in the pale green stone much favored by Early Cycladic bead makers. Like so much Cycladic work it has, even on this miniature scale, a charm that arises largely from its simplicity and the absence of any superfluous surface decoration.

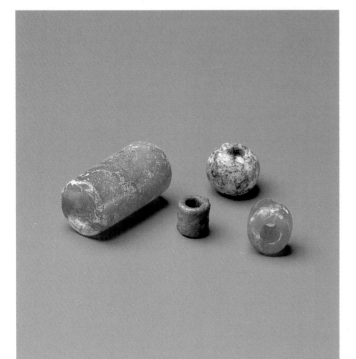

20

19
BEAD IN THE FORM OF A QUADRUPED
Grotta-Pelos culture
Green stone, length ⅝″

20
BEADS
Grotta-Pelos culture
Colored stone, length of cylinder ¾″

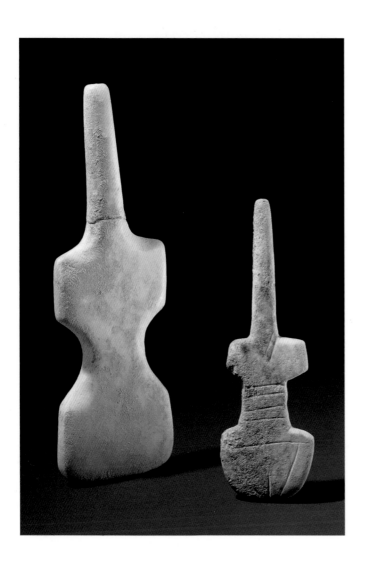

The most interesting objects, in some ways, from the early phase (Pelos group) of Early Cycladic I are the little objects in pure white marble that archaeologists call "fiddle figurines" or "violin figurines" (plate 21). For once the name is quite a reasonable one, since there is no doubt that they do represent the human figure and they are very small. Their keynote is their simplicity. Often the "body" is just a simple, flat piece of marble less than half an inch thick surmounted by a much narrower, cylindrical prong or "neck." Generally the head is not separately indicated. Often the body is constricted at the middle to give the impression of a "waist." The outline can then resemble, to our eyes, that of a violin.

Sometimes, as in the second piece illustrated here, there are incisions below the waist clearly indicating the female pubic area.

It is interesting to compare these "schematic" forms with the example from the Neolithic settlement of Saliagos, which is well over a thousand years older.[3] They are very similar. Why little figurines like this, up to fourteen in number, were sometimes placed in the grave is a matter for speculation: Most graves had none.

21

VIOLIN FIGURINES
Grotta-Pelos culture
Marble, heights 5⅛″ and 3¹³⁄₁₆″

MARBLE BOWLS

Three or four forms of marble objects are occasionally found together in graves of the Grotta-Pelos culture. There are marble bowls, often with a single lug handle; footed vessels or kandeles, conical vases or beakers; and a special form of human figure. Together they constitute the Plastiras Group, named after the cemetery excavated by Christos Doumas where they have most recently been found together. The Plastiras Group is generally dated late in the Grotta-Pelos period, but it might conceivably be just a rich form of burial furniture, not necessarily a later one. In any case, the marble vessels of the Plastiras Group are never found with the incised pottery pyxides discussed earlier.

The marble bowl illustrated here (plate 22) has a pleasing simplicity. It anticipates the long series of marble bowls, generally without handles, that are seen in the succeeding Keros-Syros culture. Although we may justifiably regard these marble bowls as typically Early Cycladic, it should not be forgotten that they have predecessors in the Final Neolithic cemetery at Kephala on Kea and even earlier in the late Neolithic settlement at Saliagos near Antiparos.

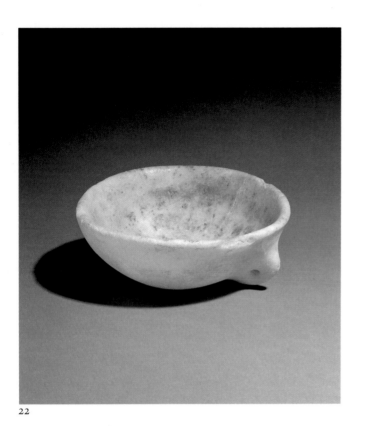

22

22

BOWL WITH PIERCED LUG HANDLE
Grotta-Pelos culture
Marble, diameter 5 1/16"

23
KANDELA
Grotta-Pelos culture
Marble, height 7 1/8"

24
CONICAL VASE
Grotta-Pelos culture
Marble, height 4 3/8"

The collared vase or kandela (plate 23) is the most characteristic marble form of the early phase. It is known from dozens of examples and can be assigned to the Plastiras Group. The form is a particularly pleasing one, strictly tripartite: each piece has a foot, body, and "collar." The body has a wonderful swelling fullness. While the lower part is almost spherical, the curvature increases above, turning inwards to an almost horizontal surface, from which the collar rises. The collar has inturned, almost straight sides, usually conical in arrangement, but sometimes so near the vertical as to be virtually cylindrical. Almost invariably there are four vertical lugs with horizontal perforations. It is notable that these perforations, which may have functioned as string holes, are very frequently broken. For me this is clear evidence that these marble vessels are likely to have been used in the home as well as later buried in the grave. Occasional breakages during manufacture would be conceivable, but to break so many would be inexcusably careless.

With these bold, handsome, simple forms of pure white marble we are already in the mainstream of Cycladic art.

The typical Early Cycladic beaker is a rather wide-mouthed vase with straight sides and a wide flat base. The example illustrated here (plate 24) is a special one. First of all it has three features that remind one of the human body: There are two relief knobs that resemble breasts, although Christos Doumas conceives them as eyes; there are handles reminiscent of ears; and there is at the base a protuberance that might be thought to give an indication of feet. In resembling (to some extent) the human body, this beaker may be compared with one in the Ashmolean Museum in Oxford, where arms and legs in relief make the identification of the breasts and the feet more certain.[4]

The beaker is special in another way. In shape it is much more slender than is usual and the two perforated vertical lugs are a little pointed at the top. In these respects it resembles the splendid conical beaker from the Final Neolithic cemetery at Kephala on Kea, although the Kea one does not have a flat base: there the sides continue to a point.[5] This object is thus unusual, for the Early Cycladic, in departing from strict adherence to the well-defined repertoire of forms.

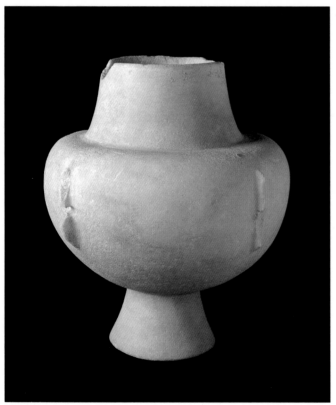

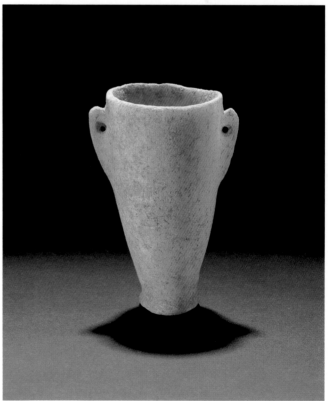

23

24

This name describes a well-defined representation of the human figure, characteristically shown standing, with the legs separately defined and the arms placed so that the hands meet below the breasts and above the waist (plate 26). The breasts are well indicated. The head has a prominent nose, a mouth indicated by an incision, and well-defined ears. Further details are generally present: the kneecaps in relief, the navel and pubic area by incisions. Further examples in Oxford (plate 25) and in Athens (plate 27) — in this case a male figure — are illustrated here for comparison with the Goulandris figure.

Although simple enough, the Plastiras figures sometimes display a quality notably lacking in most of the folded-arm figures of the succeeding mature phase: an interest in the rounding, the volumes, of individual parts of the body. The well-modelled buttocks in the figure in plate 25 are not to be seen again in later Cycladic figures.

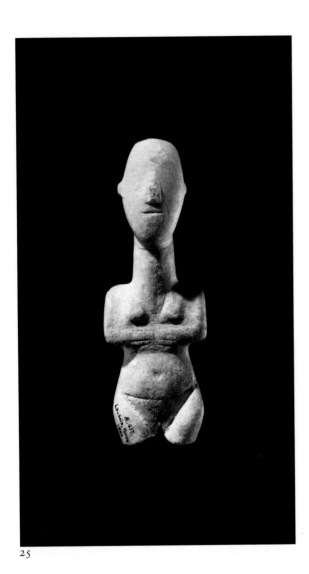

25

25

FEMALE FIGURE

Paros, Plastiras group

Marble, preserved height 3⅜″

Ashmolean Museum, Oxford

26

FEMALE FIGURE

Plastiras group

Marble, height 3⅛″

27

MALE FIGURE

Plastiras group

Marble, height 12⅛″

National Museum, Athens

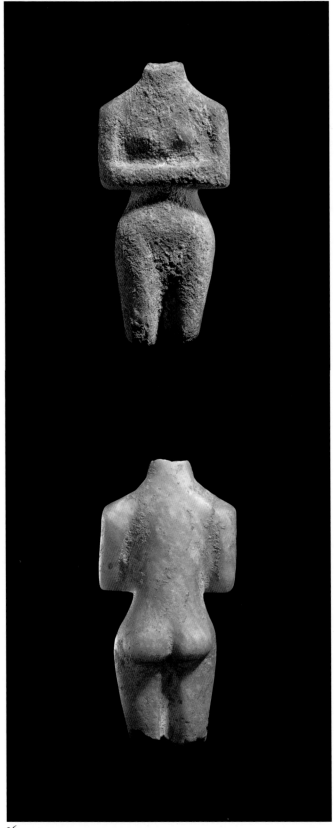

26

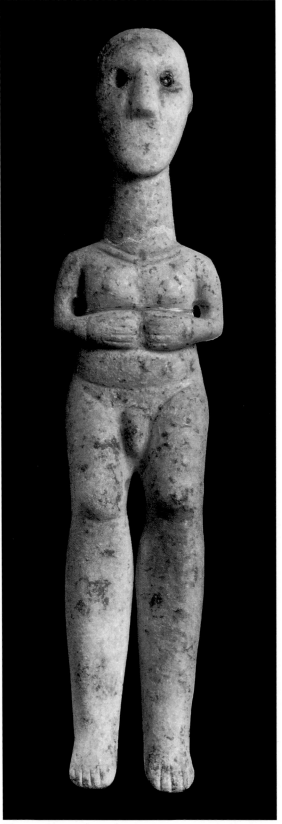

27

The Cycladic tendency to specific forms is well-represented in these globular bottles, which always have a conical neck and two tunnel lugs set opposite each other on top of the globular body. Typically, as in the bottle illustrated here (plate 28), there are four incised lines on each side in the middle of the decorated area (the whole of the globular body), and on each side of these there are incised parallel lines, arranged once again in "herringbone" arrangement, somewhat reminiscent of the designs on the cylindrical and spherical pyxides of the Grotta-Pelos culture.

These bottles belong, however, with other finds (notably the Kampos-type "frying pan" and the Louros figurine, described below) in a group that may be regarded as transitional between the early (Grotta-Pelos) and mature (Keros-Syros) phases of Cycladic culture. Whether one ascribes it to the former, that is to Early Cycladic I (as I have done here) or to the latter, Early Cycladic II, as some writers prefer to do, is just a matter of definition.

These little bottles have been found on several sites in Crete and help to establish the chronological links between the Cyclades and Crete.

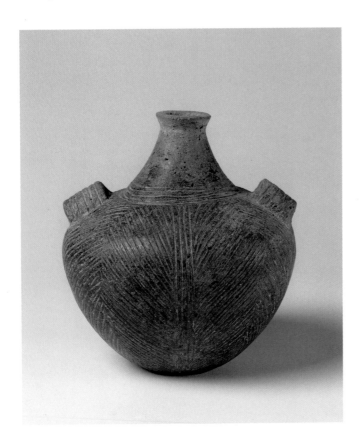

POTTERY "FRYING PANS"

These pottery vessels take their modern name from their shape, but their function is unknown and it is not seriously suggested that they were used for cooking. They may have been used as mirrors or they may simply be trays. In the mature (Keros-Syros) phase they have a well-defined form and are decorated with stamped circles and sometimes with incised longships (plate 35). Those of the Kampos group, at the end of the early phase, have straight sides, which are decorated as well as the flat outer surface.

One example in the Goulandris Collection (plate 29) is rather crudely decorated: The design of concentric incised lines surrounded by triangles suggests a rather simplified version of some of the neater examples, which clearly show the sun in the middle emitting rays of heat and light. More typical is another (plate 30) that has a continuous "running spiral" decoration as the principal motif on the flat, outside surface, and a similar design running right around the outer side. Instead of the sun, there is a spiral at the center, and the decoration is completed with a series of stamped triangles arranged so as to give zig-zag lines. Often — but not in this example — the central motif, in this case a spiral, is surrounded by radial lines or rays suggesting a sun motif. As Lucy Goodison has argued, the symbolism may be of sun (the central motif) and sea (the running spirals), often augmented on later "frying pans" by an indication of the female sex — which buttresses the case for the female associations of the sun at this time. That these designs had some symbolic significance seems very likely, but it should be noted that Kampos-type "frying pans" are found in settlements as well as graves and clearly had a role in daily life.

28

BOTTLE

Kampos group

Pottery, height 4⅞″

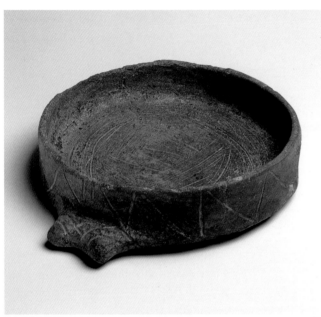

29A 29B

29

"FRYING PAN"

Kampos group

Pottery, diameter 6½"

30

"FRYING PAN"

Kampos group

Pottery, length 8⅛"

30

These little bottles (plate 32), with their decoration of running spirals, may be assigned to the Kampos group for three reasons. First, several of them were found in Grave 26 at Louros Athalassiou, which is generally regarded as belonging to the group.⁶ Second, the shape of the bottles may be compared with the larger pottery bottles of the Kampos group (see above). And third, the decoration resembles that on many of the Kampos "frying pans." In some cases such bottles contained the blue pigment azurite (plate 31). In other cases their use is unknown. But they certainly form a charming addition to the pottery of the time, for they are always miniature. This is in itself an indication that their contents were considered to be of special value.

31

31
BOTTLE CONTAINING AZURITE
Kampos group
Pottery, height 1½″

32
BOTTLES
Kampos group
Pottery, height (tallest) 2¼″

32

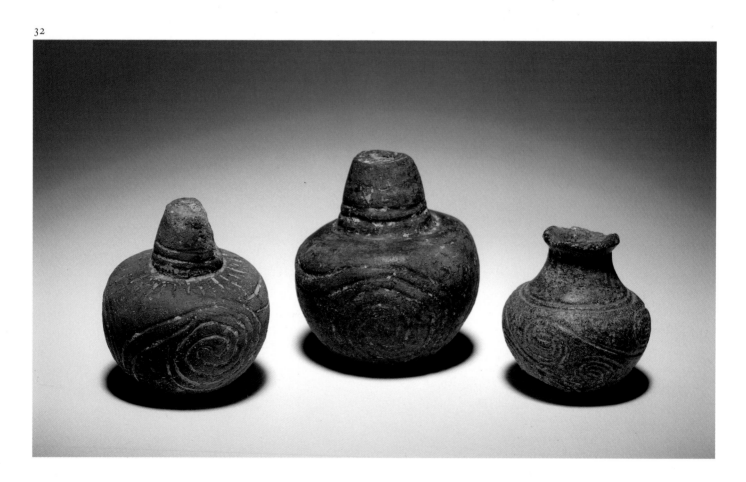

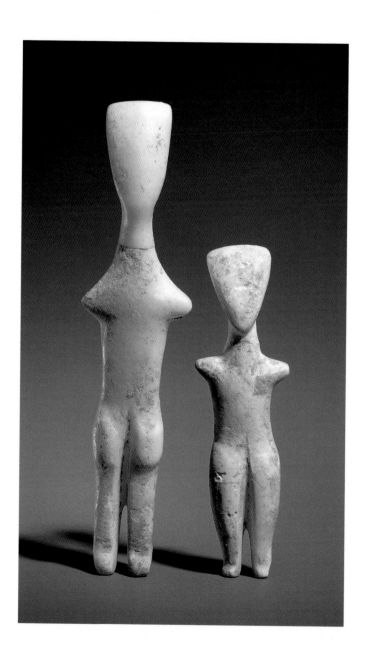

The development of this very simple form (plate 33) at this time, probably only a little later in date than the Plastiras-type figurines, is very interesting. They are named after Grave 26 at Louros Athalassiou on Naxos, which contained pottery (including a "frying pan" and miniature bottles) that allow them to be included within the Kampos group, at the end of the early phase (or as some would prefer at the beginning of the mature phase).

Their most striking feature is their total lack of detail. The head is flat and entirely featureless, the arms are indicated by means of stumps, and there are no incisions of any kind, not even to emphasize the pubic area. The legs are well separated, sometimes with modelling, for instance, at the knees (as in the figure on the left). These are the first Cycladic human representations that combine a well-modelled approach to the human form—for these are not merely schematic "plank figurines" like those violin figurines that we saw earlier—with a special quality of abstraction. It is an abstraction that continues to recognize the essentials of form while effacing surface details and other irrelevancies. They are very close, therefore, to what is essential in the Cycladic spirit.

33
LOUROS FIGURINES
Kampos group
Marble, heights 6½″ and 4⁹⁄₁₆″

CHAPTER VI

THE MATURE PHASE: THE CLEAR LINE

WITH THE MATURE phase, Cycladic art takes on those characteristics that so recommend it to the modern eye: an undoubted grace, coupled with a remarkable economy in the means of expression. This phase, as noted earlier, is termed the Keros-Syros culture (or Early Cycladic II). It dates from about 2700 B.C. to about 2300 B.C.

The tendency for the forms to fall within very well-defined types, noted already in the preceding phase, is still evident. Indeed several of the types in the mature phase are rather clearly developments from those of the early phase. The division into phases does not imply any discontinuity.

In this chapter we shall review the principal products of the Cycladic craftsmen of the time — the pottery, the bronze tools and weapons, the marble vessels — reserving only the human figure of marble for separate consideration in the next chapter. It is a striking property of the Cycladic style that its characteristic simplicity is seen in all the media employed. There is no need to single out the representations of the human form as works of art while relegating the pots or the metal objects to some inferior status. No clear distinction between art and craft can here be drawn.

Pottery vessels are again the most abundant finds. But metal, particularly bronze, was now a material of importance and clearly of high prestige. Once again, however, it is the objects of marble, that quintessentially Cycladic material, that are in many ways the most typical. They are also the most simple.

KEROS-SYROS POTTERY

In the mature phase of Early Cycladic culture, a new crispness of line appears. Perhaps the development of metallurgy, and no doubt of metal vessels, was influential: Certainly the pottery now sometimes favors sweeping forms and distinct changes of direction at points of carination. The footed jar illustrated here (plate 34) is a good example: The gracefully curved foot and the change of direction at the carination below the neck are typical. The lustrous burnished surface may itself be partly an imitation of burnished metal. Footed jars like this are common at the Keros-Syros culture cemetery at Chalandriani on Syros. Sometimes they are decorated with incisions and with stamped impressions of concentric circles.

In the same techniques and from the same important cemetery come the "frying pans" of the mature phase (plate 35).[1] The successors of the earlier "frying pans" of the Kampos group, their decoration is no longer based upon circular symmetry with a picture of the sun at the center. Charac-

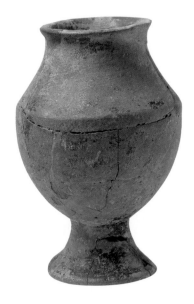

34
FOOTED JAR
Keros-Syros culture
Pottery, height 4½″

teristically, we now see the sea, depicted by a lattice of linked stamped concentric circles, upon which rides a Cycladic longship, with oars but no sail. Beneath, in the triangular space between the sea and the forked handle, is a well-defined incision of the female sex, the vulva. The significance of the symbolism is not entirely clear to us. But this is no frivolity: the symbolism is too consistent for that.

At this time too we see the appearance of painted pottery, for the first time in the Cyclades since the Neolithic Saliagos culture two thousand years earlier. This time the decoration is with dark lines on a pale surface. From the Chalandriani cemetery on Syros come decorated spherical and cylindrical pyxides as well (plate 37). It is very likely that they carry on from the incised pyxides of the Grotta-Pelos phase. There are also painted jugs and other forms. Some of these are found also on Naxos and on Keros.

The Spedos cemetery on Naxos yielded some fine painted vessels, notably in tomb 10. The painted "sauceboat" (almost certainly a drinking cup), probably for wine (plate 36), is one of these. The decoration of hatched triangles is typically Cycladic, indeed typically Naxian. This pottery form, the sauceboat, is highly popular at this time both in the Cyclades and in the Early Helladic II culture of the Greek mainland, of which it is the most characteristic type.

35
"FRYING PAN"
Syros, Keros-Syros culture
Pottery, height 11″
National Museum, Athens

36
"SAUCEBOAT"
Naxos, Keros-Syros culture
Painted pottery, height 7½″
National Museum, Athens

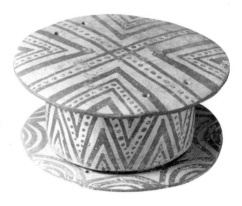

37
CYLINDRICAL PYXIS
Keros-Syros culture
Painted pottery, height 2³⁄₁₆″
National Museum, Athens

COPPER TOOLS AND WEAPONS

The great innovation in the mature phase of the Early Bronze Age was the widespread development of metallurgy.[2] Some of the techniques were already known in the Final Neolithic period, as documented at Kephala on Kea. But we see no metal objects in the graves of the early Grotta-Pelos phase until its end, with the transitional Kampos group. With the Keros-Syros culture, copper objects are widely found in the graves (plate 38). Analysis shows that in some cases the copper was alloyed with arsenic to make arsenic bronze. Tin bronze is not found until the late Kastri phase of the Keros-Syros culture.

The impact of metallurgy must have been immediate. If it was initially used for decorative purposes — for jewelry and for silver vessels — it was soon put to effective practical use, for a range of tools, notably flat axes and chisels, is now seen. One important hoard of copper tools (formerly thought to have been found in Kythnos, but now termed the "Naxos hoard") includes thicker tools with cast shaft holes.[3] There are smaller items, such as tweezers and needles, used perhaps for cosmetic purposes. And above all, there are copper, or more often arsenic-bronze, daggers.[4] Many of these have been found in cemeteries on the island of Amorgos, and some may belong with the slightly later "Amorgos group." But in any case it was during the mature phase of the Early Bronze Age that the dagger first became widely popular in the Aegean. The wooden hafts have, of course, decayed with the years, and what we see now is the blade, sometimes with a well-defined midrib. It was fixed to the haft with rivets, sometimes four, sometimes three. Today we may find these corroded pieces of bronze rather unremarkable. But if we imagine them as polished, shining, in what was then the new wonder material, in a world where hitherto most tools and weapons had been made of stone, we can genuinely envision the dawning of a new era. It may not be an exaggeration to speak here of an "arms race." For these were vastly improved weapons for hand-to-hand combat as well as objects of great prestige. Soon the developing skill of the smiths allowed them to produce ever longer versions, so that within a few centuries rapiers and then swords were being produced. New kinds of warfare were developing and with them new social structures. Accompanying these developments were the trading systems needed to supply the Aegean communities with the essential and rather rare raw materials required to manufacture bronze.

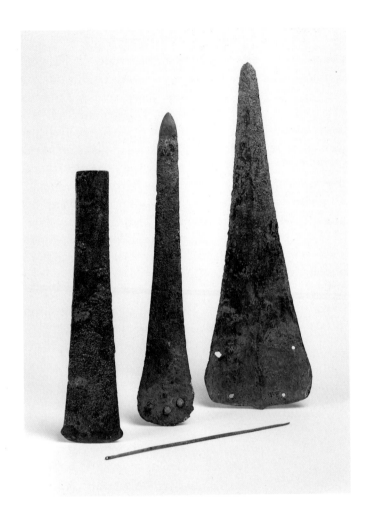

38

CHISEL, DAGGERS, AND NEEDLE
Keros-Syros culture
Copper, length of larger dagger 9½″

With the mature phase, the Keros-Syros culture, the production of marble vessels and figurines in the Cyclades comes fully into its own. The sculptures (figurines) are discussed in later chapters. Here let us celebrate the great range of forms now seen among the stone vases, nearly all of them well-defined and often repeated.

By far the commonest is the open bowl (plate 39). It is an object of great simplicity. In some cases the bowl just narrows slightly at the rim, but more often it thickens on the inside: This "rolled rim," with a line of pronounced narrowing immediately below the rim itself, is characteristic of the domestic pottery of the early Grotta-Pelos culture, which continues into the mature phase. These bowls are often small, just under six inches or so in diameter, but the larger ones can achieve a diameter of twenty inches and more.

Two of the most characteristic pottery forms find their counterparts in marble: the cylindrical pyxis and the spherical pyxis (plate 40). The former still retains from the pottery form the flange at the base and lid, which gives a spool effect to the whole. The marble version has incised horizontal lines. The spherical pyxis has incised vertical lines, the decoration making the form reminiscent of a sea urchin.

Another common form is the simple rectangular "palette" of marble, sometimes with holes at the corners, perhaps to allow suspension (plate 41). The early antiquary Karl Fiedler, writing in 1841, imagined that the marble folded-arm figures might recline on such a bed, and referred to the arrangement as a "holy swing."[5]

Just a few multiple vessels are known, some of which were probably lamps. The example in the Goulandris Collection (plate 42), with two larger and deeper cups joined to each other and to two smaller ones, all set on an elegant flaring pedestal, is unique. It is a work of great originality, where the craftsman has produced an elegant and elaborate form from a compact block of marble.

One exquisite open bowl form has a marble spout and was presumably used for pouring liquids — or it might have served as an oil lamp (plate 43). The example illustrated here, however, contained the blue pigment azurite, which was no doubt used for cosmetic purposes.

Most elegant of all these forms are the exquisite little footed cups of marble. One form has concave sides, giving a flaring effect in profile (plate 44). The other has incurved sides so that the body of the cup has a spherical shape (plate 45). Both are masterpieces of simplicity, comparable in their graceful line with the finest sculptures of the time.

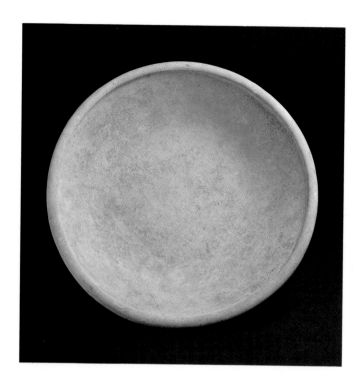

39
BOWL
Keros-Syros culture
Marble, diameter 11⁵⁄₁₆″

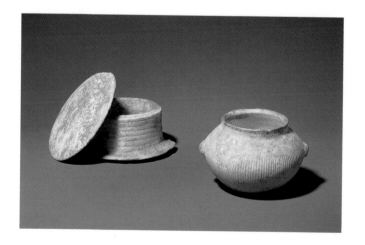

40
CYLINDRICAL AND SPHERICAL PYXIDES
Keros-Syros culture
Marble, heights 1¹³⁄₁₆″ and 2⅛″

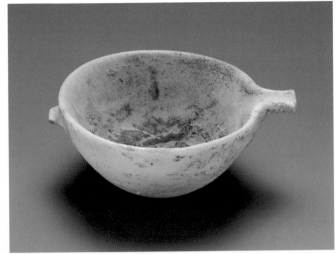

43

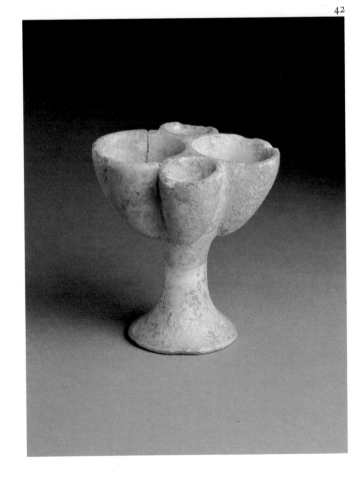

41

42

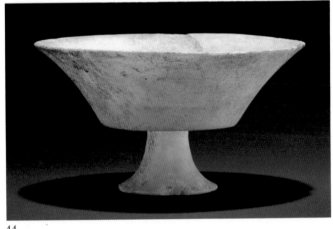

44

45

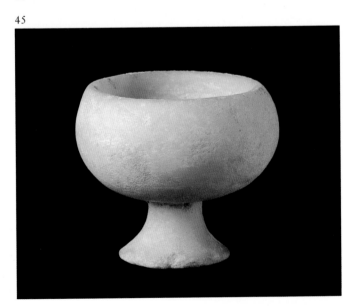

71 During the mature phase, a second kind of stone, chlorite schist, came to be used in the Cyclades for the production of special, decorative vases. Chlorite schist is a soft green stone of a darker color than the related steatite and capable of giving a smooth, polished surface. So far, the few examples found in good archaeological contexts have been of the mature (Keros-Syros) phase, and that is probably where the fragment of a pyxis illustrated here belongs (plate 46). But it is a particularly interesting piece, because the insloping sides give a conical (rather than strictly cylindrical) form, which is more typical of the late (Phylakopi I) phase, while the deco-

ration of straight, parallel lines is reminiscent of the early Grotta-Pelos pottery vessels (plate 17).[6] So this piece is cogent evidence for the suggestion that the Keros-Syros culture forms evolved from those of the Grotta-Pelos culture, which in turn evolved into those of the Phylakopi I culture.

It reminds us, too, of the splendid, complete vessels, some of them decorated in relief with running spirals, that have been found on Naxos (plate 47), on Amorgos, and on Keros.[7] They are among the finest products of the Early Cycladic period.

41
RECTANGULAR "PALETTE"
Keros-Syros culture
Marble, length 10 11/16″

42
FOOTED VESSEL WITH FOUR CUPS
Keros-Syros culture
Marble, height 3 1/8″

43
SPOUTED BOWL
Keros-Syros culture
Marble, diameter 5″

44
FOOTED CUP
Keros-Syros culture
Marble, height 2 5/8″

45
FOOTED CUP
Keros-Syros culture
Marble, height 2 3/8″

46
PYXIS WITH INCISED DECORATION
Keros-Syros culture
Chlorite schist, height 1 3/16″

47
PYXIS WITH RELIEF DECORATION
Keros-Syros culture
Chlorite schist, height 2 3/16″
National Museum, Athens

46

47

48

SPOUTED JUG
Kastri group
Pottery, height 5½"

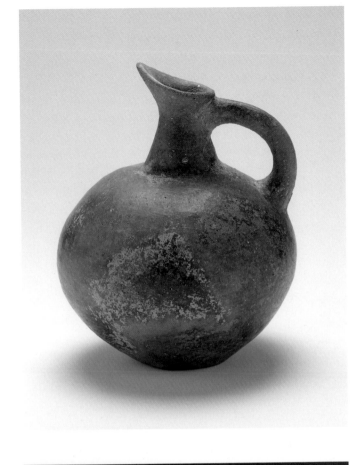

KASTRI GROUP POTTERY

Late in the mature Keros-Syros phase, several new shapes are seen in the graves. Prominent examples are the globular spouted jug with cylindrical or conical neck and the one-handled tankard (plates 48 and 49). Both of these forms are seen in the fortified stronghold at Kastri near Chalandriani on Syros, and so are assigned to the Kastri group.[8] Many of the pottery vessels at Kastri (including the ones illustrated here) resemble those of northwest Anatolia and the adjoining islands of Lemnos and Lesbos. These shapes are seen also at other Cycladic sites, notably Aghia Irini III on Kea and Mt. Kynthos on Delos, as well as Euboia.[9] They are interpreted as indicating very strong trading contacts with the north-east Aegean or even the arrival of immigrant groups in the northern Cyclades from that area. The Kastri group is set by some scholars at a late stage in the Early Cycladic II phase (EC IIB) or in Early Cycladic III — these are just matters of convention.

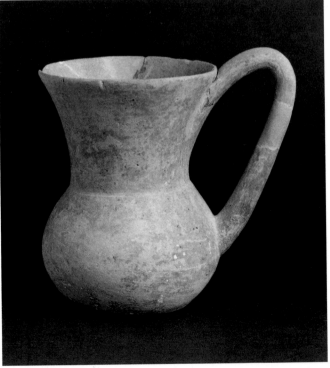

49

TANKARD

Siphnos, Kastri group
Pottery, height 5⁵⁄₁₆"
National Museum, Athens

From the island of Amorgos come other pottery forms that clearly extend in their use late into the Early Cycladic or even into the Middle Cycladic period. They are sometimes assigned to the rather ill-defined Amorgos Group (which belongs late in the mature, Keros-Syros phase and must extend in date into the Early Cycladic III period).[10] The footed jar or krater (plate 50) resembles one found in Grave 10 at Spedos along with objects typical of the mature Keros-Syros phase. It seems to be an elaboration, made probably in Amorgos clay (which does not burnish well) of the bur-nished footed jars from Chalandriani (plate 34). Excavations in Amorgos in the last century produced such forms along with numerous examples of daggers and spearheads, some of which are clearly rather late in date.

Whatever the questions of chronological interpretation, the form has a bold simplicity that is pleasing, but the quality of the surface, with its rather rough, buff clay, does not compare with the fine wares, whether painted or just slipped and burnished, that represent the best ceramic products of the mature Keros-Syros phase.

50

FOOTED JAR

Amorgos group

Pottery, height 8 13⁄16″

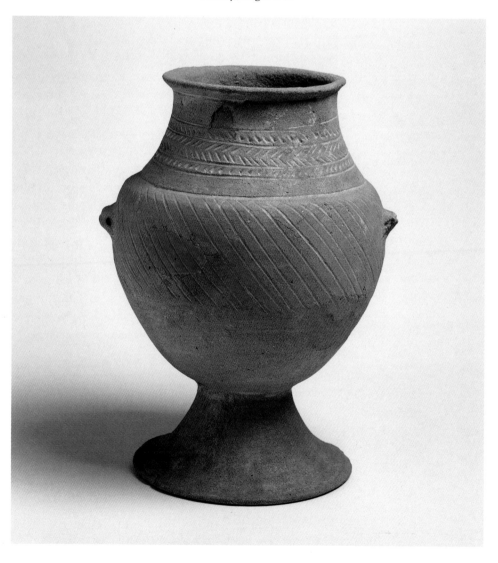

CHAPTER VII

INTRODUCING THE CANONICAL FIGURE

WE ARE NOW AT the point where we can consider the most impressive and memorable form produced in the early Cyclades: the canonical or folded-arm figure. As we shall see below, it was produced exclusively during the mature, Keros-Syros phase of the Early Cycladic period.

It is evident at once, when one looks at Early Cycladic sculptures, that most of them are represented in the same position. At first sight they are standing, albeit on pointed toes, with the arms folded across the stomach, the right arm consistently below the left. They are female, and they are nude. Despite considerable variety in their precise shape, they share an absence of surface detail. In particular the nose, shown prominently in relief, is the only facial feature to be separately indicated, on a head whose brow inclines backwards. We shall proceed in a later chapter to discuss, as far as possible, the significance and the function of these figures. But first let us look at them more closely and see how far a more careful formal analysis may take us.

There is a pleasing variety of styles among the figures — some are slender and elegant, some plump and heavy. And there is a striking range of size. The smallest folded-arm figurines are less than four inches high. The largest are life-size, and are truly monumental sculptures. But their adherence to the canon, to the conventional format just described, is a strict one. For this reason, it is appropriate to use the term "canonical figure" (introduced in 1975 by Jürgen Thimme) as an alternative to the descriptive term that I employed in 1969, "folded-arm figurine" (often abbreviated FAF).[1]

To be sure, there are some qualifications to be made. Most of the figures have feet that point downward, so that if standing, they would be doing so on tiptoe. Does this mean that they are in fact represented as lying down? This point — small but by no means easy to resolve — is considered below. In just a few cases the left arm crosses the stomach below the right: It is suggested below that most of these may be later variants. And of course there are some pieces that don't follow the rules: they cannot be considered "canonical." But they are singularly rare.

The lack of surface detail may be partly an accident of preservation. For while it is certainly true that there is a very striking absence of sculptural detail, that is not the whole story. There is good evidence that many of these sculptures had painted details, especially on the face, which opens a series of questions dealt with in Chapter X. The few cases with facial features in relief, or ears, are separately discussed below.

Above all, the standing, folded-arm sculptures, while by far the most numerous, do not complete the Early Cycladic repertoire. There is a small series of more animated figures. Some are seated, often playing a harp, while others are standing, sometimes playing pipes. They are further discussed in Chapter XV.

We may take the figure in plate 51 as a fine and fairly typical example of the folded-arm figurine. If she is compared with the figure in plate 3 the coherence of the canonical convention is clearly seen, since both figures conform completely, and yet at the same time there is freedom in the detailed treatment within it.

The canonical figure, standing on its toes (if indeed it is in reality standing)

has generally a straight back whose line is continued in the line of the neck, which is separate and well-defined. The backbone is often indicated by a light incision. Often the knees are slightly flexed, so that the thighs and the calves do not form a single straight line.

The legs are defined by an incision at front and rear that serves to distinguish them visually. Only in a few cases, however, are the legs separated by a complete cutting between them, but the feet are usually separated below the heel. The extent to which the legs are separately shown by modelling, or distinguished simply by an incision, varies. In some pieces the rounded outer outline of the calves and thighs is clearly shown.

The waist is indicated by a single incised line. The torso above and the thighs below are on different planes, because of the flexing of the legs. On this piece the pubic area is indicated by two incised lines forming a triangle as they intersect with the line of the waist. The vulva is not, on this piece, separately indicated.

The arms are folded in the usual position. Although the breasts are indicated only in very light relief, the chest area is well-rounded and clearly distinguished from the stomach and there is real modelling for the upper arms. The fingers (and the toes) are indicated by very light incisions.

The head has a broad rounded chin and very full cheeks. It is at its widest well below the nose and then narrows gradually to the crown of the head. Seen from the side or from the rear there is, in some figures, a flat vertical surface near the crown of the head (plate 103) that must indicate either a particular arrangement of the hair or some piece of headgear special to the canonical figure. Apart from the nose there are no facial features.

This brief description indicates some of the more obvious features that this particular piece shares with many others. Such straightforward descriptive analysis can be useful in bringing out the range and variety that may be seen within the standard, conventional canon.

We need, however, in seeking to understand these remarkable early sculptures, to go rather further than this. We need to be able to conduct a systematic analysis of the range of forms and the variety, sometimes subtle, in the shapes of these canonical figures. One solution might be an elaborate statistical analysis of all their features or traits. But in fact the human eye — and mind — is often better at recognizing patterns than is the computer.

As we shall see, two significant steps have been taken towards reaching some perception of the underlying order among these sculptures. The first was my own recognition, in 1969, of a series of "varieties," within which most of the canonical folded-arm sculptures could be further classified.[2]

In 1969 it proved possible to distinguish four main types or "varieties" within the range of the canonical folded-arm figures found in the Cycladic islands and a fifth found on Crete.[3] Very comparable distinctions have since been made by Patricia Getz-Preziosi in her doctoral dissertation of 1972, and the terminology that I proposed was employed by her and by Jürgen Thimme in the catalogue of the comprehensive exhibition of Cycladic sculpture held at the Badisches Landesmuseum in Karlsruhe in 1977.

Overleaf

51
CANONICAL FIGURE
Keros-Syros culture
Marble, height 18⅞"

52
FIGURE OF THE KAPSALA VARIETY
Naxos, Keros-Syros culture
Marble, height 6⅞"
National Museum, Athens

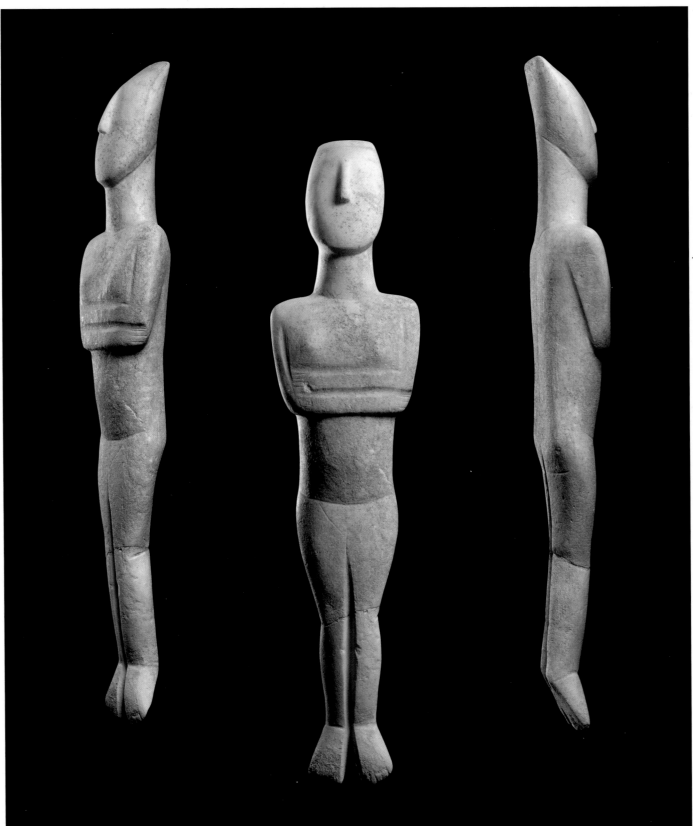

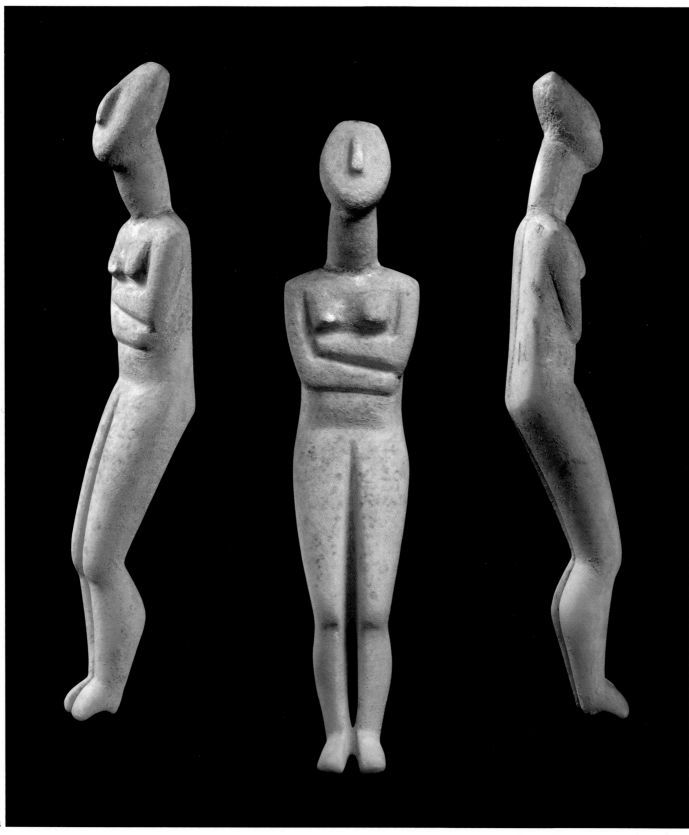

52

These varieties form also the first basis of classification in Getz-Preziosi's major publication of 1987, *Sculptors of the Cyclades*, in the systematic display set out in the National Museum of Athens by Katie Demakopoulou, and in the display in the British Museum and the accompanying handbook by Lesley Fitton.[4]

The second advance in categorizing the figures was the proposal in 1972 by Getz-Preziosi that within these varieties, which she accepted, further, more detailed groupings might be made, which she felt represented the output of individual sculptors or "masters."[5] This question is further discussed in Chapter IX. For the moment, then, I shall simply outline the major varieties, as defined in 1969, and then proceed to indicate how much can be said about the chronology and evolution of these sculptures.

THE KAPSALA VARIETY

Let us start with the Kapsala variety, because it may be the oldest. It takes its name from the eponymous cemetery on the island of Amorgos, published by Christos Tsountas in 1898.[6] The example shown here (plate 52), said to be from Naxos, is in the National Museum in Athens.

The figurine is fairly narrow across the shoulders and arms. All parts of the body show good round modelling, so that the profile is not thin or flat, nor is it stocky. The head, viewed from the front, is convex in outline, with well rounded cheeks, and it is distinctly plump in profile. Often it is not flat at the crown and usually it is well distinguished from the neck. The breasts are rather clearly shaped, often squarish, and set close to the arms. The torso is well rounded; the shoulders are not angular and only a little wider than the hips. The thighs do not bulge. The knees are pronouncedly flexed, so that the back does not form a continuous line with the legs. The legs are often separate (that is, the marble is cut right through between them) a little below the knee, and the calves are markedly rounded. There is often some slight indication of the knees themselves. The feet are neat, lightly arched, often very flat on the ground, unlike the tiptoe position of the other figurines. There are generally very few incisions on the body and consequently little emphasis on the pubic area: the overall effect is not a linear one, but is achieved by sculpting in the round.

In general these figures are quite small in size, from five to ten inches in height, although one very large figure in the Levy collection, twenty-seven inches in height (with the feet missing), is attributed by Getz-Preziosi to the Kapsala variety.[7] As she correctly points out, "the whole notion of separate varieties is to an extent an artificial construction imposed on the material: it is very difficult to assign some works to one or another of the varieties." There is, however, a series of some two dozen or so figures that conform closely to the description given above for the Kapsala variety.

place of the Kapsala variety in the development of the folded-arm figure is discussed below. In some details it seems closest to the Plastiras figures of the preceding phase, notably in the treatment of the feet (the figure stands flat, not on tiptoe), of the head (well separated from the body), and in the indication of some bodily details (notably the knees) through modelling. These arguments led me to

suggest that this is the earliest of the canonical varieties and this proposal has been generally accepted.[8]

It is instructive to compare this true Kapsala figure with one in the Goulandris Collection (plate 53) which we might regard as "transitional" between the Kapsala variety and the Spedos variety to be described below. Seen from the front it has the same general proportions and the same well-modelled breasts. Seen in profile the legs again lie at an angle to the torso and the calves are well rounded. There is very little surface detail. All these are features that it shares with the Kapsala variety. But the head is now close to the "lyre" shape of some of the figures of the Spedos variety, the feet are now pointed downwards, and there is no indication of the knees. Perhaps most significantly of all, the neck, seen from the back, flows on in a steady sweep up from the line of the back and onwards to the head: It is a more flowing sculpture and should probably be assigned to the Spedos variety, although one might well regard it as transitional between the two. The comparison is a useful one in illustrating similarities and differences.

THE DOKATHISMATA VARIETY

Although it may not be the next in terms of evolution or chronology, it is convenient now to describe the Dokathismata variety, as it is so distinctive in appearance. It takes its name after the cemetery of Dokathismata in Amorgos, where, in Grave 14, Christos Tsountas discovered two figures closely resembling each other.[9]

The Dokathismata variety (plate 54) comprises figures that are long, thin, and generally elegant, with rather sinuous lines. They are broad and often very angular at the shoulders, and the surface of the figure is flat, so that details, especially at the pubic triangle, are shown by incision.

The head is sometimes close to triangular, with cheeks straight, although the chin is usually rounded rather than pointed. The head, in profile, sometimes has a slightly S-shaped edge. The crown of the head is indicated by a smooth vertical plane, as is the case with the Spedos variety also. The head and the neck are not, at the back, clearly distinguished.

The shoulders are by far the widest part of the figure and are pointed. The breasts are very flat. The arms across the waist sometimes show a gentle upward curve at the middle and sometimes the belly bulges a little in profile. The upper arm is distinguished from the torso by an incision, and the incision between the arms sometimes cuts deep, but there is little rounding or modelling. The waist is not usually narrower than the torso and the thighs, and the buttocks are indicated by a ridge at the rear, which appears in profile as a minuscule protrusion. The waist is not generally indicated separately by means of an incision, but the pubic triangle usually is. The legs are separated by a single, continuous line, both above and below the knee, so that the knees are not shown in any relief. The legs are not flexed. The feet are on tiptoe with flat, widening soles. The toes are often indicated with incisions, the fingers generally not.

The name pieces for this variety were found together in Grave 14 at Dokathismata in Amorgos, and above the waist they resemble each other very

Overleaf

53

CANONICAL FIGURE
Keros-Syros culture
Marble, height 9⅞″

This figure is possibly transitional between the Kapsala and Spedos varieties

54

FIGURE OF THE DOKATHISMATA VARIETY
Keros-Syros culture
Marble, height 15⅜″

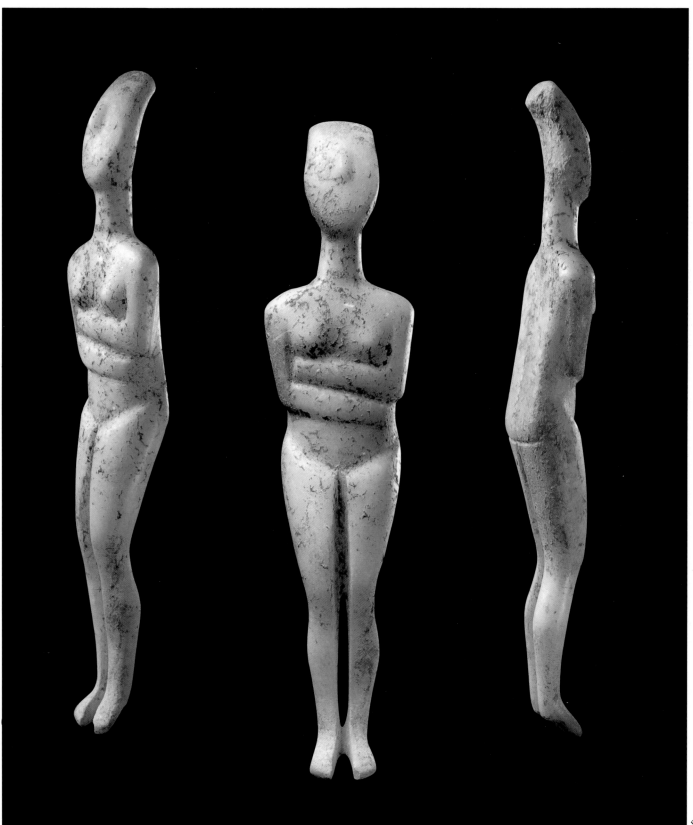

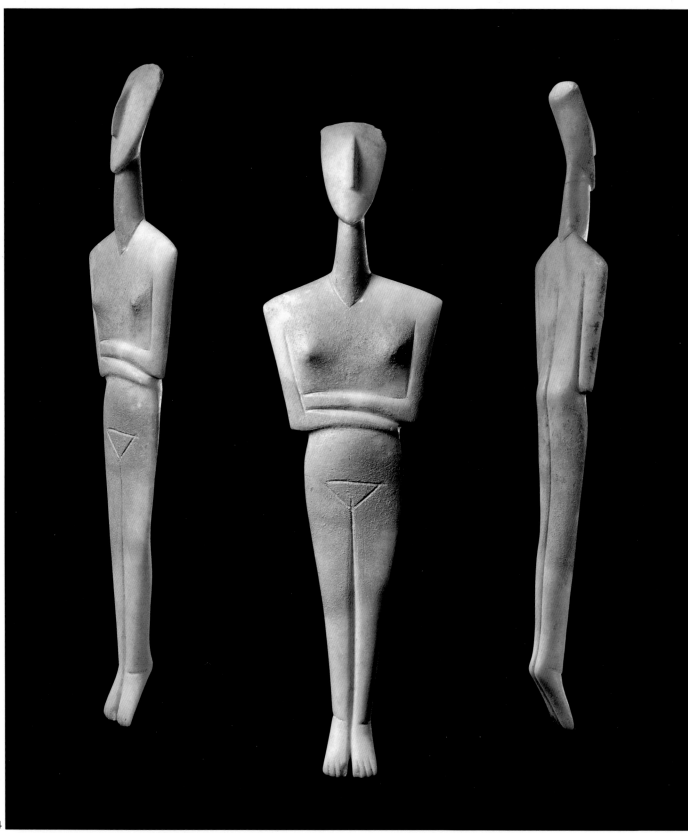

closely (plate 68). The Dokathismata figure in the Goulandris Collection is more carefully worked in some respects than these. The incisions are more precise, with the forearms indicated by light modelling. The neat and very small pubic triangle is a detail that is missing on the smaller of the two figures from Grave 14. It is interesting to see how the description given here applies well even to the very large figure in the Ashmolean Museum in Oxford (plate 105).[10]

It is fair to say that the figures of the Dokathismata variety are among the most elegant, sweeping in line, and in that sense "stylized," of the folded-arm figures. The same certainly cannot be said for those of the Chalandriani variety, although there is some reason to think that both varieties may stand fairly late in the development of the canonical figures.

THE CHALANDRIANI VARIETY

The figures of the Chalandriani variety, of which the figure in plate 55 is an example, give an impression of being squared off. The space formed by the shoulders and arms is almost exactly square. The arms are horizontal at the waist, the upper arms are vertical, and the shoulders form a right angle and then run horizontally to the neck. The neck is long and cylindrical, and the head is simply a flat, inclined triangle, set rather absurdly on the neck as if on a stalk. The nose is sometimes rather a rough blob, rather than the neatly chiseled feature of the varieties already discussed or of the Spedos variety.

The chest is very flat, with low breasts. Usually there is effectively no waist, since the pubic triangle is incised immediately below the arms. Seen from the front, the legs run straight from the arms to the feet, although there can be a slight prominence at the knees. The buttocks are represented by a prominence behind, at the same height as the elbows.

The legs are broad and short, giving a square effect also, and the pubic triangle extends almost to the knees. The feet slope only slightly, or may be flat on the ground, and the toes are sometimes heavily indicated by incision. The feet are notably broader at the toes than at the ankles.

Several examples of this variety were found by Tsountas in the cemetery at Chalandriani on Syros.[11] The example illustrated here is fairly typical, although the head gives the impression of facing slightly to one side. There is one significant departure from the canon of the folded-arm figurines, however, in that the left arm is folded below the right. This feature, exceedingly rare in the other varieties, is in fact occasionally seen in those of the Chalandriani variety. It is also a feature of figures that may also in other ways be considered "non-canonical," which are further discussed below.

The figures of Chalandriani variety stand in splendid contrast, therefore, to their Dokathismata cousins, lacking the grace of the latter and offering sometimes in contrast a rather crude effect.

THE KOUMASA VARIETY

It is convenient to consider now the figures of another well-defined variety that up to now has been recorded only from Crete, the Koumasa variety.

Figures of the Koumasa variety—the example illustrated here (plate 56) comes from the Ashmolean Museum—are, like all the other figures, made of good white marble. They are generally very small, in the range from two to eight inches in height, although at least one piece was more than twice the size originally. They are broad in the shoulder and short in the leg, with sloping shoulders. In profile they are very thin and exceedingly flat, with a slight forward inclination for the torso and a backward one at the top of the head. Among the folded-arm figures they are exceptional in that the head is usually not separated from the neck, except by a light incision.

As in the Chalandriani and Dokathismata varieties, the legs run straight, without any indication of the knees and without flexing. The arms, legs, and pubic triangle are indicated by incisions rather than through modelling, the forearms often being indicated by incised straight lines.

These figures are distinguished from those of the other varieties by the way the head merges with the neck and by their smaller size. They differ from the Chalandriani figures in the sloping shoulders, the tiptoe feet, and the head itself, which curves back and is not so markedly triangular. They differ from the Dokathismata variety by the much greater width/length ratio, the absence of a chin, and the exceedingly flat profile.

The nose is sometimes rather blob-like, and on some examples of the Koumasa variety the mouth is lightly indicated in relief. A number of these figures have been broken at the neck and repaired by boring a hole above and below the break. This is perhaps a notably Cretan custom rather than one restricted to the Koumasa variety, for it is seen in three pieces found in Crete that are not strictly of the Koumasa variety.

It is of course particularly interesting that all known pieces of this variety have been found in Crete, for this must suggest the inference that they were in fact made in Crete and in that sense should rank perhaps as "imitations" of the true Cycladic figures of other varieties—mainly the Spedos—that are indeed found in Crete.[12] Although Crete is an island without the abundant sources of marble found in many of the Cyclades, marble is in fact to be found there, and the lack of raw material was not an obstacle to local manufacture. Interestingly, too, there is an example of a double figure of this variety made out of chlorite schist.

The name assigned to this variety comes from the round tomb at Koumasa on the Mesara Plain, where five of these figures were found, and they have been found also at the nearby round tombs at Platanos and Lebena, and at the collective tomb at Archanes in north Crete. The existence of a workshop on Crete for the production of these figures is an important inference. Presumably it indicates that Cycladic burial conventions, and perhaps religious beliefs also, were influential in Crete, a conclusion that arises quite independently from the Cycladic forms of some of the objects found at the Aghia Photia cemetery in northeast Crete.

THE SPEDOS VARIETY

The figures of the Spedos variety may well, in terms of the sequence of development, belong immediately after the Kapsala figures.[13] But in view of their great

Overleaf

55
FIGURE OF THE CHALANDRIANI VARIETY
Keros-Syros culture
Marble, height 12″

56
FIGURE OF THE KOUMASA VARIETY
Siteia, Crete
Marble, height 4⅛″
Ashmolean Museum, Oxford

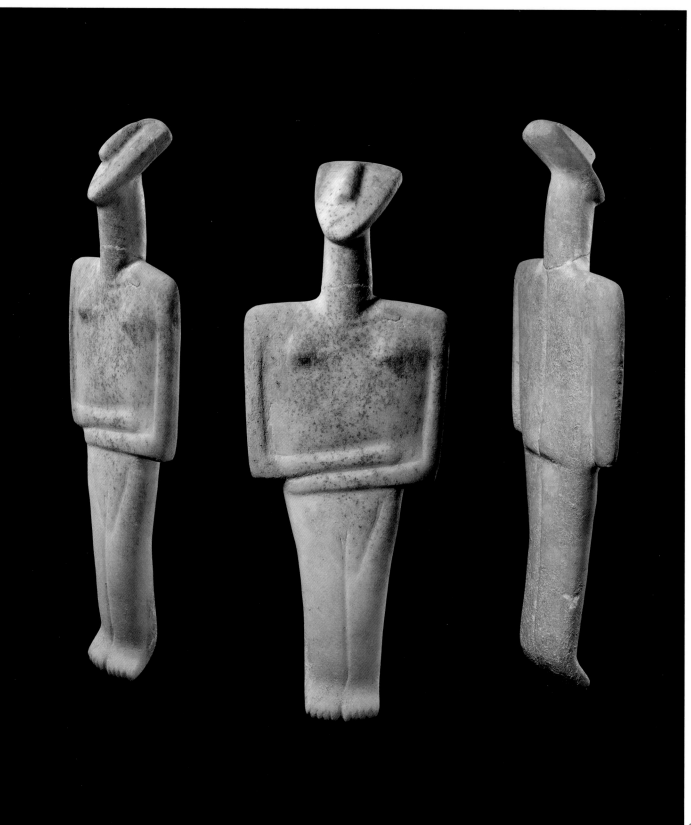

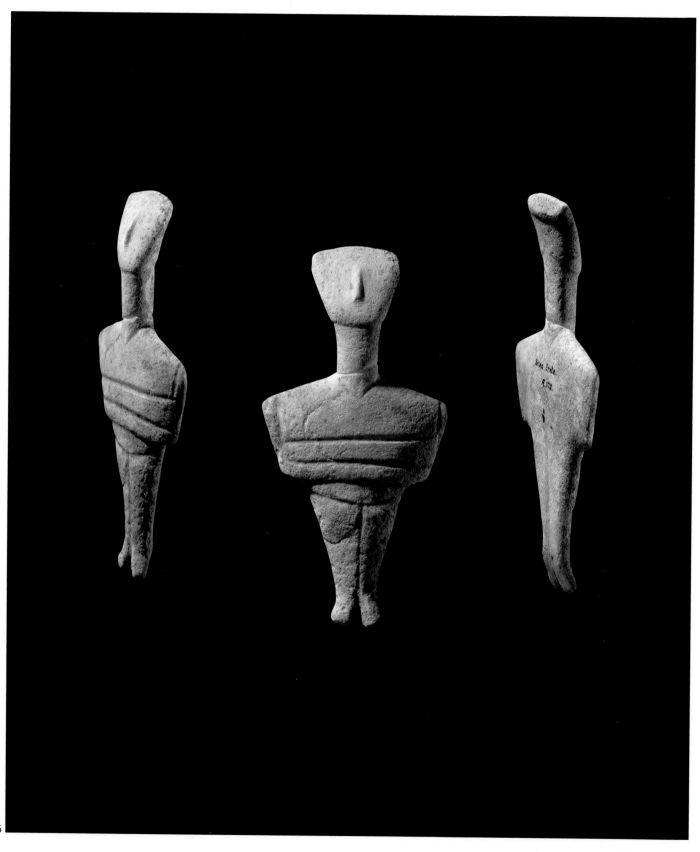

number and the range of specific forms that they exhibit, it is most convenient to define the variety, as we are doing, only after defining the other principal varieties. For in truth the Spedos variety is something of a residual category, albeit quite a useful one, "evolving naturally," as Lesley Fitton puts it, "from the Kapsala figurines in a seamless continuum that leaves some figures hard to define as belonging to one or the other category." [14]

The figures of the Spedos variety appear thick and well built in profile, and there is much sculpting in the round. The head, seen in profile, is fairly thick, with a vertical surface at the crown. Seen from the front it is sometimes lyre-shaped, broadening markedly at the crown. The face has a convex surface and the chin is rounded. There is considerable variation in the body, which may be rather straight, although it is more often flexed at the knees. The waist is usually clearly modelled, being narrower than the thighs, and it generally terminates with an incised line at the lower edge. It certainly does not disappear altogether as it does in the Chalandriani variety. The shoulders are of varying width, although not as wide as in the Chalandriani and Dokathismata varieties, and are sometimes rounded. The upper leg (pelvis to knee) is modelled separately from the calf (knee to ankle) so that the knees are shown by this modelling of the legs. The arms too are generally modelled rather than simply incised or cut. Incisions are not numerous, and often the pubic triangle is not marked at all.

Many of these features are well exemplified in the figure in plate 57, which achieves a rhythmic effect in the curving outlines of the head, shoulders, upper arms, thighs, and calves. The flat vertical surface at the upper part of the back of the head is clear, and the head broadens very slightly at this point, so that seen from the front a "lyre-shaped" effect is indeed created. The rather "solid" appearance of the figure is typical of this variety. The figure (plate 51) used at the beginning of this chapter to illustrate the folded-arm type in general may also be assigned to the Spedos variety and shares most of its defining characteristics, although the head is not lyre-shaped, as it lacks the broadening at the crown.

NON-CANONICAL FIGURES

In this category is a series of figures with bodies related to that of the Chalandriani variety, that may have arms in positions differing from the strict folded-arm posture, rather different heads, and additional, sometimes idiosyncratic, incised detail. For example, the head is no longer a triangle set upon a stalk-like neck but is rounded. Moreover the ears are often shown in relief, and the eyes and sometimes the mouth by means of incision. In just a few cases the hair is also shown by relief or incision.

Two figures in the Goulandris Collection offer very good examples (plate 58) and are unusual in forming a pair. One has the arms partly folded, but the forearms are held up somewhat against the chest. The fingers are markedly and rather crudely indicated by incisions, and the pubic area is indicated by modelling in low relief. The ears are seen in relief, and the eyes are incised. The other is the male counterpart to the female. The left arm is raised against the abdomen, and there is a strap or baldric across the chest from the left shoulder to which a dagger,

incised above the right hand, was notionally connected. The ears, eyes, and hair at the back of the head are clearly delineated. The penis is lightly indicated by modelling in low relief. Although these figures clearly relate to the folded-arm series, they have departed from it in several ways, and the harmonious appearance of the canonical form is entirely lost.

These then are the main varieties of the canonical figure, the basic subdivisions that we can at once make within the very large category of folded-arm figures. Much more closely defined typologies are possible, and these are discussed in Chapter IX, in relation to the idea that the "hands" — that is to say the autographic style — of individual "masters" may be distinguished among them. For the present it is sufficient to distinguish the major varieties, and note the very different visual qualities associated with each.

We can also be fairly definite about the date of these sculptures. All the canonical figures found in the Cycladic islands within a clear cultural context belong to the Keros-Syros culture and hence to the Early Cycladic II period.[15] None come from the earlier Grotta-Pelos phase and none have been found in a clear context with the transitional Kampos group. The heyday of the canonical figure was during the Keros-Syros culture proper, that is to say from about 2700 B.C. to about 2400 B.C.

It is not clear whether any may have been found with material of the late, Kastri phase. Certainly, as we saw in Chapter IV, Cycladic-style burial continued at Chalandriani (and at Siphnos and perhaps Naxos) into the Kastri phase, but no figures can at present be securely associated with this material. It is possible also that some of the marble figures from Amorgos may have come from late contexts of the Amorgos group: Unfortunately the lack of published contexts for material from illicit excavations makes it difficult to judge whether the manufacture and use of these figures extended into the Early Cycladic III period.

To be sure, there are fragments of canonical figures from Middle and Late Cycladic Levels at the two major settlements at Phylakopi on Melos and Aghia Irini on Kea.[16] But there is good reason to think that these are "kick-ups," that is to say pieces that were already broken and discarded in the Early Bronze Age and then left knocking around the site as fragments that subsequently became incorporated in levels of later date.[17]

There is no reliable way of deciding which of the varieties just described is early and which is late. To do this properly would require abundant, well-documented finds, with adequate associations, so that we could judge which pottery forms were long-lasting, which early, and which late, and identify the sculptural varieties that accompanied them. We do, however, know that the Plastiras figures of the early, Grotta-Pelos phase came first and that they are accompanied by a whole range of schematic figures, some of them violin shaped. It is clear also that the very simple figures of Louros type (plate 33) can be associated with the transitional phase, that is, the Kampos group. But what comes next? Which of the folded-arm varieties comes first? Or is it perhaps the case that all the different varieties were in use simultaneously, perhaps on different islands?

Overleaf

57
FIGURE OF THE SPEDOS VARIETY
Keros-Syros culture
Marble, height 29⁵⁄₁₆"

58
MALE AND FEMALE NON-CANONICAL FIGURES
Keros-Syros culture
Marble, heights 9¹³⁄₁₆" and 8³⁄₁₆"

These figures were reportedly found together

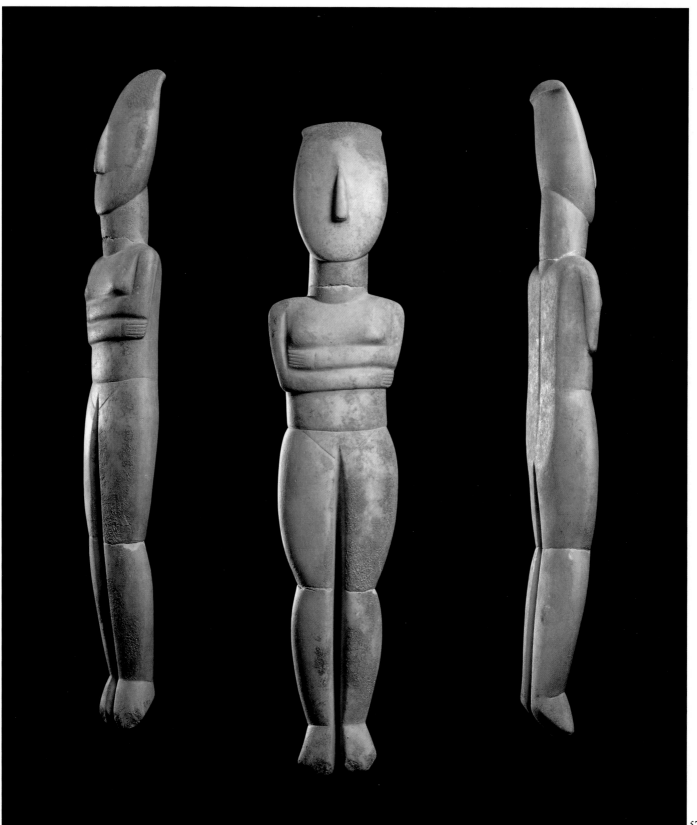

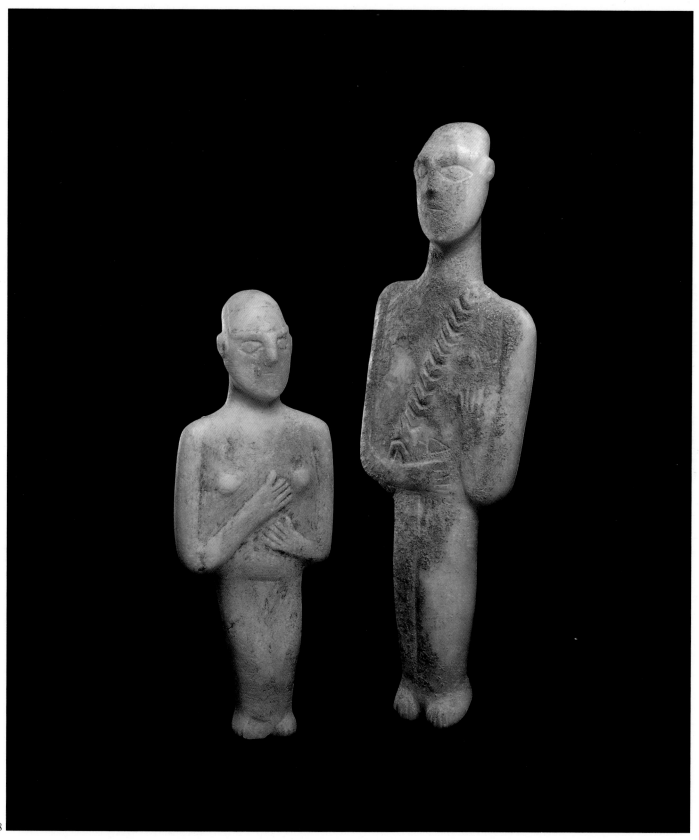

The pattern of findspots is sufficient to establish only that one of the varieties does indeed have a pronounced regional bias. As we saw, the Koumasa figures are found only in Crete and must certainly have been made there. None of the other forms is so restricted in its distribution, and the Spedos variety is very widely found. It is likely, then, that the difference between the varieties reflects a difference in date rather than differing places of manufacture—which is not to exclude that specific varieties may have been produced on just one island and traded off to the others.

If we ask which form is the earliest, it would seem on purely typological grounds that, of all the folded-arm figures, those of the Kapsala variety stand closest to the naturalism of the preceding Plastiras type. The rounded head, the flat feet, and the attention to detail support such an impression. And there is certainly no difficulty in imagining an evolution in form from there to the Spedos variety. Moreover, uncanonical features of some of the figures of Chalandriani variety suggest that some of the sculptors responsible were not entirely under the influence of the full Cycladic canon. Mistakes in the arm position are seen almost exclusively with this variety. This may, perhaps, be an argument for placing it late in the story of these sculptures. It is certainly easy to imagine that the Dokathismata and Chalandriani figures stand later than most of those of Spedos variety.

In 1969 I suggested a development as follows (see also figure 5):

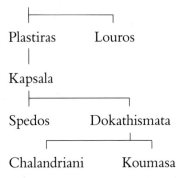

Plastiras Louros

Kapsala

Spedos Dokathismata

Chalandriani Koumasa

But it might be better to avoid quite so clear-cut an evolutionary picture, and to think rather in terms of overlapping durations:

Plastiras ⊢————⊣
 Louros ⊢———⊣
 Kapsala ⊢—————⊣
 Spedos ⊢————————⊣
 Dokathismata ⊢————⊣
 Koumasa ⊢————⊣
 Chalandriani ⊢————————⊣

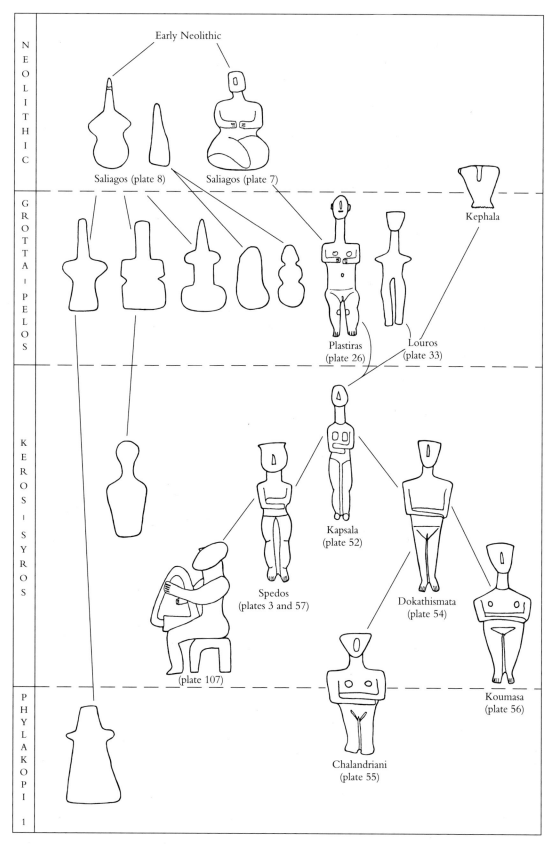

N
E
O
L
I
T
H
I
C

Early Neolithic

Saliagos (plate 8) Saliagos (plate 7)

Kephala

G
R
O
T
T
A
ı
P
E
L
O
S

Plastiras
(plate 26)

Louros
(plate 33)

K
E
R
O
S
ı
S
Y
R
O
S

Kapsala
(plate 52)

Spedos
(plates 3 and 57)

Dokathismata
(plate 54)

(plate 107)

Koumasa
(plate 56)

P
H
Y
L
A
K
O
P
I

1

Chalandriani
(plate 55)

Figure 5
Development of the
Early Cycladic figures from
their Neolithic prototypes

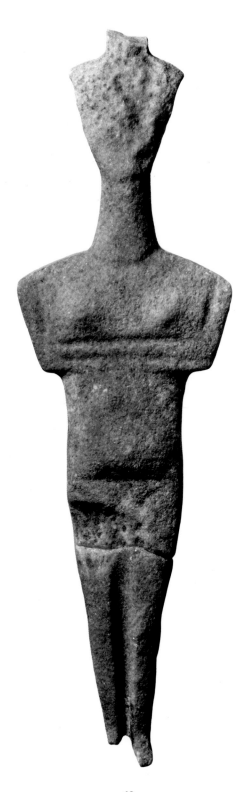

59

FRAGMENT OF A DOUBLE STANDING FIGURE

Keros-Syros culture

Marble, preserved height 8¹¹⁄₁₆″

National Museum, Copenhagen

Jürgen Thimme, in his study of 1975, proposed some further refinements.[18] He suggested that some of the non-canonical figures (with variant arm positions and other aberrant details) were made later than the Chalandriani variety figures, and he called them "post-canonical." But, like Getz-Preziosi, I am unpersuaded by this argument: they could well be contemporary.[19] Similarly Thimme proposed a "pre-canonical" figure, which would be transitional between figures of the preceding Grotta-Pelos phase and the folded-arm form.[20] None of the "pre-canonical" figures come, however, from published excavations, and they may simply be variant forms of the five varieties of figure.

Moreover, following Thimme, several authors feel able to distinguish "Early Spedos" from "Late Spedos" within the Spedos variety. "To the former belong the figures with a strongly curving outline and an accented profile axis, relatively narrow waist, curving abdominal line marking the pubic area and legs divided by a perforated cleft. . . . To the late Spedos group belong figures with a lyre-shaped head and an incised pubic triangle. These figures tend to be more elongated and straighter in profile than the earlier ones, and the leg-cleft is usually not perforated. Details are rendered more by incision than by modelling."[21] This distinction, as expressed by Getz-Preziosi, seems perfectly plausible. But we should be clear that there is absolutely no independent evidence for it. It is simply a statement of what today would seem typologically convenient.

Other aspects of all these sculptures, including the use of painted decoration on some of them, will be discussed in later chapters. It is important also to bear in mind that there is a series of "special" or "occupational" figures, where individuals, often male, are seen playing the harp, or the pipes, or in one case holding a cup; there are double and triple figures; and, during this period, schematic figurines were still made, although they are no longer violin-shaped. But before saying more about these other Cycladic sculptures, it is time to try to situate the canonical figures within their social context once again and ask ourselves what they were used for. If we could answer that question we would be very much closer to being able to consider what, if anything, they were intended to mean.

Before turning to these wider questions, there is one obvious, yet surprisingly difficult question that we should ask about the canonical figure. Were these sculptures conceived by those who made them and used them as standing? That might at first seem likely. But given that in most of them the toes are inclined downwards, so that if standing they would be on tiptoe, is it not more reasonable to view them as lying down, as reclining? Certainly, as found in the grave, they have generally been in a prone position. And if they were indeed made exclusively for use in funerary ritual and for burial in the grave, as some authors believe, then it might be right to see them as reclining. There could clearly be some relationship between the prone position of the deceased person (although he or she was generally buried in a contracted position) and that of the figure itself.

Many scholars today favor the "reclining" view.[22] While it is surprisingly difficult to find decisive arguments on the point, I am inclined to the view that the figures were made to stand. I would suggest, to begin with, that the folded-arm

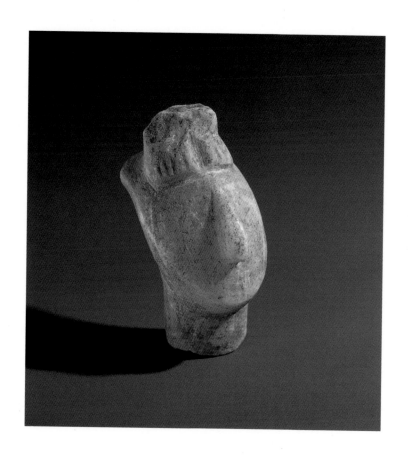

60

FRAGMENT OF A DOUBLE STANDING FIGURE

Keros-Syros culture

Marble, preserved height 2³⁄₁₆″

position, seen in so many figures, does rank as a gesture that had some well-defined meaning, even though we today cannot know precisely what that meaning was. It could be one of respect, or of power and dignity (both of which might be more appropriate in a standing position), or it might convey eternal rest, for which the reclining position would be a more fitting one. Among the "special" or "occupational" figures further discussed in Chapter xv there are some seated on stools that have the arms in the folded-arm position.[23] There is even one example in the Badisches Landesmuseum in Karlsruhe where a woman in the folded-arm position is seated on, and supported by, the linked arms of two standing males.[24] In these cases at any rate the folded-arm position is not associated with lying down, or reclining, or resting, or any other modes of being (including death) that we might associate with a recumbent effigy.

For me the clinching argument, although it is a very specific one, is offered by the double figures, where a small female in the folded-arm position stands upon the head of a similar but larger female with arms similarly arranged. There is an excellent example in the National Museum of Denmark, Copenhagen (plate 59), another in Karlsruhe, and fragments of others are known, one in the Goulandris Collection (plate 60).[25] It is far from clear why these two persons are behaving in this way: One suggestion is that they are acrobats, but surely it is evident that they are conceived of as alive, and standing! The configuration is already odd, and it would be altogether extraordinary if these figures were lying down in such an arrangement. This is for me a convincing indication that both figures are indeed upright, and that the folded-arm position is therefore associated with persons who are in fact vertical rather than horizontal. Moreover, with the double figures in Copenhagen and Karlsruhe, the lower figure is in each case shown with toes pointed downwards, just as in the ordinary canonical figures.

Whatever the arrangement of the toes, if it was intended that the canonical figures should stand, they would certainly have to be propped up against a wall or some comparable vertical surface. Paradoxically it may have been a more secure arrangement to lean the figure against the wall than to have it "stand" upon its own feet vertically, in what would inevitably be a very unstable arrangement. The Plastiras figures of the early phase were indeed made to stand upon their own (flat) feet, and it may be no coincidence that quite a few of them show signs of repair. It should be noted that the figures of the Kapsala variety also have feet upon which they are capable of standing. It is to me unlikely that if these earlier folded-arm figures were intended to be standing, the later canonical varieties would be imagined in a different (that is, reclining) position.

This is not a matter that can be definitively settled until we know more about the contexts in which these figures were used. Meanwhile I shall go on imagining them very much as we see them displayed in many museums: As figures whose down-pointed toes allow them very conveniently to be propped up against a vertical surface and thus seen upright.

TODAY WE MAY ADMIRE the splendid products of Cycladic craftsmanship: the fine pots, the metal weapons, the marble vessels, the human figures. But what were they used for? And in those cases where they functioned as symbols, as is certainly the case for the sculptures, what did they mean?

Those are questions that modern archaeology ought to be able to answer — certainly as far as function is concerned, if not necessarily meaning. But as noted earlier, the lack of context for so much of this material implies that the established techniques of archaeology have not had the opportunity of bearing on the problem. Whole categories of object — from the great life-sized figures (plates 103 and 104) to the "dove bowl" (plate 112) — have never been found in a documented context.

In such a situation we have to proceed by inference, and happily the material is so rich that inference can take us quite a long way. Most of our material comes from graves within cemeteries, as described in Chapter III. At this point we have to consider what is undoubtedly a central issue. What was the purpose of burying such objects as these with the deceased? The dead person was no doubt normally buried by his or her kinsfolk in ceremonies or rituals that may also have involved the larger community. The remains that we find are the end product, as it were, the buried result, of these proceedings. What objects were used in these ceremonies, and which of them were buried? Although it is possible that the buried objects were in many cases quite simply the principal possessions of the deceased, it does not follow that all of these were buried, nor that all the objects found in the graves were actually in daily use. But this line of thinking would nonetheless see the inventory of burial goods as deriving from the repertoire of tools and objects used within the living community.

Professor Saul Weinberg suggested many years ago, in an important article, that many of the objects found in the graves were, on the contrary, made specifically for funerary use.[1] They were not, he argued, objects from daily life at all. That is, indeed, one possible interpretation for the Early Cycladic sculptures, which several scholars have followed. Their function would obviously have to be considered mainly in funerary terms.

Among the suggestions that have been made, on this assumption that the marble figures were made specifically for burial in the grave, are that they were intended to perform the same role as the ushabti figures in Egyptian tombs — to serve the dead person, and in some cases to fulfill sexual needs. Christos Doumas has reviewed the range of theories on offer: The figures might have functioned as "substitutes for human sacrifices, images of venerated ancestors, *psychopompoi* (guides for the soul of the deceased in the Underworld), or as toys to amuse the deceased."[2] He points out that "the discovery in graves of broken idols has led some scholars to believe that they had an apotropaic function" — that is, to ward off ill luck. He quotes also the view of Karl Schefold that the idols represent figures of Cycladic mythology, resembling the heroes and nymphs of the later Greeks, and the suggestion of Jürgen Thimme that the folded-arm figures were made specifically for grave use "as images of the Great Mother in her role as goddess and guardian of the dead."[3]

These suggestions are, however, in the main, merely that. Many of them have little supporting argument and others are based on a series of rather old-fashioned assumptions. One of these is the myth that there was in early pre-historic times some widespread veneration of a supposed great earth mother. But although several writers on prehistoric religions have indeed written of a sup-posed mother goddess (and there is nothing inherently unreasonable in the suggestion), there is remarkably little evidence for such a divinity.

Lucy Goodison has made a number of original observations about the religious beliefs of the Early Bronze Age. Among other things she rightly stresses the occurrence of the sun motif on the "frying pans" of the Kampos group, where it is sometimes associated with an unmistakable symbolic representation of the vulva. The same symbol is seen on "frying pans" of the succeeding Keros-Syros phase, in association with interlocking concentric circles, clearly representing the sea, on which Cycladic longships are sometimes shown. She argues, plausibly, that the sun in Early Bronze Age times was regarded as a female entity, and goes on to suggest that "burial beliefs in this period may have associated the journey of the deceased with the movements of the sun, in particular envisaging some form of rebirth assimilated to the reemergence of the rising sun in the east, and that more generalized rituals at the cemetery site may also have been connected with the sun."[4]

In her study Goodison is rightly skeptical of the traditional assumptions of a "mother goddess," and quotes the criticisms made of the concept by Peter Ucko, citing with approval the verdict offered by Andrew Fleming in another study: "The mother goddess has detained us for too long: let us disentangle ourselves from her embrace."[5] Goodison's study has the great merit of studying the co-occurrence of the symbols that have been found, rather than merely proposing a favored theory out of the blue. Many of the other theories quoted are not so systematic and rest on the assumption that the objects in the grave were specifi-cally made for funerary use. This is far from obvious.

The resolution of this problem would require the comparison of the finds from a well-excavated settlement with those from an accompanying cemetery. If only we were so fortunate. We can, however, attest that some of the objects from the graves were indeed in daily use: the obsidian blades and cores and the spindle whorls have been found in settlements, most recently at Markiani on Amorgos. Moreover, many of the metal objects from the graves — the daggers, the tweezers, the chisels — do not seem to be objects made exclusively for display. They are objects with a self-evident function. The same is less certain for the silver objects — the beads, the bracelets, the rare diadems, and the silver bowls — but I would go so far as to say that such "display objects" of metal would not have been manufactured specifically for burial if they did not at least have their counterparts in daily life. It could perhaps be argued that the diadems might be seen as special to the funerary context, as were presumably the gold face masks of the Late Bronze Age found by Heinrich Schliemann in the celebrated Grave Circle A at Mycenae. But the other objects certainly had a counterpart in common use or indeed were themselves simply possessions that had been used in this way.

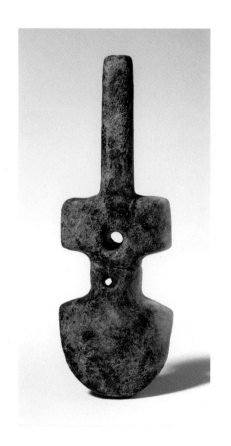

61

VIOLIN FIGURINE

Grotta-Pelos culture

Marble, height 3¹¹⁄₁₆″

This figurine shows evidence of
breakage and repair

97

Figure 6
Incised design, possibly of religious significance, on a silver diadem of the Kastri group in the National Museum, Athens. Length 19″

And there is more to say on the subject of the silver diadems. One was indeed found in a grave context, at the cemetery of Dokathismata on Amorgos (plate 12), the same cemetery that gives its name to one of the varieties of the canonical figure.[6] But the second silver diadem known comes from the stronghold at Kastri near Chalandriani on Syros.[7] This is not a funerary context and the implication must be that it was for the use of the living. It is a particularly interesting object, as it carries an incised scene (figure 6) in which an individual with upraised arms, presumably human, is confronting (or very possibly worshipping) what appears to be a solar disc, drawn by a quadruped. This scene supports Lucy Goodison's views on the significance of the sun in Cycladic religion.

Turning now to pottery, was it specially made for the burial rituals, or were the vessels for burial selected from the household? If the latter, the selected objects might be among the finest in the home. For the early period, my own work at Phylakopi in Melos suggests that while the early cemetery forms (the pyxides and the footed pottery jars) were not common in the settlement, they are at least found there. The same, for the transitional phase, is true of the Kampos group "frying pan." But it must be admitted that the commonest form from the settlements, the thick burnished bowl, and of course the coarse wares, are rarely found in the graves. The marble vessels (the bowl, the kandela, and the beaker) are rarely found in the settlements, but they do occur there. Moreover there is one valuable clue from the grave goods themselves: Not infrequently they are found in damaged condition and sometimes they have even been repaired.

Breakages could, of course, have occurred after burial or indeed during excavation. The break on one of the figurines of the Pelos phase (left, plate 21) could certainly be explained in this way. But a break on a similar figurine (plate 61) has been carefully repaired by the drilling of two holes, through which some kind of string or twine was no doubt placed to secure the two parts. It has been argued, notably by Getz-Preziosi, in a valuable study, that such breaks as these might have occurred during manufacture in the workshop, and so do not necessarily document non-funerary use.[8]

When we turn to one particular marble vessel form, the kandela, however, the case is clearer. The kandela always has marble lugs protruding from the body, each with a hole drilled through it. It seems likely that sometimes string was run through the holes, possibly to allow the vessel to be suspended rather than stored on a flat surface. In very numerous cases these string holes are broken. This was indeed something of a design defect, and the pottery versions of these vessels may have had a better balance between weight and strength. Such breakages would have been rare in the workshop or in storage (or indeed in the grave after burial),

but understandably common during use. I take this as a good indication that the kandela did have a use in the living community, and the various known examples where the holes have been drilled anew after breakage serve to confirm this.

What their use was within the community is at present a matter for conjecture. Were they just high-quality vessels for trade and storage? Or did they have some symbolic function, possibly connected with ritual? Until we find some in good settlement contexts it is hard to say, since for us there is nothing overtly symbolic about the form.

For the mature phase we can follow related arguments. As concerns pottery, the fine painted wares (plate 37) in the graves do find counterparts in the broken potsherds from the relevant settlement layers at Phylakopi and at Aghia Irini. The same is probably true for some of the marble vessels: The common grave forms do have their counterpart finds, usually fragmentary, in the settlements. But there are special pieces—the vessels of chlorite schist (plates 46 and 47), some beautiful sauceboat shapes in marble—that have not yet been found in the settlements. This may simply be because they are so rare anyway that they have not yet turned up. Or it may well be that they were produced specially for ritual or funerary use. We do not yet know.

Turning now to the marble figures of canonical form, it should be noted that while these have sometimes been found complete within the grave (and in some cases in pairs, for instance the non-canonical one in the Goulandris Collection; plate 58), they are sometimes found in fragmentary condition—just a head or a body part. Sometimes too they have been repaired. I have suggested, counter to the "workshop repair" theory of Getz-Preziosi, that the pattern of damage and sometimes of repair suggests that these figures were indeed utilized in the settlements and that they had a considerable use-life before being buried.[9] Indeed my suggestion is that they were used during the life of the owner in some domestic cult and buried with that owner after death.

The finds from the two principal excavated settlements support the theory of domestic use. At Phylakopi, eleven fragments of marble figures have been recovered, at Aghia Irini no fewer than forty-two, although in most cases they turn up in contexts in the town dating from well after the Early Bronze Age. Jack Davis has argued persuasively that these are "kick ups" from the Early Cycladic levels, churned up during later building works.[10] All these pieces would have been used, and ultimately broken, during the Early Bronze Age occupation of these two sites. Since no trace of a workshop and no concentration of figures suggestive of a "shrine" have been found, it is easiest to think of them as widely used throughout the settlement (as their distribution suggests). One may perhaps imagine them in use in little household "shrines," just as in traditional Greek houses today there is always a portable icon in some corner, generally with a lighted lamp before it.

This theory of the daily use of the objects ultimately consigned as grave goods, and of the cult-use of the figures, can be extended to take account of the monumental figures also. So far, none of these has come from a well documented grave context (although some are reported as from graves by dealers or others not

in a position to give a reliable account). In fact they are too unwieldy for grave burial: the very large ones would not fit within a normal cist grave. I suggest therefore that these large figures were also made for cult use and that they had a role that went beyond that of the single household. It is possible that they had some larger function, perhaps in a building or area that was set aside as a communal place of special religious and ritual significance.

No such building has yet been found for the Early Bronze Age period. But just such a cult center, with large effigies of terra-cotta, was found in the succeeding Middle Bronze Age at Aghia Irini in Kea.[11] And I had the good fortune to find a comparable sanctuary from the Late Bronze Age at Phylakopi in Melos, with terra-cotta figures of Mycenaean type.[12] Perhaps we shall one day have such a discovery from an Early Bronze Age settlement.

Sanctuaries and cult places need not, however, be restricted to settlements and cemeteries. One site in particular, although wrecked by looters, seems especially significant: Kavos, opposite the tiny islet of Dhaskaleio, on the now uninhabited island of Keros. Christos Doumas told me in 1963 that he had heard of an important looted site there, and I was able to visit it soon after in the course of a Cycladic site survey authorized by the Greek Archaeological Service. The slopes above the sea were covered with soil tipped down from above by illicit diggers, and on the surface were numerous sherds of painted pottery and of broken marble bowls. In the course of a couple of hours I found several figurine fragments.[13] Professor Doumas himself later conducted excavations there as did Mrs. Photeini Zapheiropoulou, the Ephor of Antiquities for the Cyclades (finding among other things a fine complete canonical figure), and in 1987 a surface survey with further investigations was conducted for the Ephorate by Professor Doumas, Professor Lila Marangou, and myself.[14] The archaeological contexts of the figures and the stone vessels was by now completely destroyed. But we could establish that the key area measured 130 by 230 feet and that the disturbed soil still contained hundreds of potsherds and pieces of broken marble bowls and dozens of fragments of marble figurines. The Naxos Museum has vast quantities of such material, all overlooked or discarded by the looters, who were clearly seeking complete or nearly complete pieces. The quantity of broken material among the marble vessels and figures was surprisingly great. Naturally the looters will have taken away the complete pieces and may have dumped several others in careless and hasty digging. But, given that their objective was to secure complete objects for sale, there is no way that breakage on the scale observed by us could have been caused by them. The possibility of extensive damage through earthquakes is also to be considered, and there are indications there has indeed been local tectonic action. But again this seems an insufficient explanation for the breakage. It is to be concluded that the process of deposition on this quite exceptionally rich site either involved deliberate breakage there or the discarding there of pieces that had previously been broken.

The looted site at Dhaskaleio Kavos was not a settlement: the settlement remains are nearby. Nor was it a workshop — there are no incomplete figurines and no production debris. One might consider it an exceptionally rich cemetery,

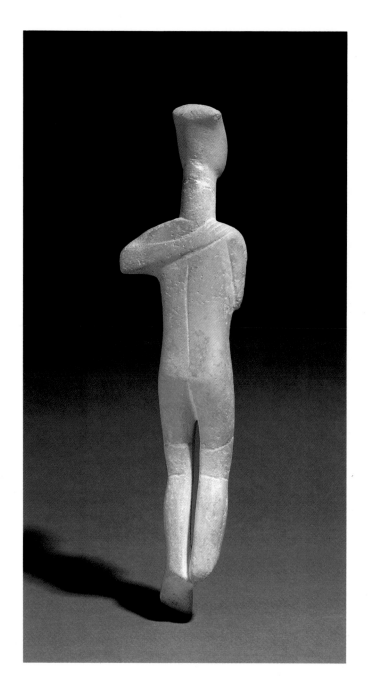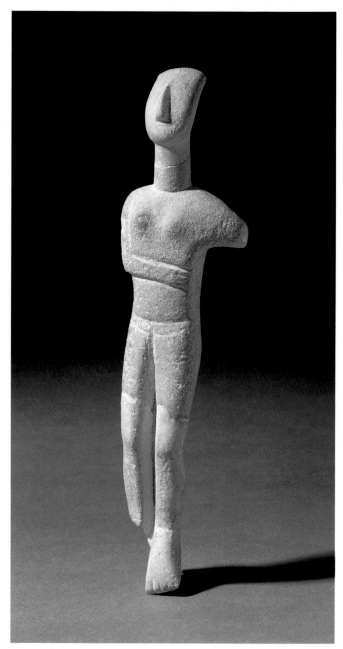

62

FIGURE

Keros-Syros culture

Marble, height 9⅛″

This was once a double figure and was modified
after breakage into a single figure

but if so it was far and away the largest and richest known in the Cyclades and one with a remarkably high proportion of broken marble objects.

It seems more likely that this was a different kind of site; possibly a sanctuary or perhaps just a very rich deposit of broken objects of high symbolic value, deliberately damaged and discarded here in the course of some well-defined ritual. But no fragments, however small, of monumental sculptures were found in our researches, and the hypothesis that large sculptures were displayed here for public rituals gains no direct support from our work.[15] The significance of Dhaskaleio Kavos lies in the great quantities of rich material found there, representing several varieties of figure. The pottery probably includes imports from several islands. This then was a center, probably a ritual center, that must have served a number of the Cycladic islands, a focus of more than local significance.

The suggestion of the deliberate breakage of symbolic objects, undertaken with ritual purpose, suggests another explanation for the fragmentary pieces found in the cemeteries themselves (and indeed for the broken pieces also found in the settlements). For it is possible that the funerary ritual itself involved the breakage of marble figures. In two places, the cemetery on Ano Kouphonisi excavated by Mrs. Zapheiropoulou and the cemetery of Aplomata on Naxos excavated by Nikolaos Kontoleon, caches of marble figures, including complete and broken pieces, have been recovered, not actually in the graves but outside them.[16]

At Aplomata it was possible to interpret the find as the result of the partial destruction of the cemetery, but we do not in fact know that all the objects there were ever actually inside graves. At Ano Kouphonisi it seems that some of them were not. This opens up the whole question of the rituals undertaken in the cemeteries, and the possibility that objects were discarded there that were never intended for grave burial at all. At the cemetery of Aghioi Anargyroi on Naxos, Christos Doumas found a whole series of pottery vessels, in shape rather like large, broad-brimmed hats, that had evidently been used there and that were not interred inside the graves.[17] Rituals evidently took place at the graveside, and they may have involved the deliberate breakage of symbolic objects.

This does not however mean that these objects were made solely for that purpose. And the arguments set out earlier, together with the evidence for the repair and reuse of figures and marble vessels serve, in my view, to sustain the case that these symbolic objects of marble were not made solely for the funeral but were used in daily life, presumably in some ritual context. Several pieces in the Goulandris Collection may serve as examples. The most convincing is a figurine (plate 61) from the early, Grotta-Pelos culture that has been broken at the waist and repaired by drilling a hole on each side of the break, through which some kind of string was no doubt wound. The second piece (plate 62) is of particular interest: It was originally intended to be a double figure, the left arm extending out to go across the shoulders of its partner, while the right arm of the partner can be seen on the right shoulder at the back. But at some point this interesting and unusual piece was broken and the break ground down, so that we are left with a single standing figure. The third piece (plate 63) is a very much larger figure, today

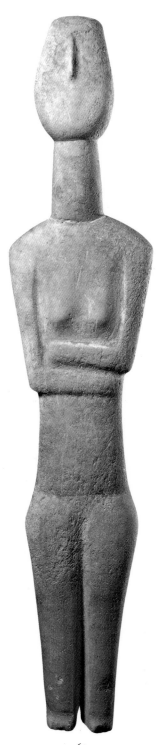

63

CANONICAL FIGURE
Keros-Syros culture
Marble, height 27½″

This figure was modified after breakage at the knees

standing 28 inches in height. But, as Getz-Preziosi has also noticed, the proportions make clear that what are now the feet were originally the knees, and the sculpture was once very much larger. It was evidently broken below the knee, and whoever repaired it decided to make the best of a bad job and simply carved feet where the knees had been. Now in each of these cases, the original damage could certainly have occurred during the original process of manufacture, in the workshop, as Getz-Preziosi has argued.[18] But I find it likely that some of these breakages occurred during use and that these objects were indeed utilized on a regular basis, not simply carved in order to go straight into the grave. On balance, given that many of the known complete figures come from graves, it seems that they were generally buried unbroken where possible and that ritual breakage was far from a universal practice. Many of the damaged pieces that were buried suffered this damage during their use life.

If we accept that the marble figures and most of the other objects found in the graves were made in the first place for use and were normally buried in the grave only after a definite use-life, we can begin to speculate about the rituals among the living in which these pieces were involved. (It should be kept in mind that only a small proportion of the population received burial accompanied by a human image: Well under one-tenth of the recorded burials were so accompanied and it is very possible that only a small proportion of the total population received any formal burial at all in well-constructed graves such as archaeologists and looters discover today. Not every member of the population owned such a figure, or if

Do these figures depict a deity, or a range of deities? Or are they instead designed as offerings to the deity or other supernatural powers? The vast majority of the figures depict the female form. But there are just a few males, notably (but not quite exclusively) of the Chalandriani variety. And in two cases, one of them illustrated here (plate 58), the male was accompanied by a female, or so it is plausibly reported — a "king" with his "queen."[19] In the case of the seated figures discussed in Chapter xv and the other departures from the canonical form, including the standing musicians and the "acrobats," we may suggest that some at least served as votaries to the deity, within the framework of the cult. The little seated figure with cup (plate 1) can certainly be interpreted in this way, as also the delightful pair of musicians from Keros (plates 107 and 108). If we regard these as servants of the deity, the same may possibly apply for many of the canonical figures. It is possible that the folded-arm position, which may well have some conventional significance, is one representing special respect or worship.

On the other hand, the monumental figures, and indeed many of the others, could well have been seen as representations of a deity or deities. It could be that the folded-arm position is, then, a sign of divinity. Nor does it follow that a single deity is represented. Had there been several different deities, we might well have expected these to be distinguished by specific attributes, like the saints carrying the instruments of their martyrdom in some medieval Christian portrayals. But there are depictions of saints in the Byzantine tradition, and of fathers of the Church, where the individuals are not distinguished in this way. Similarity or conformity of dress and position does not necessarily imply identity of subject.

As to the sex of the deity, it is notable that while the majority of the Plastiras figures of the early, Grotta-Pelos phase are female, males do exist. The preceding Neolithic period offers little guidance although there are certainly no male figures from Neolithic Saliagos, just a seated "fat lady" and a schematic violin figurine. But there is no evidence either to suggest the existence of a great mother goddess. Indeed, Lucy Goodison has called into question whether it is appropriate to think of explicit and well-defined deities at this time at all: "Whatever notions of female divinity may have existed, they had little in common with our concept of a monotheistic religion and a considerable amount in common with traditions of animistic religion. . . . The figurines therefore offer no evidence incompatible with the concept of animist or 'animate divinity,' against a background of which it may be possible to propose the sun as another element in a schema which can embrace stone and tree as manifestations of divinity."[20]

This is indeed a useful reminder that we are probably not dealing either with monotheism, of the kind with which we are familiar from the Judaic, Christian, and Muslim traditions, nor with the explicit and well-defined polytheism that we know from the Greek and the Hindu pantheons. But at the same time, I am not sure that so diffuse a concept as "animism" is entirely appropriate.

In the first place, with the canonical figures, we undoubtedly see unity: unity of artistic convention, and thus possibly of belief. The canon operates strictly in the majority of cases. At the same time we see some measure of diversity. The occurrence of males, albeit rare and usually not in strict canonical form, has just been mentioned. Only a single male figure of truly canonical form is known (plate 97), with arms folded across the waist in the appropriate manner and without the baldric that is characteristic of a group of late figures of the Chalandriani variety. This splendid and monumental piece, which must originally have stood about forty inches in height, is unique in indicating the male sex by means of a penis, shown in well-articulated relief. (The absence of testes is not, I think, of anatomical significance, but rather in keeping with the simplified approach to human anatomy and general absence of detail that is characteristic of all the canonical figures.) Interestingly the legs are separated by about an inch, a feature not seen in other folded-arm figures, and there are indications that the right leg may be set a little in advance of the left. This beautifully carved and so-far unique piece emphasizes that, if the larger figures did indeed represent deities, male deities were not necessarily altogether excluded, although they were exceptionally rare.

In considering the nature of the deity or deities represented by the canonical figures, it may be pertinent that just a few of them are shown distinctly pregnant. Others have a swelling at the stomach that might suggest pregnancy (plate 65) and there are some with folds across the belly suggesting a post-parturition condition (plate 64). But the great majority of the figures, while undoubtedly female, suggest no hint of pregnancy. While this observation militates against any kind of assumption of a fertility goddess, it would certainly be in harmony with Goodison's view that we may be dealing with a divinity, associated with the sun (and perhaps sometimes identified with it), who is involved also with birth and regeneration and who, in this capacity, has an appropriate role in funerary ritual.

ABDOMEN OF A CANONICAL FIGURE
Keros-Syros culture
Marble, height (complete figure) 12⅛″

The folds in the abdominal area suggest
a post-parturition condition

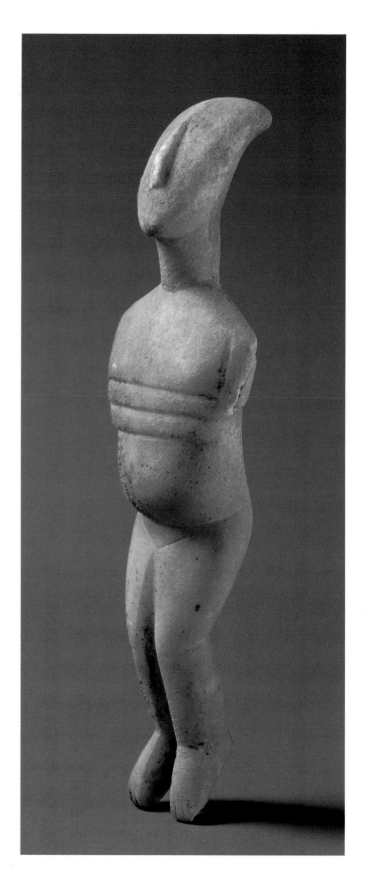

65

CANONICAL FIGURE
Keros-Syros culture
Marble, height 6³⁄₁₆″

The swollen stomach suggests
that this figure is pregnant

Intriguingly, similar questions have arisen over that other famous series of female figures, the korai of the Acropolis at Athens, dating from the sixth and early fifth centuries B.C., which are further discussed in Chapter XI. Surprisingly, perhaps, for that important a series of works so much closer to our own time, the meaning of the kore type is far from clear. "Did they represent the deity to whom the statue was dedicated, or the dedicant, or neither? Curiously enough in most cases we do not know." The discussion in Gisela Richter's definitive study considers the possibilities very much as we have done here, although of course the find circumstances are different, and there is no reason to imagine that Cycladic and archaic sculptures had any closely similar functions.[21] Richter wondered whether the korai might represent priestesses, but thought probably not, and pondered whether the habitual gestures of the korai shed light on their significance. Her conclusion was a rather general one: "It seems best, therefore, in trying to understand the meaning of our korai not to be too precise, and merely to surmise that the person who in archaic times passed a kore on the Akropolis of Athens, would have recognized in her an appropriate dedication to any female deity, since she represented a beautiful girl, a *pais kale,* in the service of the goddess."

My own provisional conclusion is that the monumental Cycladic figures, which are all of canonical form (and among which only a single male is known), are divine representations.[22] They may, with the single exception discussed, represent a female deity. The various other figurines, smaller in scale and sometimes different in form, would be votaries and votives. All the figures are likely to have been used in the course of cult, some domestically, others publicly.

Certainly the cult was practiced in funerary contexts as well, and probably also in special sanctuaries. It was not, however, primarily a cult of the dead. It was life-affirming and life-supporting, as well as aiding the deceased person (and the living kinsfolk) in the rites of passage surrounding those two most decisive of events: birth and death.

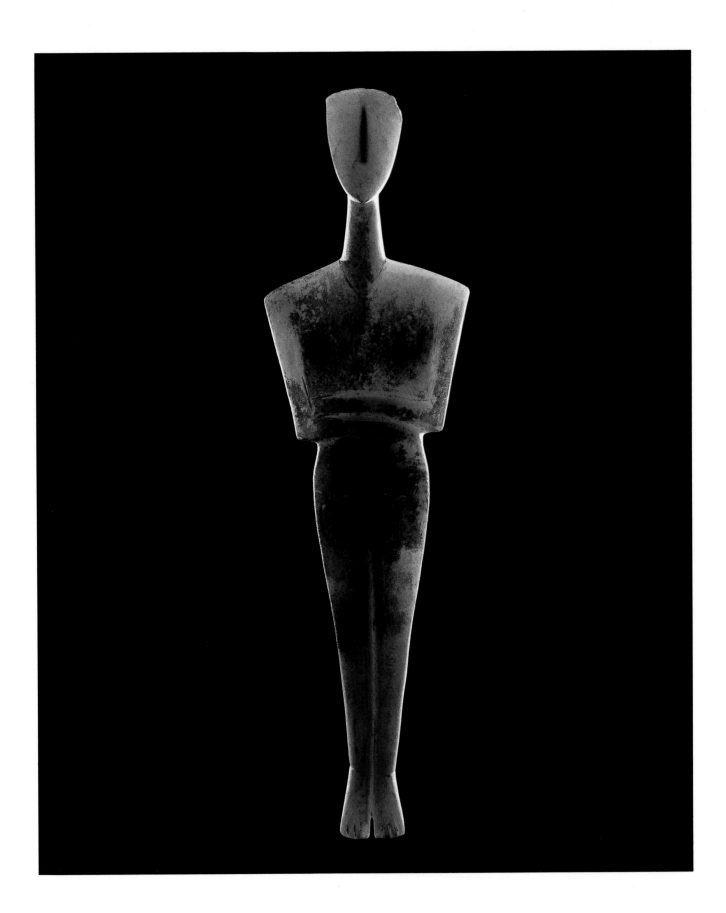

ASPECTS

OF

CYCLADIC

ART

66

CANONICAL FIGURE

Keros-Syros culture

Marble, height 15⅜"

Figure also reproduced in plate 54

CHAPTER IX

MAKERS
AND
MASTERS

OF THE CRAFTSMEN WHO made the sculptures of the Cyclades we know remarkably little. No workshop has yet been found on any of the islands. Although a few unfinished pieces are known (plate 67) their provenance has unfortunately not been recorded. It is not even certain to what extent we are considering specialist craftsmen. In many nonurban communities, the production of necessary artifacts, including pottery and stone vessels, was and is organized on a household basis. In others there are part-time specialists who, in addition to tilling their fields and sometimes managing their livestock, specialize in the production of a particular class of object at which their special competence is recognized. And again, many non-urban societies do support craft specialists who spend most of their time producing one particular class of object — pottery, for example — and who are provided with food and other necessities in exchange. Generally, the development of more centralized organizations, such as the palace economies of Middle Minoan Crete, permit the support of craft specialists. It is far from clear that the putative chiefs, whom we have sought to identify in the mature phase of the Early Cycladic period, commanded such organizations.

Certainly in the early, Grotta-Pelos phase, we have no evidence for large settlements or of prominent personal ranking. As we saw in Chapter IV, the population was probably scattered across the island countryside in small farmsteads. For the products of the time, then, we should perhaps be thinking of the production of marble objects at the household level. But the Plastiras figure, to take the most prominent example, is a sophisticated product of well-defined shape. Our household producers therefore must have been skilled and few, and in that sense specialists. But our present vision of the social structure does not encourage us to see them as full-time specialists working at some organized center of production.

In the succeeding Keros-Syros phase, when some of the figures produced were exceedingly large, we might be tempted to suggest that they were made by full-time specialists, but relevant supporting evidence is lacking. Only in the fortified Kastri near Chalandriani in Syros (which, as we have seen, is of later date, possibly after the time when production of these sculptures ceased) do we have good, direct evidence for craft- specialist activity, for there we find crucibles and other indications of metal working. And as noted in Chapter IV, the tool kit of a craftsman was found, with fine implements for carving, possibly of sealstones. This is as close as we come so far to the traces of one of our Cycladic sculptors.

Indications of metal working have also been found at other sites, including Pyrgos on Paros, and these are relevant to the issue of craft specialization. Perhaps a workshop will be discovered one day, recognizable not only by some rough-out figures or vessels, but by quantities of marble debris. In particular, the waste products from the manufacture of marble vessels should be obvious: we may expect to find cylindrical cores, the result of the drilling out of the center of such vessels. There may also be broken or discarded pieces that were damaged in the manufacturing process. Indeed it is noteworthy that such traces have not been identified at the settlements already recognized. This may be an indication that the sculptures were produced at a restricted number of specialist workshops.

These should perhaps be sought near outcrops of particularly good quality marble. The remarkable site at Dhaskaleio Kavos on Keros, with its hundreds of broken figures and bowls, cannot however be considered the location of a workshop. There is no appropriate debris, and (with the exception of a single uncompleted small bowl) there are no unfinished pieces. Dhaskaleio Kavos seems to have served as a special center, but it was not a manufacturing one. More may be learned when the nearby settlement is explored.

It is likely, I think, that the marble vessels were produced within the same workshops that produced the marble figures. And since the skills needed were much the same, the splendid vessels of chlorite schist occasionally found in the Cyclades may also have been produced in a marble workshop. These chlorite schist pieces are so rare, however, and indeed so splendid, that they may all have come from one single manufactory.

In thinking about these workshops, it would be helpful if specific varieties were strongly associated with particular islands: the Spedos variety with Naxos, for example, or the Dokathismata variety with Amorgos. But what little we know of the findspots of the various varieties shows each of them to be very widely distributed. The Dokathismata variety, for instance, is known from Dokathismata in Amorgos but also from Syros, Ios, and Crete, and much the same is true for the other principal varieties. There is at present no clear association of one form or variety with one specific region within the islands. Only the Koumasa variety can be pinned down: all the known examples are from Crete and were presumably made there.

At the same time, it does seem likely that the well-defined varieties, notably the Kapsala, Dokathismata, and Koumasa varieties, each reflect a specific tradition of manufacture. This would most easily be achieved within a single workshop or group of workshops. It would not be surprising if the Koumasa figures of Crete, for instance, emanated from a single workshop. The term "workshop" here may of course beg an important question. If manufacture was at household level, each "workshop" might be represented by a single craftsman. But it is of course true that skills (and conventions) might have been handed on from parent to child. Nor is it excluded that more than one member of the family was involved in production.

Of the method of manufacture of the figures we may be reasonably confident, since recent experimental archaeology has given some helpful clues. Elizabeth Oustinoff set out to create a schematic figurine, a figure of Louros form, and a folded-arm figure using Cycladic marble, restricting her tool kit to what must have been the Cycladic repertoire — emery, obsidian, and stone hammers.[1] While confessing a complete lack of experience in stone carving, she was able to produce a small schematic figurine in five hours, a figure of Louros type in thirty hours, and a small folded-arm figure (seven inches in height) in sixty hours. These terms could be reduced, perhaps by one half, with the benefit of greater experience. The experiment emphasized the rate of breakage and gives an order-of-magnitude estimate for the time involved in the carving of the smaller pieces.

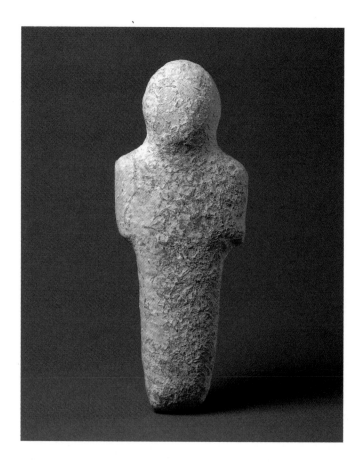

UNFINISHED FIGURE
Keros-Syros culture
Marble, height 4¹¹⁄₁₆″

This figure is
presumably from a
sculptor's workshop

If the circumstances in which the sculptors worked are not yet clear, nor where they did so, perhaps we can say something further about individual sculptors. For Getz-Preziosi has proposed, in an influential article, and then in an important monograph, that many of the Cycladic sculptures may be divided into closely defined groups on the basis of the strong resemblances between them.[2] These resemblances would, she argues, be much closer than those already recognized between the varieties within the canonical form discussed in Chapter VII. These closely defined groups she assigns to the hand of individual "masters," naming these systematically after a particularly characteristic and important piece in the group.

Assessment of these group divisions, and of their assignment to specific craftsman, is aided by the rich photographic documentation that Getz-Preziosi offers in her monograph (with three groups of Plastiras figures and thirteen of canonical folded-arm figures). But the defining criteria for each group are not set out with sufficient rigor to allow an entirely satisfactory division, and I have encountered problems with some of the groups (or masters) in systematically following the criteria. In other cases however the resemblances are indeed very compelling. Here, the archaeologist enters into the art historical realm of connoisseurship, in which judgments of attribution are made on the basis of intuition and experience as much as of evidence.

In approaching this question it is appropriate to begin (as Getz-Preziosi does) by considering certain pieces that are actually known to have been found together. For instance, two canonical figures were discovered in Grave 14 at the Dokathismata cemetery in Amorgos, which gives its name to their variety (plate 68). They resemble one another both in general and in specific details, most closely in the outline, notably of the neck and shoulders, and in the treatment of the arms, which are indicated in rather summary manner by incisions. This gives the forearms a tapering effect. But despite these similarities, they are far from identical: In the larger piece the feet are more carefully delineated and the pubic triangle is indicated by incisions. A slightly different arrangement of the legs in the smaller figure may be explained by irregularities in the marble block after it was roughed out. The excavator of these pieces, Christos Tsountas, was the first to suggest that they were made by the same craftsman, and the suggestion, based on the close similarity in the execution, certainly gains in force by their being found together.[3] It may be inferred that they were acquired by their owner from the sculptor, remained together during whatever use-life they had, and were buried together with the deceased.

Tsountas made the same suggestion for thirteen out of the fourteen schematic figurines of the Grotta-Pelos culture found together in Grave 103 at the Pyrgos cemetery on Paros and the thirteen from Grave 117 at Krassades on Antiparos.[4] But while there are some strong resemblances between pieces within each of these groups, others are quite dissimilar in form. So it is unlikely that anyone would have considered that they were the work of one sculptor had they not been found together. Tsountas's suggestion is in this case less plausible, as concerns the complete assemblages, although persuasive for more restricted groups within them.

Christos Doumas, in his excavations at Plastiras in Paros found four figures within Grave 9 that give their name to the Plastiras type.[5] Three of the four have oval heads on prong-shaped necks, square shoulders, and rather hollowed-out pubic areas, which distinguish them from the fourth.[6] It would certainly seem that these three were made by the same hand. This is precisely what Getz-Preziosi concludes, terming the craftsman the "Doumas Master": she likewise excludes the fourth piece from the inventory of his work. She classes with them six other pieces, of which two (from Levkes in Paros and Akrotiri in Naxos) seem to me completely convincing, with a third (from Glypha in Paros) very plausible. Of the three other pieces, two are male and two have incisions on the stomach, and while the identity is not complete, it is close.

Similarly, in Grave 26 at Louros Athalassiou in Naxos, seven figures of what is now termed the Louros type were found, of which five are preserved in the National Museum in Athens.[7] Getz-Preziosi assigns all five to the same craftsman, the "Stephanos Master," but in one of them the head and arms are recognizably different from the others (although still within the Louros type), and I believe that, had it been found separately, it would not have been attributed to the same craftsman as the other four. Here, as with the schematic pieces found by Tsountas, there is room for considerable doubt.

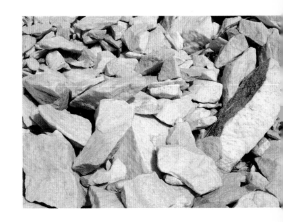

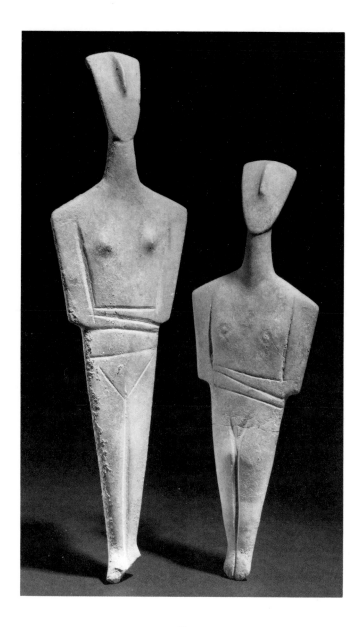

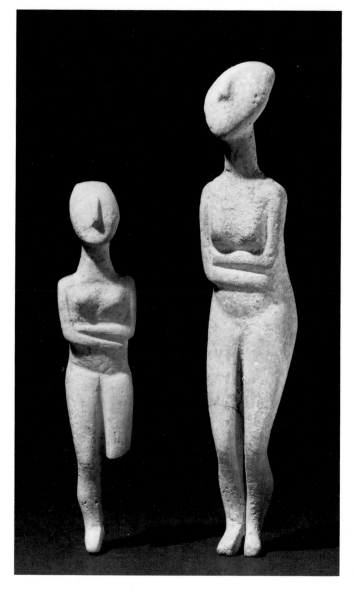

68

TWO CANONICAL FIGURES

Amorgos, Keros-Syros culture

Marble, heights 8⅛″ and 6⅜″

National Museum, Athens

These figures, discovered in Grave 14 at the Dokathismata cemetery
on Amorgos, were possibly made by the same sculptor

69

TWO CANONICAL FIGURES

Naxos, Keros-Syros culture

Marble, heights 5⁵⁄₁₆″ and 7⁵⁄₁₆″

Ashmolean Museum, Oxford

These figures, reportedly found in the same grave on Naxos,
are *not* clearly by the same sculptor

Difficulties also arise in the case of two pairs of folded-arm figurines, two from Grave 10 at Spedos in Naxos and two (of the Kapsala variety) reportedly found together in Naxos (plate 69).[8] Of the latter, Getz-Preziosi, in noting various specific differences concludes: "Nevertheless, both figures are not only typical of the Kapsala variety but are also similar enough to each other to warrant an attribution to a single hand. It is possible that they were carved at somewhat different points in the artist's career."[9] Some will find this proposal not entirely convincing. Regarding the two Spedos pieces, it is worth quoting Getz-Preziosi's comments at greater length, for they encapsulate the difficulties with such ascriptions:

The two figures found in grave 10 at Spedos differ in so many obvious points of form, outline contour and detail that it is not easy to ascribe them to the same artist. . . . In a case like this where two figures share certain features but not enough, it would seem on first appraisal, to attribute them with confidence to a single hand, there are two possible explanations. One is that they were carved by two different sculptors who were closely associated: one figure would have been fashioned by a master, the other presumably by his apprentice, the limited demand for marble objects making it unwise to postulate anything more complicated than a master/apprentice or father/son relationship. The idea of a workshop in which a group of sculptors worked side by side, mutually influencing each other, while attractive in the abstract as a way of accounting for differences observable among somewhat similar works, simply does not fit the available archaeological evidence.

The second explanation is that the two works are indeed the productions of a single hand, but that they were carved at different times. As mentioned earlier, it is likely that two figures carved in close chronological proximity will resemble each other more closely than two figures by the same sculptor carved some years apart.[10]

Getz-Preziosi develops this theme further. Yet while the arguments which she advances have a certain validity, the conclusion smacks rather of "saving the phenomena" by introducing a subsidiary argument (variation during the career of the Master) when the primary case (a really close identity between the figures) fails.

Before leaving the cases of figures found together — and there are several other instances — it is worth mentioning two more finds. The first is that of the famous flautist and lyre player, reputedly found together in Keros, and discussed further in Chapter xv. Rather to my surprise (since on a subjective basis I find the freedom of treatment rather similar) I note that Getz-Preziosi, who often links together works that I do not find closely similar, concludes: "Not only does the piper have a somewhat stockier structure than the harper but the two works are carved on a different scale, which probably means that they were not originally conceived as companion pieces. . . . It is not possible to tell if the two musician figures were made by the same person."[11]

The second find is of two figures, reputedly found together, that are in several respects very different from each other (plate 58). These are non-canonical figures and they do share several features — the shape of the heads, the ears in relief, the eyes, the incised mouths, the treatment of the feet — that make one inclined to see them as the work of the same hand. Getz-Preziosi terms their

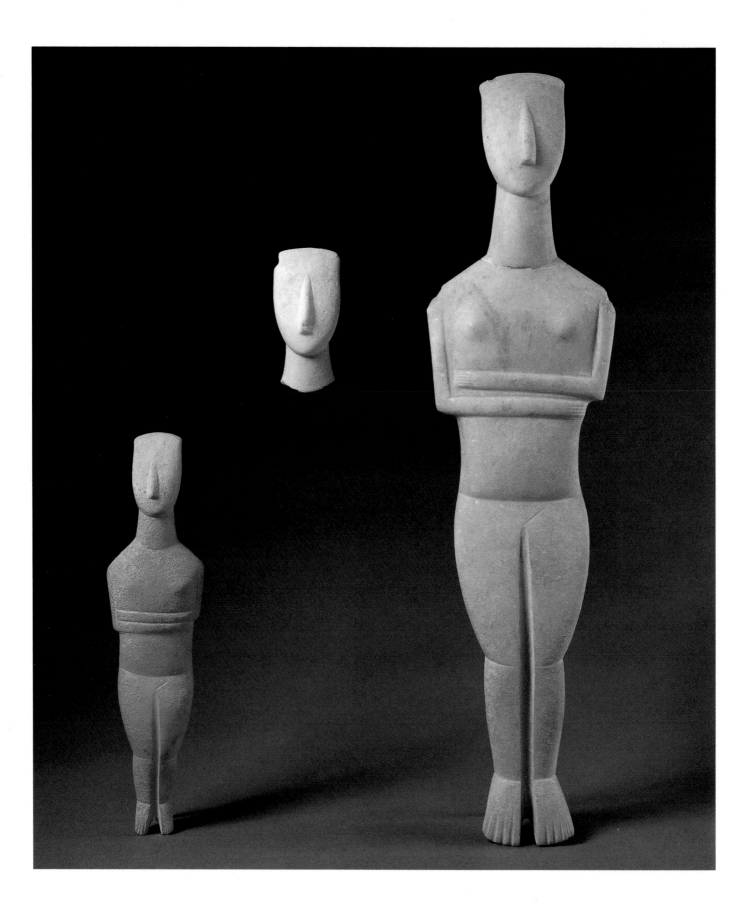

maker the Goulandris Hunter/Warrior Master and is able to cite a third figure that she feels, very plausibly to my eye, to be by the same hand.

Taking now a wider view, it is certainly possible to find figures, of quite different provenance, that resemble each other very closely indeed. When they are virtually identical, as happens in some cases, it may well be permissible to regard them as the work of a single sculptor. At the same time this is a field with many pitfalls, one of which is the widespread existence of modern fakes. There is the serious risk, if one goes on to consider sculptures lacking a well-documented archaeological context, that one piece resembles another very closely for the very good reason that it is a direct and recent copy of it. This, I suspect, may be the case for one or two of the works in Getz-Preziosi's lists of pieces attributed to individual masters. The name piece of the so-called Berlin Master, acquired by the Staatliche Museen, Berlin, in 1930, closely resembles a magnificent sculpture in the Athens National Museum that entered the collections with an unknown provenance early in this century, but the treatment of the wrists and hands of the Berlin piece leads me to wonder whether it might be a fake (although I have not inspected it personally and should withhold judgment until I do).[12] If my reservations are correct, the explanation for the resemblance is obvious. At least one other closely-matched pair illustrated by Getz-Preziosi prompts the same misgivings. A double figure, with the smaller individual standing on the head of the larger, is clearly similar to the well-known example in Karlsruhe, acquired in 1860.[13] But the suspect piece, labelled "Private collection, Provenance unknown," has various details, notably at the wrists and hands, that arouse my suspicion. Of course when two pieces resemble each other closely, it will often be the case that one is the copy of the other, and the explanation will be an innocent one if the copying took place in Early Cycladic times. But I would argue that it is always preferable to base one's arguments, so far as possible, upon pieces of well-established provenance.

Setting these difficulties aside, the general question now presents itself. Just how closely should two pieces resemble each other in order that their creation by a single sculptor may be inferred? All the pieces of the canonical folded-arm form already have some similarities and those within a given defined variety, as outlined in Chapter VII, share several more. At what point may we justifiably speak of "the hand of the master"? Can we exclude the possibility of a "workshop" — that is to say, of several sculptors working together and producing very similar products? And how do we cope with the time dimension, since we believe that the canonical figures were made over several centuries? Could we not speak also of several "traditions," with similar works being made by members of the same family, perhaps over several generations? I should like to see these issues more fully explored before accepting that a specific degree of typological similarity can automatically lead to the recognition of the hand of a particular master.

A very good case in point is offered by those very numerous sculptures (now more than fifty-one) that Getz-Preziosi has grouped together on the basis of formal similarities and classified as the work of the Goulandris Master. If we examine the three examples in the Goulandris Collection (plate 70) — two figures

70

TWO CANONICAL FIGURES
AND THE HEAD OF A THIRD
Keros-Syros culture
Marble, height of largest 25″

These figures are attributed to the same sculptor,
the Goulandris Master

and a head—there can be no doubt as to the similarity between the two complete pieces, despite their difference in size. Their sloping shoulders and rounded thighs are particularly persuasive. On the larger piece, however, the arms are carefully and separately shown in relief and the fingers indicated by incisions, while on the smaller piece the arms are distinguished merely by incision and the fingers not at all. It may be that more care has gone into sculpting the larger piece, for after all, the products of the hand of a single master need not all be identical in form. But it cannot be claimed that the same rule of proportionality has been applied to both figures, this being one of the criteria offered by Getz-Preziosi for ascription to a single hand. The head of the larger figure is almost precisely one sixth the length of the full figure; in the smaller piece, on the other hand, the head is by proportion larger and does not represent a simple fraction of the total length. While the resemblance is undoubted, can we be sure that these two are by the same hand? Cannot some lesser cause of affinity be postulated—that they were made in the same workshop or at different times but in the same tradition? When it comes to the third piece, an isolated head, one must express considerable reservations. There is indeed a similarity. But are there, in a single, small, simple head, enough diagnostic points of detail to permit ascription to one maker or another?

These queries are certainly not intended to call into doubt the value of many of Getz-Preziosi's observations nor to question the very great importance of the issues that she has raised. In fact I am personally persuaded of the soundness of her suggestions as concerns the two complete pieces in the Goulandris Collection and there are those in other collections identified by her as works of the same sculptor to which one does indeed respond with a shock of recognition, as if one were meeting an old friend.[14] But the majority of the claims rest on highly subjective perceptions and, once again, the dearth of well-documented contexts for these pieces has deprived us of much of the information that we would need for a more adequate interpretation.

We may, however, be confident that the sculptors were working under their own inspiration and that of their neighbors. Their tradition does not seem to have been a borrowed one: it developed from evident Cycladic antecedents. The skill and probably the essential concepts were all local ones. These craftsmen found their inspiration from the basic elements of the Cycladic world, not least in that wonderful raw material in which they carved their most exquisite and powerful works. They may also have been influenced by the thin-walled elegance and the flowing lines of the vessels of sheet silver that the Cycladic smiths were now producing. The invention of the form of the canonical figure was their own, drawing in part upon the inspiration offered by the human body, mainly the female body, and employing a sense of balance and grace evident as much in their delicately simple marble vessels as in their human representations. Such works as those had no obvious source for their simple perfection, just as they had no evident successors. They simply were.

WE SEE CYCLADIC SCULPTURES as pure in their whiteness. The absence of surface detail emphasizes the simplicity of form and all is reduced to clean lines and the polished surface of Cycladic marble. But it was not always so. These sculptures, it may now be asserted, were frequently painted. Pigments were used to add details that were not generally shown in relief: the eyes, the hair, and facial markings, as well as some details on the body.

Christos Tsountas reported painted decoration on some of the schematic figurines of the Grotta-Pelos culture, and painted lines have been observed also on figurines of Plastiras type.[1] But the painted decoration is most prominently seen on figures of the folded-arm type. As Getz-Preziosi puts it, "It is probably safe to say that by the time of the first true folded-arm figurines at the beginning of the second phase, virtually all figures except the schematic ones received at least some painted detail."[2] In general, however, that applies to the Kapsala and, especially, the Spedos varieties. No cases have been reported of painted decoration of figures of the Dokathismata, Chalandriani, or Koumasa varieties, and the custom evidently declined during the later part of the Keros-Syros culture.[3]

Some of this painting is still visible. The Cycladic head in Copenhagen (plate 71) has four very prominent vertical lines in red on each cheek as well as indications of eyes (the left eye is better preserved than the right) and of hair. The mouth is lacking. The splendid head from Amorgos in the Athens National Museum (plate 72) has similar markings, although most exceptionally the mouth is shown in relief. On this, as on a number of other very large pieces, the ears are also indicated in relief: only very rarely are they indicated by means of pigment. The Amorgos head again has four vertical lines on the cheeks and indications of eyes and hair.

Bodily markings are less commonly preserved. In general, after thousands of years of burial in the ground the pigment has disappeared entirely. We do see traces of a shoulder band of some kind on one figure (plate 73) and paint on the arms of another (plate 74). There are no indications that any of the figures were shown wearing clothing.

There is further evidence that painted decoration was applied to some figures.[4] The figure in plate 77 offers a splendid example: the eyes and eyebrows are actually preserved in low relief, along with a flat band at the top of the head. The remainder of the surface is rough and a little corroded. Careful study of this and other such pieces makes it clear that these details were not rendered in relief by the sculptor but are "paint ghosts." The original surface has instead been preserved, in low relief, through the presence of the paint upon it, while the remainder has been corroded somewhat by salts in the sometimes damp ground in which the sculptures were buried. The paint in its turn has now disappeared completely, but at least it had the effect of preserving from corrosion the original surface of the figure. Here and in other cases, the figure in plate 76 for instance, we see the eyes preserved in outline with a dot in each for the pupil. Sometimes they were rendered by a flat area of color. The figure in plate 75 also shows one eye in clear relief.

Of particular interest in these and other cases is the treatment of the hair. Indeed, I think that it is the style of hair, as indicated by the indications of now-

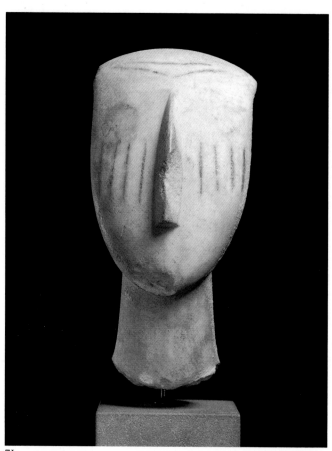

71

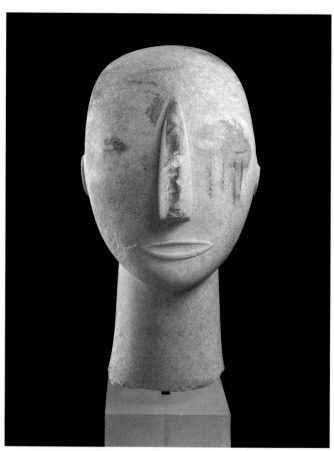

72

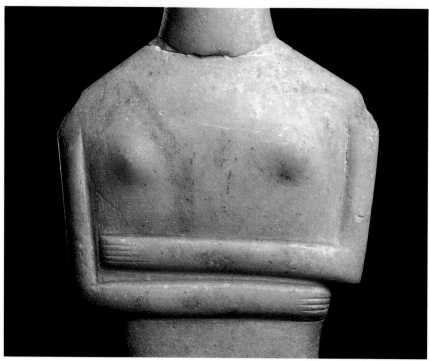

73

71

HEAD OF A CANONICAL FIGURE WITH PAINTED DECORATION
Keros-Syros culture
Marble, height 9¹¹⁄₁₆″
National Museum, Copenhagen

72

HEAD OF A CANONICAL FIGURE WITH PAINTED DECORATION
Amorgos, Keros-Syros culture
Marble, height 11⅜″
National Museum, Athens

73

TORSO OF A CANONICAL FIGURE
Keros-Syros culture
Marble, height (complete figure) 25″

Note traces of a painted shoulder band
For complete figure, see plate 70, right

74

CANONICAL FIGURE
Keros-Syros culture
Marble, height 29⁵⁄₁₆″

Note bands of red paint on the upper arms of this figure

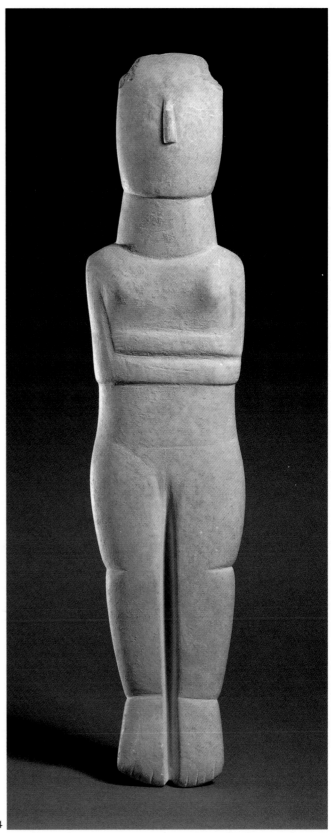

74

75

CANONICAL FIGURE

Keros-Syros culture

Marble, height 18⅝″

Note "paint ghosts" of left eye and hair

76

HEAD OF CANONICAL FIGURE

Keros-Syros culture

Marble, height 4⅜″

Note "paint ghosts" of the pupils of the eyes

77

HEAD OF CANONICAL FIGURE

Keros-Syros culture

Marble, height (complete figure) 14″

Note "paint ghosts" of the facial features

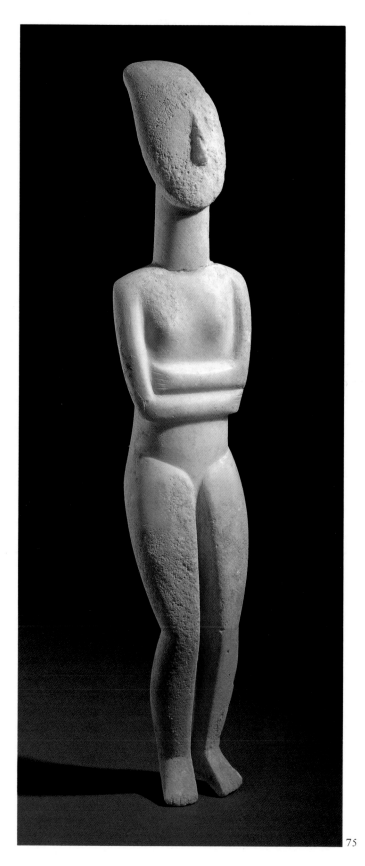

75

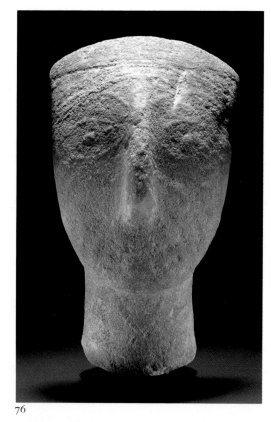

76

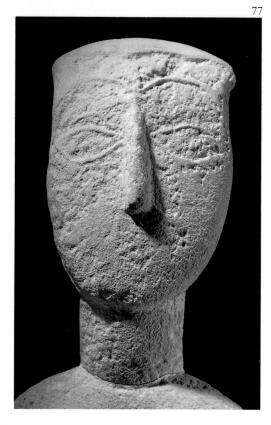

77

Figure 7

Diagram showing the arrangement of hair as indicated by paint decoration on the head and neck of a canonical figure (after Getz-Preziosi). The height of the complete figure, shown in plate 70, right, is 25″

vanished paint, that explains the curious lyre-shaped effect on many of the heads of the Spedhos variety. The figures in plates 75-77 do suggest that it is particularly at the part of the head that becomes notably widened or elongated that paint was used to indicate the hair. This impression is reinforced when we examine the back of the head of some of the figures. There we see a central mass of hair descending down across the nape of the neck, in some cases with a curling lock of hair at each side.

Careful examination of the back of one monumental figure (plate 78) reveals that this mass of hair had been indicated by a line of pigment, now seen as a faint white mark, extending down behind the ears to the nape of the neck. The same faint effect may be discerned at the back of the figure in plate 73, shown in the accompanying diagram (figure 7), and almost certainly caused the differential weathering or corrosion of figures in plates 3 and 77. All of these figures had well-defined painted eyes, hair, and facial decoration.

The pigments used to paint the sculptures have, in some cases, been preserved in the graves. Quite frequently, marble bowls are found containing red pigment, iron oxide or hematite, often with the small stone pestle that was used for grinding it. Blue pigment, copper carbonate or azurite, is also found, sometimes in the little pottery bottles of the Kampos group (plate 32). Some have speculated that such marks as are found on the cheeks of Cycladic heads described above may represent tattoos, others that they may be a special decoration painted on the faces of the deceased as part of some funerary ritual. The existence of such carefully prepared containers suggests to me that the pigment was not employed solely for funerary rituals, but was indeed used for cosmetic purposes in daily life.

It is interesting to note that in some of the non-canonical figures that are probably rather late in date, details are sometimes shown in relief or, in the case of the eyes, by incision and paint was apparently not used. The details that we now see in relief or incision — eyes, mouth, hair, a band across the shoulder — are those that were earlier indicated in paint.

These observations may, at first impression, modify somewhat our vision of these sculptures. They have lost something of their virginal purity of spotless white. But we are not obliged thereby to imagine them as garishly painted maquettes setting out to assault the eye by means of primary colors with the brutal directness of Pop Art. For the Greek sculpture of the classical period was also painted, as is now well known, although all traces of their painted decoration have generally disappeared.

Some years ago, in Cambridge, Professor Robert Cook took a full-sized cast of a well-known archaic Greek sculpture of the late seventh century B.C. in the Louvre, the so-called Lady of Auxerre, and added what he felt, after the necessary research, to be the appropriate painted decoration (plates 79 and 80). The effect is, to the twentieth-century eye, undeniably rather arresting. The paint brings out the contrast between face and hair and emphasizes the facial features, making the piece distinctly more lifelike. The effect is somehow also less archaic — the hair becomes less prominent and the sweep of the skirt less emphatic, being broken in

its simplicity by the decoration of squares. Interestingly, too, the subtle plastic values for whose discreet treatment archaic art is so much admired have almost disappeared: The rounding of the breasts and the modelling in the lower figure are no longer apparent. For me at any rate the painted decoration certainly does obscure to some extent the simplicity of form for which I have admired this sculpture for more than thirty years. Were our Cycladic pieces equally forceful in their painted effects?

I think not. A more appropriate comparison may be found among the korai, the Ladies of the Acropolis in Athens.[5] After the Persian sack of the city in 480 B.C., these pieces, many of them in excellent condition, were buried. Their coloring has in part been preserved, although no doubt, as in the Cycladic pieces it is now pale and attenuated. But what we can discern here — and the paint is in some cases well-enough preserved to let us reconstruct the whole decorative scheme — is not the use of great blocks of color over large areas of the marble. Rather we see added detail, like the red pomegranate in the hand of one or the tresses of the hair of another (plates 81 and 82). This latter figure also has stars of pigment, perhaps originally of silvery color, ornamenting the diaphanous garment, with the same color in the bracelet and decorating the mass of gathered-up hair at the top. Of course this red pigment would have originally been somewhat brighter. But here, I think, is a closer comparison for the Cycladic pieces of two millennia earlier. Indeed had the hair not also been delineated in this piece by means of incisions, the general effect on the overall shape of the head would have been broadly comparable with some of the Cycladic lyre-shaped heads. The colored decoration in both cases was linear — it delineates forms and emphasizes line. It does not create large surfaces of color.

But at the same time the pigmentation reminds us that the korai were intended to be lifelike. Greek sculpture, as we know from the ancient source, was indeed admired for its balance and proportion (those qualities that we most respect today), but also for its lifelike qualities. We must, I think, assume something of the same for our Early Cycladic sculptures.

When we compare these archaic pieces and their Cycladic predecessors with the works of Classical Greece or the Italian Renaissance, we are inclined to perceive them as radically different. But it may be that Cycladic sculptures lack facial detail in relief precisely because the sculptors and their clients felt that a more lifelike effect was obtained by painting details upon the marble. The simplicity and abstraction that we so much admire may in part have been the result merely of showing detail in another way. But it was done with some discretion and, as in the case of the carving itself, with a notable economy of means.

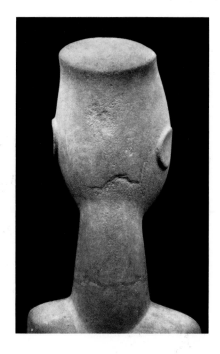

78

HEAD OF CANONICAL FIGURE
Keros-Syros culture
Marble, height (complete figure) 55⅛″

The traces of paint in this view show
the arrangement of the hair
For complete figure, see plate 103

79

THE LADY OF AUXERRE

Greece, Archaic period, c. 620 B.C.

Marble, height (with base) 29½″

The Louvre, Paris

There are indications of painted decoration on the figure

80

THE LADY OF AUXERRE

Plaster cast with reconstruction of painted decoration

Height 29½″

Museum of Classical Archaeology, Cambridge

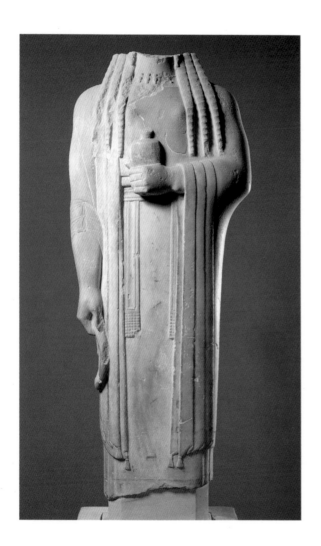

81

KORE

Athens, Archaic period, c. 560 B.C.

Marble, height 39⅛"

Acropolis Museum, Athens

Note traces of red decoration on pomegranate and clothing

82

KORE

Athens, Archaic period, c. 520 B.C.

Marble, height (complete figure) 45 3/16"

Acropolis Museum, Athens

Note traces of painted hair, headband, and bracelet,
and painted stars on clothing

THE
CYCLADIC
CONVENTION:
CANON
AND
PROPORTION

Filles des nombres d'or
Fortes des lois du ciel.

PAUL VALÉRY, *Cantique des colonnes*

THE MOST STRIKING FEATURE of the sculptures of the Cyclades is their adherence to the canon. This is most evident in the conventional stance of the folded-arm figures. The canon also may have required the adherence to certain underlying principles of proportionality. First, however, it is appropriate to consider further the notion of canonical form, not in the sense of strict proportionality, but in the wider one of a convention of conformity to type.

Already in Chapters V and VI it was noted that Cycladic artifacts as a whole seem to confine themselves, in a very controlled way, to a series of types. The marble vases of the Plastiras group, for instance, apart from a few bowls, are restricted with few exceptions to the kandela and to the flat-based beaker or deep cup. Much the same is true of the pottery, where the dominant forms in the early, Pelos phase are the spherical and cylindrical pyxis and the pottery version of the kandela. There are few creative or imaginative "one-offs," nothing to rival, for instance, the range and variety of the pottery or the terra-cotta figurines of the Neolithic period in Thessaly.

The same is true of the mature phase. Time and again, where one seems to have come upon an original form, a shape created by some gifted craftsman in a moment of inspiration and never again utilized, we find that this is instead a "type." That is to say it exists in multiple examples. It was conceived as such, at any rate after the prototype, and is no mere *jeu d'esprit*.

An excellent specific example is offered by the little pottery bear from Syros (plate 83).[1] For many years it seemed a unique piece, a charming creation by some potter of Syros. It was not until the late 1960s that a companion piece was found at the site of Aghia Irini on Kea, in the excavations of Professor J. L. Caskey.[2] The piece is not identical to the Syros one, but the form and position are the same, with the bowl (perhaps containing honey) held in the paws of the seated animal. A related piece has also been found in Naxos (plate 84).[3]

A careful adherence to convention, then, seems one of the keynotes of Early Cycladic art, and here it differs, or appears to, from the freedom and the exuberance, indeed sometimes the flamboyance, of the Minoans, as seen on the pottery and in the frescoes of Middle and Late Minoan Crete (which are some centuries later than the Cycladic examples under consideration).

Nowhere is this adherence to rule more clearly seen than in the conformity of the folded-arm figures. As we saw in Chapter VII, the position of the limbs and the convention as to which features were or were not to be represented were so closely regulated that the type itself may indeed properly be termed "canonical." Within this form are several yet more narrowly defined varieties, as set out in Chapter VII. And within these, as reviewed in Chapter IX, are the still finer groupings which, it has been claimed, represent the production of individual craftsmen or masters.

So well-defined is this convention that when it breaks down, late in the mature phase, the solecism is instantly evident. In some figures of the Chalandriani variety, the left arm is placed under the right, instead of in the canonical position (plate 85), and with this lapse comes a certain ungainliness. In the later non-canonical figures, this deteriorates into what is virtually a new style altogether (right, plate 58). Surface details are now added, the head loses its pristine simplicity of form, and the whole effect of the canonical figure is lost.

It is worth noting that the acceptance of order, or perhaps imposition of order, through the adoption of a canon is a recurrent feature of Western, and particularly Greek, art. Already in the Upper Paleolithic period the female form was the subject of special attention by the very earliest of sculptors, and their so-called "Venus figures" have a very wide distribution in Europe, from France to the Urals, around 25000 B.C.[4] To speak of a canon in this case would be to exaggerate, for there is considerable freedom in position and form. And yet there appear to be at least some conventions of representation: Many of these figures are shown standing, often with the hands below the breasts. There must be some underlying order here. No doubt each of these little sculptures was produced in response to some more general concept and many may be the embodiment of a single symbol.

It is not proposed to undertake their analysis here however. The intention is simply to indicate a tendency towards an ordered restriction of form — we need not go so far as to call this a stereotype — in the earliest representations and thus the earliest, full-fledged works of art in the human story.

Other examples can be found, for instance, in the predynastic period in Egypt, just a few centuries before our Cycladic examples, and in the stone figures of the Late Neolithic of Bulgaria a few centuries earlier still.[5] These latter stone figures seem to adopt a more restricted range of forms than their terra-cotta counterparts, produced in the same cultural milieu. This prompts the speculation that the hardness and lack of plasticity of the raw material is one of the factors that may contribute to the development of a more rigid canon.

This certainly is the impression given by Egyptian sculpture of the Old Kingdom, which was the contemporary of our Cycladic sculptures. There a popular standing form, usually a male with one foot (normally the left) extended before the other, the arms rigidly to the side, was clearly a canonical one, to which sculptors (and perhaps their clients) chose to conform. Again we may wonder whether the term "stereotype" may not be appropriate. So it would be if the sculptor were simply manufacturing a great quantity of low-quality works, to a narrowly preconceived formula. This may have been so in some phases of Egyptian art — one thinks of the endless, rather dull ushabti figures accompanying the dead — but it was emphatically not the case for some of the more handsome work of the Old Kingdom. At that time there were many masterpieces that achieved that status while conforming to their canon. Precisely the same is true of Early Cycladic sculpture.

It is, of course, most interesting to consider the Cycladic predisposition toward canonical forms in relation also to archaic and Classical Greece. Ideals of

83
BEAR
Syros, Keros–Syros culture
Painted pottery, height 4³⁄₁₆″
National Museum, Athens

84
BEAR
Naxos, Keros–Syros culture
Pottery, height c. 3″
Archaeological Museum, Naxos

order and balance were very much the qualities that underlay the art and thought of ancient Greece. We may look first at that remarkable creation of the early Greeks, the Doric order of architecture.

There is no doubt that the Greeks laid out their buildings with very great care, nor that in the Doric order the proportions were strictly regulated. As the Roman writer Vitruvius stated: "Of whatever thickness they made the base of the shaft, they raised it along with the capital to six times as much in its height. So the Doric column began to furnish the proportions of a man's body and strength and grace."[6] If we compare three well-preserved Doric temples of the later fifth century B.C., one from Athens, one from the Rhodian colony of Akragas in Sicily, and one from Poseidonia, now Paestum, the colony of Sybaris in Italy, we can see how strictly they conform to a clear canon (plates 86–88). That canon, setting out the various parts of the temple and their relationships, has frequently been expounded and made explicit, and there is no cause to repeat it here in detail. These temples reveal a regularity both in general form and in proportion that is altogether remarkable. There were, no doubt, traveling architects in ancient Greece, and the resemblance is of course no accident. There was a "right way" of building temples, and the colonists or their descendants in Magna Graecia clearly wanted to do things properly.

The kouroi are the life-sized nude male sculptures of marble of the archaic period.[7] They certainly adhere closely to a positional canon that has been shown to derive from the Egyptian convention for the standing male statue, developed two thousand years earlier: They stand erect, with their arms held rigidly at their sides, and one foot placed ahead of the other. Like the earlier Cycladic works, the kouroi are of marble, and many are of Cycladic manufacture. For in the islands of the sixth century B.C. (as in Attica and elsewhere) and based largely upon marble from the quarries of Paros and Naxos, there grew up distinguished "schools"— notable successions—of island sculptors, some of whom signed their works.

The kouroi have been authoritatively divided into "groups" by the distinguished American historian of art Gisela Richter, an ordering with which we may compare the later division of the Cycladic folded-arm figures into a well-defined series of varieties.[8] (It should be noted that Richter never went so far as to attempt a separation of the kouroi into the products of individual "masters," of the kind recently attempted for the Cycladic sculptors.)

The kouroi show a striking progression, when they are arranged in appropriate order (plates 89–91), from the very schematic to the relatively naturalistic, culminating in the most recent of the series, the so-called "Kritios Boy" of around 480 B.C., with which we are on the very threshold of the Classical ideal of Greek art. One might add, however, that the relative dating of the kouroi depends almost entirely upon these stylistic criteria, so that the impression of a well-dated evolutionary sequence is a spurious and circular one, the product of the preconceptions of the modern scholar. The general progression, from schematic to naturalistic, can, however, hardly be doubted.

The consideration of this wonderful series of sculptures has much to teach us about our Cycladic series of two millennia earlier. (It is not to be suggested,

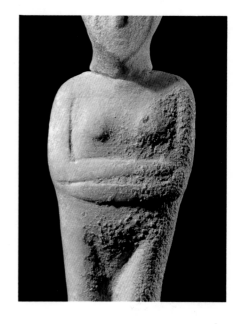

85

NON-CANONICAL FIGURE
Keros-Syros culture
Marble, height 5¹³⁄₁₆"

In this figure, the left arm is below the right

86

CANON IN THE DORIC TEMPLE

"The Hephaesteum"

Athens, C. 450 B.C.

87

CANON IN THE DORIC TEMPLE

"Temple of Concord"

Agrigento, Sicily, C. 450 B.C.

88

CANON IN THE DORIC TEMPLE

"Temple of Neptune" (Temple of Hera II)

Paestum, Italy, C. 450 B.C.

although the proposal has been made, that there is any kind of continuity between the two series of sculptures.) The comparison is a *processual* one, where two independent trajectories of evolution, taking place in analogous environmental circumstances, may usefully be compared. One may note again that the chronological arrangement within the Cycladic series is likewise purely a typological one, unsupported (as in the case of the kouroi) by any precise chronological evidence, and it too could be erroneous.

Undoubtedly, despite the reservations just expressed, the archaic series may be considered in evolutionary terms, as a progression from the stiff, schematic forms of the archaic period to the free, almost naturalistic style of the late fifth century. The naturalistic style involved a greater attention to bodily volumes and to the accurate rendition of surfaces. The Cycladic series, if my proposed chronological schema is correct, shows almost the opposite. In the preceding Grotta-Pelos phase, the Plastiras figures are emphatically modelled (although not, to our eyes, with great accuracy of proportion) with well rounded pelvis and buttocks, and with prominence given to such details as the knees, the navel, the ears, and the mouth. Some of these features linger on with the Kapsala variety of the folded-arm figure if the proposed sequence of varieties is correct. But after that there is a shift towards the sweeping planes and the linear emphasis of the Dokathismata variety, which is less carefully observed in terms of bodily volumes than the Spedos variety, yet more "stylish" in terms of the bold sweep of the body. The Cycladic craftsmen clearly did not set anatomical fidelity and naturalism as their long-term goal in quite the same way that the archaic and Classical Greeks did.

Then there are the korai, the votive maidens who formed the female counterparts to the kouroi. While the kouros is often associated with the gods Apollo and Poseidon as an offering (although some of the statues were funerary monuments) many of the korai come from the Acropolis at Athens, where they were associated principally with the cult of Athena, mainly as votives.

The canonical form of the kore, as it emerged during the sixth century, is of a standing maiden, feet together, clad in the appropriate draped clothing (the himation and the peplos), with one hand crossing the waist, holding a votive object, and the other, generally the right, again with an offering, held forward. Here the canonical form was not so closely defined in the early days as it was for the kouros. In the earliest part of the series, from around 560 B.C. (plates 81 and 106), the right arm is held straight down the side and the left comes across the waist. In this way, as in the kouros series and as with the Cycladic folded-arm figures, the unity of form was preserved, without any parts jutting forward. In the later, canonical form of the kore, with the right forearm held forward from the elbow, the forearm was almost invariably made from a separate piece of marble. A hole to take it was carved in the main block of the sculpture, to which it was secured by means of a peg. In nearly every case the protruding arm has since been lost. Although its bold protrusion from the plane of the body may have given a surprisingly lifelike effect, that effect was achieved at the expense of bodily unity, and the subsequent loss of the protruding forearm emphasizes for us the price that has to be paid for such a breach of unitarian convention.

In the two korai from around 525 B.C. shown here (and once again, the detailed dating is based mainly upon uncorroborated typological principles) the canon has not yet been formalized, for it is not yet established (as it soon will be) that it is the right forearm that is supposed to come forward (plates 92 and 93). If we compare these korai with their earlier Cycladic predecessors (and again no continuity in sculptural tradition is being suggested) there is no doubt that the Acropolis korai with their flowing robes are to our eyes the more graceful. In a cultural milieu that equates femininity with grace, they appear to us in consequence more feminine. But to my eyes, neither series sets out to exploit the explicitly female elements of the human body. The sexuality of the sculptures in both series is, I think, very much understated. The korai, of course, are draped, perhaps for the sake of modesty, and we must not forget that most of them were offerings to the Parthena, the virgin goddess Pallas Athene. The pubic area is obscured by the flowing robes. The breasts, on the other hand, although sculpted in low relief, are perceptible, as they are in Early Cycladic figures. And of course the drapery has been used to emphasize the bodily volumes, just as it obscures the surface detail. The Early Cycladic pieces are undoubtedly female but the indications in the pubic area that document this are tactful and restrained. The treatment of the sexual parts could scarcely be considered voluptuous.

My final example from the field of Hellenic art of the working of a coherent canon is from the Byzantine and post-Byzantine periods. Here the chosen medium is the two dimensional form, whether as a mosaic, as a wall-painting, or as portable painted icon. Byzantine iconography is another specialist field. But no long acquaintance with it is needed to appreciate that canons of order and gesture (although not necessarily of proportion) are frequently at work. The historical iconography of each personage might of course be considered in detail, but here it is sufficient to refer to the most obvious case, the representation of the Panaghia: the Blessed Virgin. She is represented in many forms, both with and without the infant Christ. Among the most common is the Panaghia Odhigitria, the Virgin Showing the Way.

Let us compare an icon of the thirteenth century, perhaps painted at Constantinople, and now in the National Gallery of Art, Washington, D.C., to a panel icon by the Cretan painter Emmanouil Lambardos, working in the post-Byzantine tradition in the seventeenth century, in the Benaki Museum, Athens (plates 94 and 95). In both works the conventions are closely followed, and the gestures of the Virgin and Child have the same symbolic meaning. The treatment of the halos is similar and the gold edging of the Virgin's mantle are strictly comparable, although the colors are different.

Once again we see evidence of a long tradition, in which the iconographic form, the canon, has been carefully preserved.[9] Yet within that canonical form there is abundant room for subtle variation, in detail, in color, in feeling.

This adoption of a strict canon, whether or not accompanied by conventions of arithmetic proportionality, is a recurrent feature of Greek art from the Early Cycladic to the post-Byzantine era. It stands in contrast to approaches to representation seen in the west, notably in Italy during the Renaissance.

89

KOUROS

Melos, Archaic period, c. 550 B.C.

Marble, height 84³⁄₁₆″

National Museum, Athens

90

KOUROS

Volomandra, Archaic period, c. 570 B.C.

Marble, height 70³⁄₈″

National Museum, Athens

91

LATE KOUROS ("THE KRITIOS BOY")

Athens, Archaic period, c. 480 B.C.

Marble, height 33¹³⁄₁₆″

Acropolis Museum, Athens

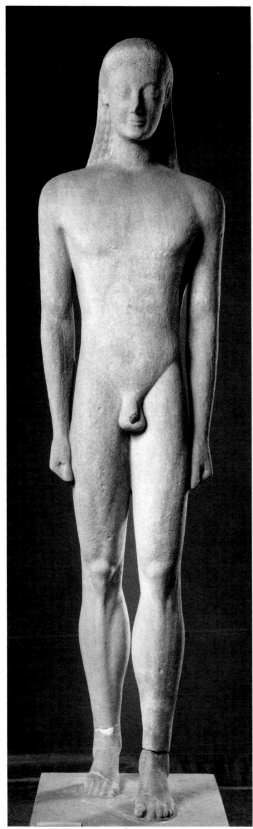

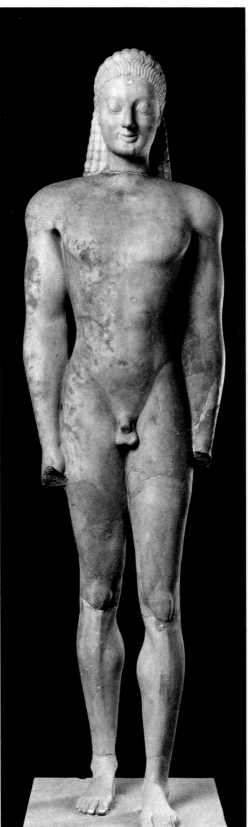

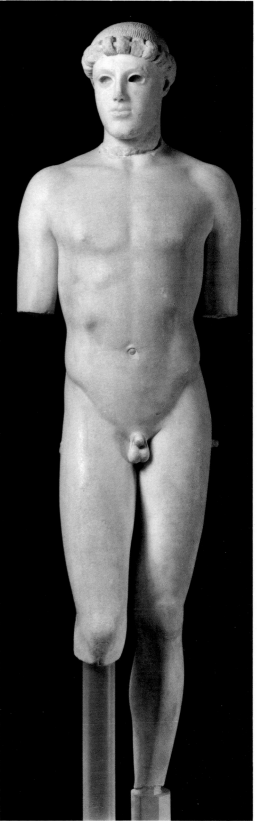

89

90

91

92 93

92
KORE
Athens, Archaic period, c. 535 B.C.
Marble, height 47³⁄₁₆"
Acropolis Museum, Athens

93
KORE
Athens, Archaic period, c. 525 B.C.
Marble, height 65¹¹⁄₁₆"
Acropolis Museum, Athens

As we shall argue below, it is this interplay between canonical convention, on the one hand, and the variations of treatment within it, on the other, that explains the power of Early Cycladic sculpture.

So far we have been using the notion of canonical form in the more general sense of order, of conformity to a well defined schema. But it is pertinent now to ask whether there was also some canonical system of metrical proportionality underlying the orderly appearance of the Cycladic figures. Such was certainly the case for the sculpture of Old Kingdom Egypt.

The Egyptian canon has been studied by a number of scholars, and the well-defined system for laying out the representation of the human body in paintings, reliefs, and sculptures is directly documented for us in a number of sculptors' trial pieces. The tombs in Thebes, mainly from the Eighteenth Dynasty (around 1500

B.C.), are decorated with painted scenes, in many of which the guidelines are still visible, so that the layout system can be clearly understood. As the distinguished Egyptologist Heinrich Schäfer expresses it: "We can see that the method of representation based on frontal images, when used by a people with the Egyptians' feeling for geometry, is the most favorable breeding-ground for a system for fixing proportions and for its further development. Only in such a context could lines and dots indicating proportions be used to the extent to which they were in Egypt, where they are found wherever one looks."[10]

The system at Thebes involved the division of the body into eighteen vertical divisions, although in some cases this was simplified to a layout using just six horizontal lines.[11] Later an alternative system involving twenty squares was used. The older system has its origins in the early days of the sculpture and the reliefs of the Old Kingdom, not long after 3000 B.C. By the time of the Eighteenth Dynasty it was common to block out more complex sculptures with a grid of squares. These regularities underlay much of the artistic production of Egypt from the development of monumental sculpture in the early days of the Old Kingdom. As Schäfer concludes: "We can now understand why Egyptian pieces, even of moderate quality, still almost always possess a certain degree of success and dignity."[12]

Modern research certainly suggests in addition that the kouroi and other Greek sculptures were also carefully laid out according to canons of proportionality, like their Egyptian predecessors (although not necessarily to the same canonical rules).[13] A graphic account is given by Diodorus, writing in the first century B.C., of Theodorus and Telekles, two Samian sculptors of the sixth century B.C., who employed the "Egyptian" system to make, separately at Ephesos and Samos, the two halves of a statue of Pythian Apollo, which were then triumphantly united:

This type of workmanship is not practiced at all among the Greeks, but among the Egyptians it is especially common. For among them the *symmetria* of statues is not calculated according to the appearances which are presented to the eye, as they are among the Greeks; but rather, when they have laid out the stones, and after dividing them up, begin to work on them, at this point they select a module from the smallest parts which can be applied to the largest. Then after dividing up the lay-out of the body into twenty-one parts, plus an additional one quarter, they produce all the proportions of the living figure. Therefore when the artists agree with one another about the size of the statue, they separate from each other, and execute the parts of the work for which the size had been agreed upon with such precision that their particular way of working is a cause for astonishment. The statue in Samos, in accordance with the technique of the Egyptians, is divided into two parts by a line which runs from the top of the head, through the middle of the figure to the groin, thus dividing the figure into two equal parts. They say that this statue is, for the most part, quite like those of the Egyptians, because it has the hands suspended at its sides, and the legs parted as if in walking.[14]

The concept of a canon of proportionality may well have been adopted by the Greeks from the Egyptians, along with the basic form of the kouros and kore positions. But for some Greek sculptors, at least, *symmetria*—the commensurability of the parts of a statue—became an important guiding principle of their

94

95

94
ICON OF THE VIRGIN AND CHILD
Byzantine, c. A.D. 1290
Oil on panel, 32 x 19½"
National Gallery of Art,
Washington, D.C.

95
ICON OF THE VIRGIN AND CHILD
Emmanouil Lambardos (Crete)
17th century A.D.
Oil on panel, height 48 x 35½"
Benaki Museum, Athens

art, rather than just a convenient way of laying out the block. Pliny, Galen, and
Quintilian all make reference to a treatise, *The Canon,* by the sculptor Polykleitos,
written in the fifth century B.C. As Galen put it:

Beauty he believes, arises not in the commensurability of the constituent elements, but in the
commensurability of the parts, such as that of finger to finger, and of all the fingers to the palm
and the wrist, and of these to the forearm, and of the forearm to the upper arm, and in fact of
everything to everything else, just as it is written in *The Canon* of Polykleitos. For having
taught us in that work all the proportions of the body, Polykleitos supported his treatise with a
work; he made a statue according to the tenets of his treatise, and called the statue, like the
work, the "Canon."[15]

The beliefs and practices of Greek sculptors in the fifth century B.C. can,
however, scarcely be taken as a guide to those of their Cycladic predecessors of
two millennia earlier, nor can they be used to determine how far the concept and
application of *symmetria* may have been exercised by Cycladic sculptors, a ques-
tion that we can now address.

Turning again to the Cycladic figures, we can investigate whether, in addition to conforming to a general rule or canon governing their form, they adhere to some specific system of metrical proportionality. Such a system, as we have seen, can be demonstrated for Egypt at about the same time that our Cycladic sculptures were being made in the Aegean. And we have seen that such a system was in use in Greece itself in the archaic period, two millennia later.

In the Cyclades, however, we do not have the benefit of any sculptor's trial pieces, which, in the Egyptian case, actually document the way sculptures were initially laid out. In the absence of any descriptive texts, which are so illuminating for Classical Greece, we have to turn to the evidence of the completed sculptures themselves and see whether the finished product gives any firm indication of the use of some system of metrical proportionality.

Here we face a difficult question.

The question is one of precision. Naturally one cannot expect exactitude in the proportions of the finished figure. For even if the sculptor, using string or compass, marked out the proportions on the rough block with very great care, by the time that the block has been carved away to produce the finished figure, something of the original proportionality will have been lost. But, on the other hand, if we are taking measurements of these sculptures today, and then dividing one measurement into another in a search for simple proportionality, a generous allowance for "sculptor error" in rounding the figures would allow us to produce all manner of plausible ratios that are no more than the artifact of our approximation procedures.

That the outlines of the figures were sketched out by their sculptors on the blocks of marble from which they were carved is likely on purely practical grounds. Getz-Preziosi has suggested that in planning the figures, the makers of the figures of Plastiras type used what she terms the "archaic three-part canon": roughly one part for the head and neck, one for the torso, and one for the legs (the elbows are often at the midpoint of the figure). Most of the folded-arm figures, she would argue, were made using the "classical four-part canon": "The classical sculptor conceived his figure as divisible into four equal parts, with the maximum width (at the shoulders) often equal to one part. Compass-drawn arcs marked off the shoulders, the elbows or waist, and the knees. The top of the head and the ends of the feet were also curved, revealing further the influence of the hypothetical compass" (figure 8).[16]

My own investigations suggest that the matter is not so straightforward: I am skeptical as to whether the majority of the folded-arm figures were laid out using a standard four-part canon. Indeed it seems possible that many of them were laid out on an ad hoc basis, without any underlying principle of proportionality at all. But it does seem likely that a significant number were laid out employing simple principles of proportionality, of which several seem to have been in use.

A strict analysis would involve statistical procedures. Accurate measurements would be undertaken on a very large series of complete figures. Only quite narrow latitude in adjustment would be permitted for each measurement, perhaps

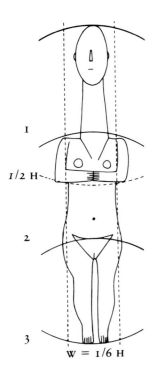

$1/2\ H$

2

3

$w = 1/6\ H$

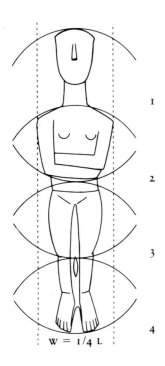

1

2

3

4

$w = 1/4\ L$

Figure 8
The "archaic three-part canon" and the "classical four-part canon" as proposed by Patricia Getz-Preziosi for figures of the Plastiras type (above) and canonical figures of the Spedos variety (below)

of the order of one percent or even less, and any apparent patterning in the proportions that might emerge would be subjected to tests of probabilistic significance. No such project has yet been carried out, and my colleague John Cherry tells me that a preliminary inspection of the issue does not leave him optimistic about a positive outcome—that is to say about the recognition of regularities of proportion that would be of high statistical significance. Certainly it is the case that the use of rather vague diagrams involving the drawing of arcs or circles, or the imposition of a grid of squares, can easily make the notion of strict proportionality appear plausible, without in any way documenting it.

Although I feel that Getz-Preziosi has drawn attention to an important issue and opened up new avenues of enquiry, I am at present skeptical about the conclusions offered. The case is not unlike the issue of the megalithic yard, which Professor Alexander Thom suggested was used in the layout of the stone circles and other constructions in Neolithic Britain (although in that case an absolute unit of measure was being proposed, not simply a strict canonical regularity of proportion).[17] Very sophisticated statistical tests have not yet, in the megalithic case, yielded definitive conclusions. But it is easy, on simple inspection of the excellent array of examples illustrated in Getz-Preziosi's valuable monograph, to see that not all the works that she would assign to a particular master were laid out according to the same canonical system. Of course there is no particular reason why they should have been. That a given sculptor should, on occasions, employ different methods to lay out the human figure does not necessarily call into question either the integrity of his production or the likelihood that the greater part of his work was indeed carefully produced using one or several systems of proportion. But if we look at the name pieces of her Fitzwilliam Master or of the Steiner Master, or indeed at the two complete pieces in the Goulandris Collection assigned to the Goulandris Master, we can see that they are not identical in proportions to others assigned in each case to the sculptor in question.[18]

The only appropriate approach, in my view, is to inspect a good number of cases, without strong preconceptions, and to see what patterns may begin to emerge. A desirable next stage would be to find some appropriate statistical test to assess the significance of any proposals offered.

As a first step I have tabulated the dozen largest preserved figures in the Goulandris Collection. So far I have worked only from the published photographs. This would be adequate for the investigation of proportionality if one were confident that the photographic process involves no distortion. But since one does not have such confidence, the effort can only be regarded as an exploratory one.

It seems necessary to define precise points on each figure from which measurements may be taken. The crown of the head is one of these, and the tip of the toes the other extreme, allowing the computation of maximum length. But there is some reason to think that the distance from the crown to heels (which is generally slightly shorter than crown to toes) may be more relevant in some cases. The distance (along the central axis) from crown to chin, and from crown to the lower point of the lower arm, is easy to measure. The base of the neck is not always

so easy to define: in most cases it may be equated with the upper shoulder. The distance from crown to crotch (defined as the division of the legs in cases where these in fact divide) and from crown to lower abdomen (in cases where this is indicated by a horizontal line) are also potentially useful measurements. Using these I have prepared a table, indicating, by means of a fraction, those cases where an approximate proportionality is observed. This is only a trial. A more adequate treatment would give the precise measurements, and would indicate clearly how far the actual ratio differs from the simple proportionality suggested:

TABLE OF PROPORTIONS FOR THE LARGER PRESERVED FIGURES IN THE GOULANDRIS COLLECTION

Ratios are expressed as length of specified portion of figure in relation to total length of figure

Height of Figure	Plate Number	Length of Head	Crown to Lower Neck	Crown to Lower Arm	Crown to Crotch	Crown to Knee	Maximum Width	Comment
55⅛"	103	1/5	—	—	c. 3/5	c. 4/5	1/5	W=H
29⁵⁄₁₆"	74	1/5	—	—	3/5	—	—	Broad
29⁵⁄₁₆"	57	c. 1/4	—	—	—	c. 3/4	c. 1/4	W=H
28⁵⁄₁₆"	122	1/6	—	1/2	—	c. 3/4	1/6	
27½"	63	—	—	—	—	—	—	Reshaped
25¹³⁄₁₆"	3	1/5	—	1/2	3/5	c. 3/4	1/5	W=H
25"	70 right	1/6	1/4	—	3/5	c. 3/4	1/4	W=H+N
18⅞"	51	c. 1/6	1/4	—	—	c. 3/4	1/4	W=H+N
18⅝"	75	1/5	—	c. 1/2	3/5	c. 3/4	1/5	W=H
15⅜"	54	c. 1/6	c. 1/4	—	3/5	—	—	W=2H
14½"	—	1/5	—	—	3/5	—	1/4	
14"	77	1/4	—	c. 1/2	3/5	c. 3/4	1/4	W=H
13"	70 left	c. 1/5	1/4	—	—	4/5	1/4	W=H+N

Ratios preceded by a "c." allow for 2% deviation and are less precise.

W=H indicates that the maximum width of the figure is approximately equal to the length of the head.

W=H+N indicates that the maximum width of the figure is approximately equal to the length of the head and neck together.

Note that the figure in plate 63 is broken at the knees and was reshaped to convert the knees to feet.

This admittedly small sample suggests some rather different conclusions from those that have previously been offered. Comparable figures have been plotted for the remainder of the thirty complete figures in the collection, the smaller pieces being apparently less regularly laid out. In the first place the length

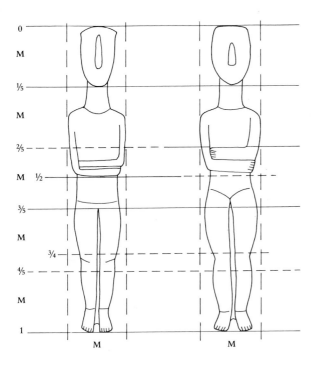

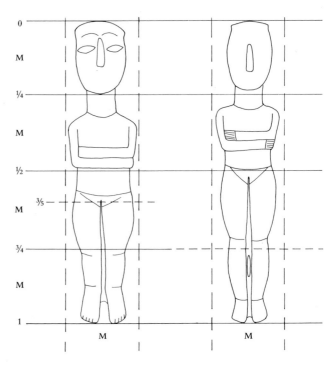

Figure 9
Diagram of canonical figures of quintile modularity. M indicates the module, which is based on the length of the head. Heights of actual figures 25¹³⁄₁₆″ (plate 3) and 18⅝″ (plate 75)

Figure 10
Diagram of canonical figures of approximately quartile modularity. M indicates the module, which is based on the length of the head. Heights of actual figures 14″ (plate 77) and 29⁵⁄₁₆″ (plate 57)

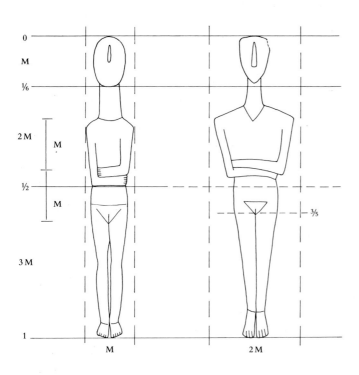

Figure 11
Diagram of canonical figures of sextile modularity. M indicates the module, which is based on the length of the head. Heights of actual figures 28⁵⁄₁₆″ (plate 122) and 15⅜″ (plate 54)

of the head is frequently a simple fraction of the total length, or to put that another way, the total length is frequently a multiple of the length of the head. Frequently the head is one fifth of total length. This we may term a convention of quintile modularity. In such cases, the distance from the crown to crotch is sometimes ⅗ total length, and from crown to knee ⅘ total length. It is notable that in several cases the maximum width, normally at the shoulders, is the same as the length of the head, which therefore constitutes a significant modular unit. Sometimes the distance from crown to lower arm is half total length. Two such cases are seen in figure 9.

A different proportionality is seen in certain cases, with a notably large head, measuring about one quarter of the total length: a possible quartile modularity. In the two examples illustrated in figure 10, the width at the shoulders is again the same as the length of the head, but the placing of the knees varies, occurring at approximately ¾ and ⅘ respectively.

It would seem that in the later part of the Keros-Syros phase, notions of proportionality changed radically. Characteristically the head is now one sixth of the total length: a convention of sextile modularity. A good example of the characteristically broad Dokathismata variety is seen in figure 11, along with a large piece, to be assigned to the Spedos variety, which is exceedingly narrow, as it still follows the convention that shoulder width equals head length, but this is now only one sixth of total length. It should be noted that the two figures of the Chalandriani variety in the collection, not included in the table since they are smaller in size, also show a head to total length ratio of ⅙.

Several of the large figures examined for this exercise have so far shown no obvious indications of simple proportionality. And what is offered here is not a conclusion, but a line for further investigation. It may be that, as many more figures are examined, several coherent patterns will emerge, revealing a number of systems of proportionality for the folded-arm figures. Among these Getz-Preziosi's suggestion of a three-part canon for the figures of Plastiras type looks at first sight very plausible.

My own provisional conclusion is that the existence of different proportional systems for the canonical varieties of folded-arm figures looks increasingly likely, but has not yet been rigorously demonstrated. Many of the Dokathismata variety figures (of which there is only one in the Goulandris Collection) look so similar in outline that one might expect further study to bring out the underlying relationships of proportionality. And for many of the figures of Spedos variety, it seems that a body length of five modules of the head, with a maximum width of one module, and sometimes with the crotch and knees at three and four modules respectively from the crown, may prove to have been used. The employment of a regular system of this kind does seem likely, although it will not be easy to demonstrate with rigor.

CYCLADIC
HEADS

DELIBERATE FOCUS ON DETAIL can bring out the range and variety of forms used by the Cycladic sculptor. The Cycladic canon seems to have required that the head normally be shown with a nose and with no other facial features whatever indicated in relief. Eyes and hair were regularly shown by the addition of colored paint.

In the earlier, Grotta-Pelos period, the head of the Louros figure was presented without a nose (1), but the Plastiras figures were represented with various facial features that reappear in the later non-canonical figures (8) at the end of the mature phase. The only important exceptions to the general rule forbidding sculpted surface features are the representations of ears on monumental figures greater than two and a half feet in height (20), and the manner in which the hairpiece at the top of the head was indicated.

Early on the head was rounded (2, 9, 10). In the Dokathismata variety (6, 11, 14) the face was flatter and pointed at the chin, and in the Chalandriani variety (7, 12, 15), it became almost schematic, a flat triangle set at an angle to the neck with a nose roughly shown in relief. With the later non-canonical figures the head is again rounded, but in a much less well-defined way (8), and with a variety of additional detail (16).

The figures of Spedos variety show a pleasing range of variations in the representation of the head (3, 4, 5, 10, 18), the nose being given more or less emphasis, the cheeks rounded or flat, and sometimes with a lyre-shaped widening at the top (5, 18). This feature is to be interpreted as a hairpiece set upon the crown of the head, and was either wide and narrow (17-19) or rounded (20), depending mainly on the shape of the head.

Of the heads shown here only 1 (Louros type, early) and 8 and 16 (non-canonical, late) lie outside the main series of folded-arm figures. The others reflect the great range and variety that was possible within the Cycladic canon.

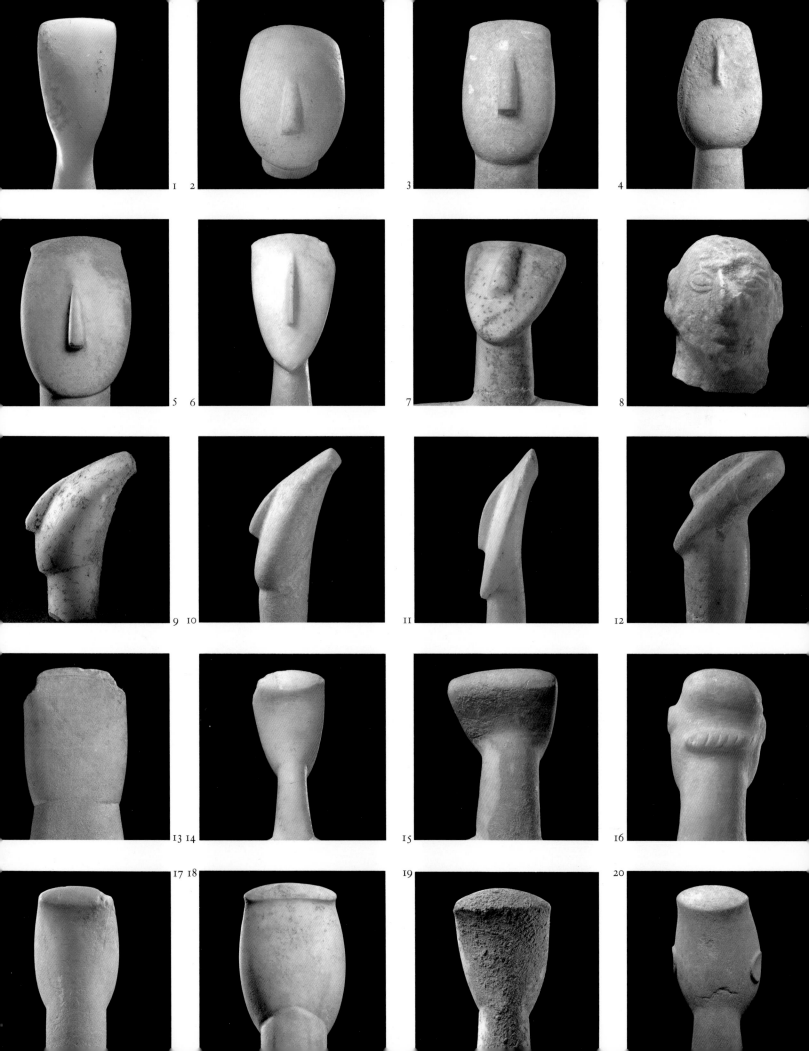

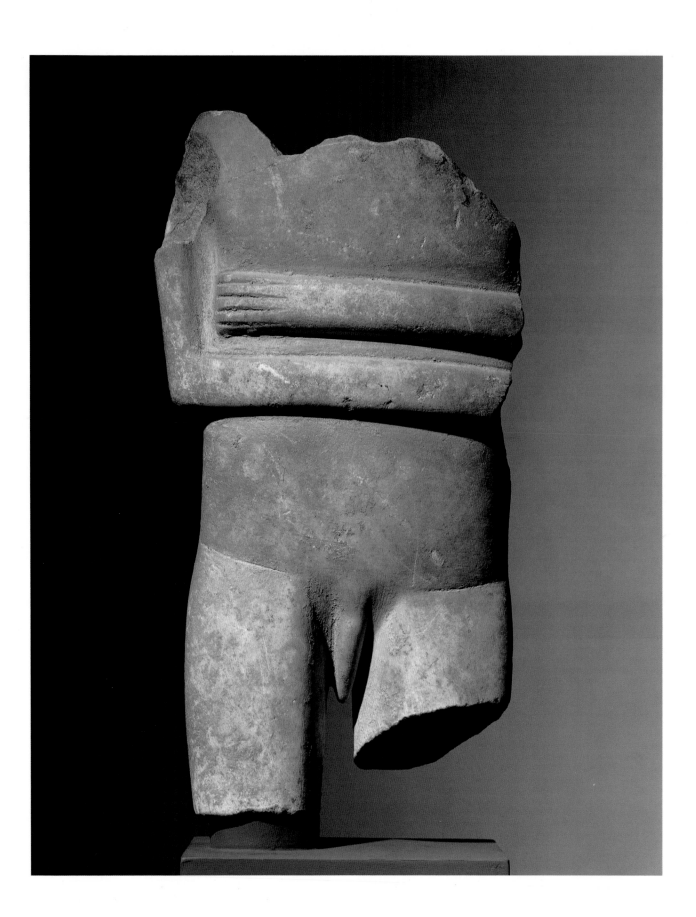

WITH THE CYCLADIC CANONICAL figure, it is perhaps for the first time that sculpture shows simultaneously such consistency and yet also so many degrees of freedom. The different character of various pieces suggests that the sculptors conceptualized the human form in very different ways. They achieved this expressiveness within the canon by varying proportion, the degree of plasticity in the representation of forms, and the treatment of anatomical details.

The issue of proportion was dealt with in Chapter XI: its effects are graphically seen here in plate 98. Here two figures of the same height (twenty-eight inches and twenty-nine inches respectively) are reproduced side by side, but they could hardly give a more different impression. In the figure on the left, the head is shown one sixth the length of the body, and the width at the shoulders is the equivalent of one head length (the principle of sextile modularity outlined in Chapter XI). In the figure on the right, the more usual quintile ratio is employed, the head being one fifth the total length, but the figure departs from the usual convention of quintile modularity in being wider at the shoulder than one head-length: It gives a decidedly thickset impression.

The piece on the left also follows the sextile system in setting the lower arm precisely in the mid-point position. On the right, as is usual with the quintile system, the arms are set higher. It would be wrong to exaggerate the effect of this proportional layout upon the character of the figures, but to understand it certainly helps to see how some of the salient differences arise.

A high degree of plasticity is a feature of the earlier folded-arm figures, admirably seen on the left in plate 99. On this beautiful piece there is no incised detail whatever, other than light indications of the fingers and toes. The arms are in three-dimensional relief and the tops of the legs are seen also in relief, with no other demarcation of the pubic area. Indeed the figure could be regarded as sexless, although it should probably be considered female. On the right the reverse is true: the arms are indicated by incision, the pubic area is shown in the same way, and the legs are divided by a cut rather than carefully modelled. (In many respects this figure resembles those of the Dokathismata variety, lacking only the elongated head with pronounced chin. Interestingly it follows the sextile modularity of the Dokathismata figures, where the head is one sixth the length of the body, and the maximum width is twice the head length.)

Cycladic torsos (plate 100) show these variations in proportionality and surface treatment. Correlating with the different proportionalities are different shapes: The regular figures of quintile modularity in which the width equals the length of the head possess a rectangular torso (7 and 8); the narrow figures of sextile modularity in which the width equals the length of the head is distinctly hollow chested (9); the sloping shoulders of the Dokathismata variety of sextile modularity in which the width equals twice the length of the head are decidedly elegant (2); while those of the Chalandriani variety of sextile modularity in which the width equals three times the length of the head are broad, and the torso very square (1).

The two figures very plausibly assigned by Getz-Preziosi to the same sculptor (the "Goulandris Master"), numbers 3 and 4, have markedly sloping shoul-

CYCLADIC
ANATOMY

97
CANONICAL MALE FIGURE
Keros-Syros culture
Marble, preserved height 16¾"

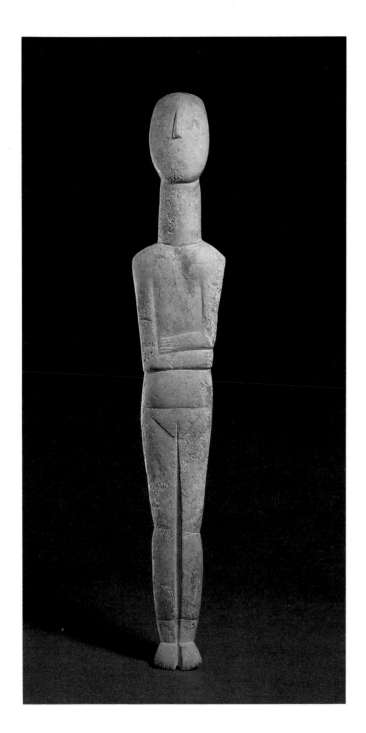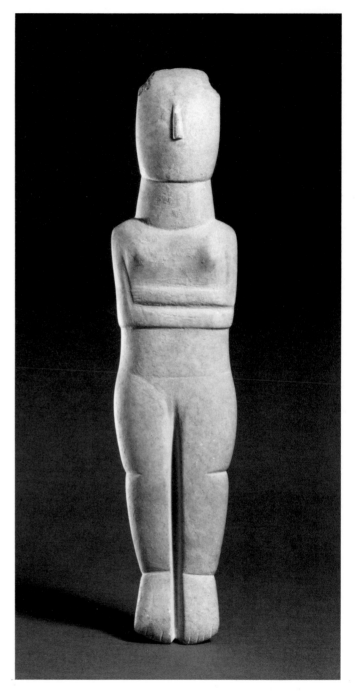

98

CANONICAL FIGURES

Keros-Syros culture

Marble, heights 28⅝⁶″ and 29⅝⁶″

Figures compared with regard to proportionality

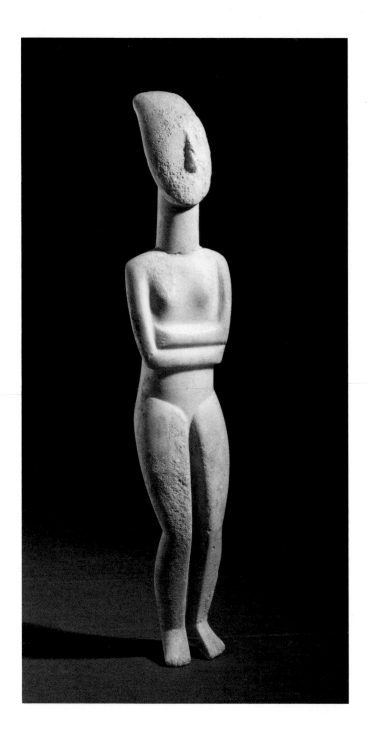
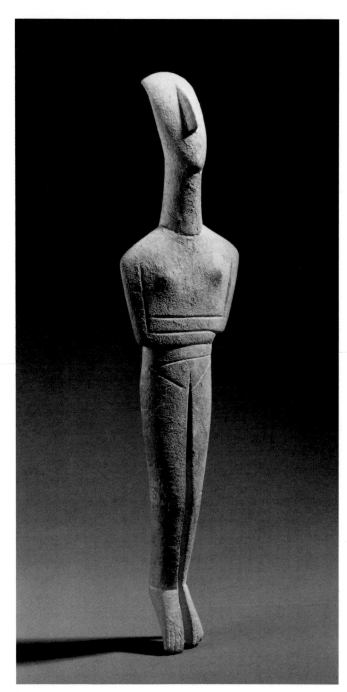

99

CANONICAL FIGURES

Keros–Syros culture

Marble, heights 18⅝″ and 10⅝″

Figures compared with regard to plastic values

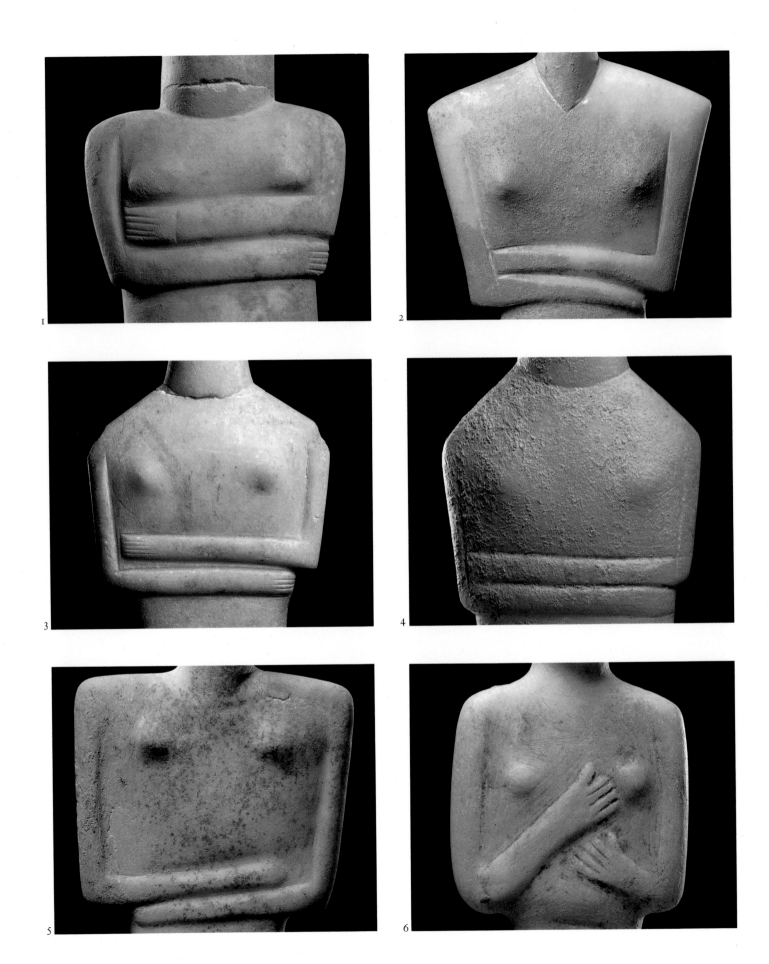

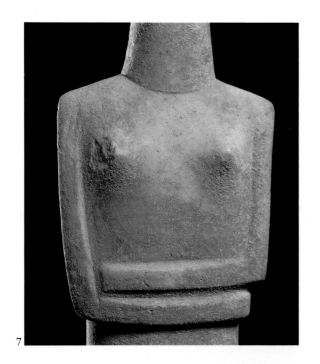

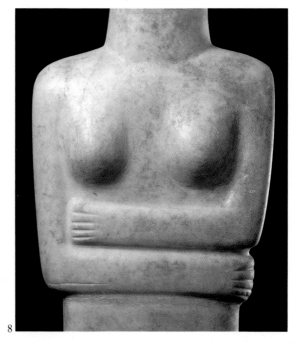

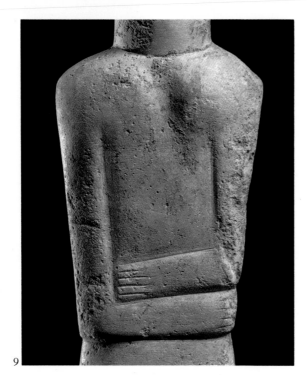

100

TORSOS

Not reproduced to scale

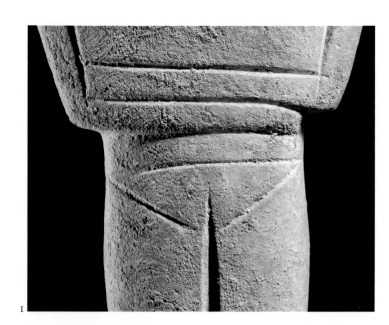

101

WAISTS AND ABDOMENS

Not reproduced to scale

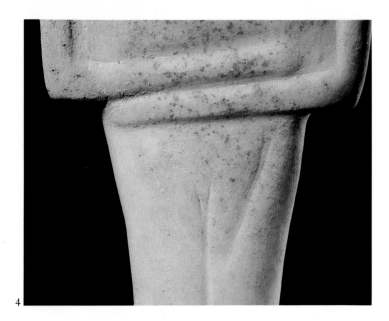

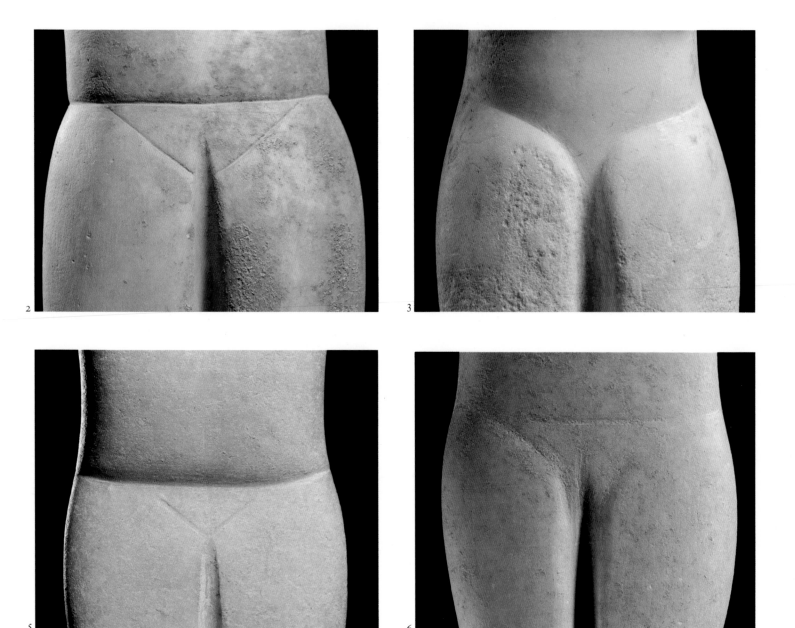

2

3

5

6

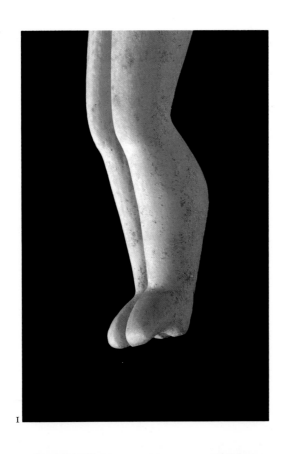

1

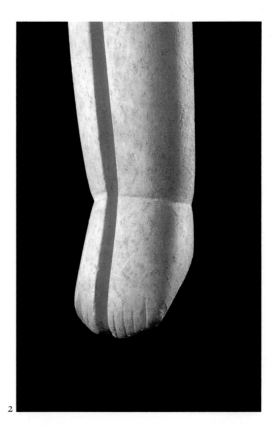

2

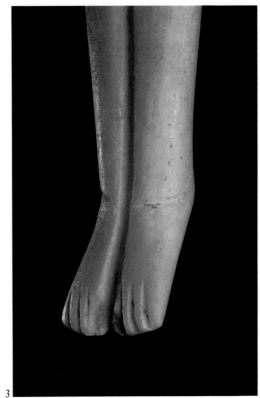

3

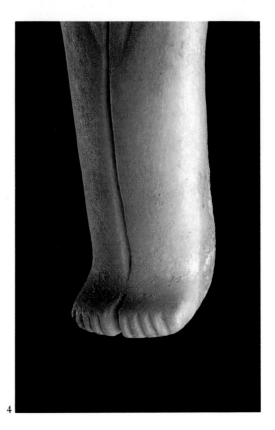

4

ders. They are not laid out to the same system of proportionality as any of the others illustrated here, the width being about equivalent to the length of the head plus the neck. They achieve a harmony of their own.

The breasts are very variously treated. In most cases they are shown discreetly, and in the late examples (5 and 6) rather schematically. In the narrow chested figure (9) they are absent altogether, while in the great monumental figure (8) they achieve a notable fullness.

The joker in the pack is of course the late non-canonical piece (6), the female partner of the hunter-warrior figure. The arms are in a most anti-canonical position and, quite exceptionally, the fingers of the hands are separately modelled, with that somewhat inconsistent attention to detail characteristic of these late pieces.

Cycladic waists and abdomens also vary from figure to figure (plate 101). In the late pieces the waist vanishes entirely, no space being left between the lower arms and the pubic triangle (1 and 4). In other cases the lower abdomen is delineated by a firmly incised line, below which the pubic triangle is placed (2 and 5). Sometimes the abdomen is modelled separately from the hips (2) or no clear distinction is achieved (6). The vulva is sometimes scarcely indicated (3, 6) and only in the non-canonical pieces (where the left arm is below the right) is it emphasized (4).

Even the four pieces belonging to the Spedos variety (2, 3, 5, and 6) show considerable variation.

Cycladic feet (plate 102) correlate closely in the main with the other aspects of the specific variety of figure to which the sculpture belongs. Those of the Kapsala variety are genuinely sculpted in the round (1): they are delicate, with the feet markedly arched. They are not on tiptoe, and the toes themselves are not separately distinguished by incision. Spedos-variety feet (2) are generally separated by the firm cut that distinguishes the lower legs. Those of the Dokathismata variety (3) are narrow and graceful, as one would expect. Those of the Chalandriani variety (4) are broad, and often very short, with a narrow surface on which incisions are made to indicate the toes.

102

FEET

Not reproduced to scale

CHAPTER XIV

THE
GENESIS
OF
MONUMENTAL
SCULPTURE

NO MENTION WAS MADE during the comparison in Chapter XI between the Early Cycladic sculptures and the kouroi and korai of archaic Greek art, of the scale of the former, which are often quite small, generally less than twenty inches in height (see plate 2). Just a few of them, however, as noted in the discussion of their function in Chapter VIII, come close to life-size. These are truly monumental sculptures.

At once one should stress how truly exceptional a moment this is in the story of human representation. Only three other areas on earth can claim life-size, or near life-size, sculpture at this early date, probably before 2500 B.C.

The first of course was Egypt, where life-size statuary in stone and in wood became a frequent feature in Old Kingdom sculpture from the time of the pharaoh Cephren onwards (c. 2570 B.C.). The powerful simplicity of the very earliest of the life-size Egyptian royal statues marks one of the great moments in world art. It should be noted too that, although monumental sculpture in Old Kingdom Egypt has few precursors, there are several slab-like figures, greater than life-size, of the predynastic period from Coptos in Upper Egypt, which must rank as the earliest monumental sculptures known.[1]

The second, perhaps rather unexpected, locality with early monumental sculpture is Malta. In the temple of Hal Tarxien, and dating from its last constructional phase, around 2700 B.C., was found the lower part of a stone figure, probably a seated female, which must when complete have reached some six and a half feet in height.[2] Only the plump legs and the lower fringe of the skirt are preserved. This sculpture appears to be unrelated to those of the Aegean or the East Mediterranean but rather the product of the extraordinary local development of the Maltese temple culture.

The third, more obvious, home of early monumental sculpture is Mesopotamia, although relatively little has been found from so early a date as the Early Cycladic period around 2500 B.C. One notable, life-size head from Uruk, however, can be set several centuries earlier, in the Uruk phase around 3200 B.C.[3]

The infrequency of such cases emphasizes how truly remarkable was the emergence of monumental sculpture in the Cyclades at this early time. Nor was this an early urban civilization, like Old Kingdom Egypt or proto-literate Sumer. It was, as we have seen, a culture of farmers and fishermen who had also become smiths and traders. Their leaders and chiefs were certainly not princes on a Sumerian or pharaonic scale. The palaces of Crete had not yet come into existence.

It is all too easy for us as we switch our attention from culture to civilization, and from millennium to millennium, as we construct in our minds our *musée imaginaire* of human history, to overlook the colossal originality of a step so bold as the representation of the human body at life-size. Thomas Carlyle, although he was writing of a later period, caught something of this in his exhortation:

Transport yourselves into the early childhood of nations, the first beautiful morning light of Europe, when all yet lay in fresh young radiance as of a great sunrise, and our Europe was first beginning to think, to be. Wonder, hope, infinite radiance of hope and wonder, as a young child's thoughts, in the hearts of these strong men.[4]

103
MONUMENTAL CANONICAL FIGURE
Keros-Syros culture
Marble, height 55⅛″

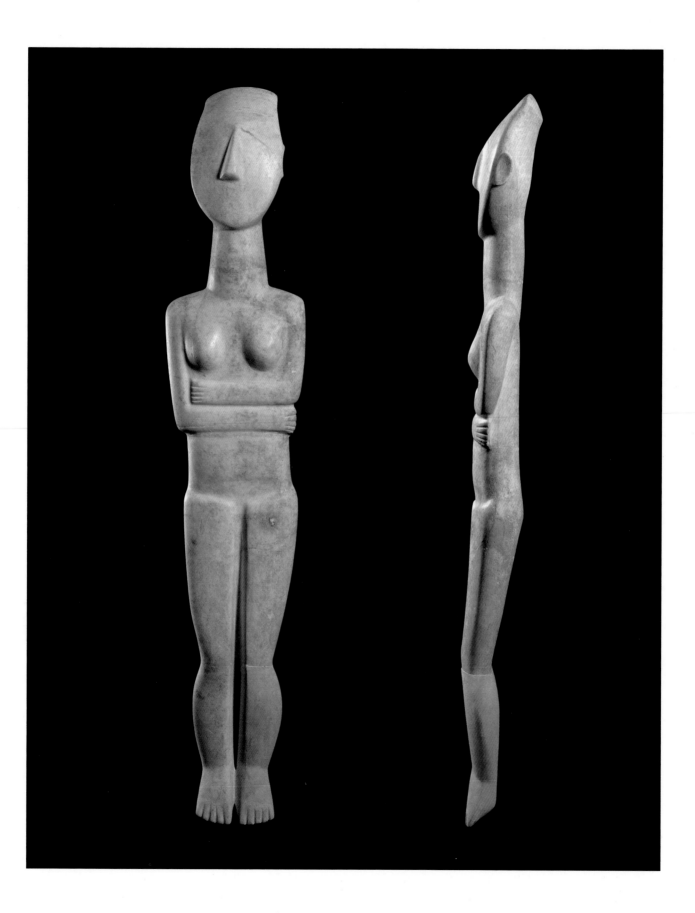

Let us now turn to one of the most notable of these monumental sculptures, a figure in the Goulandris Collection, which stands four and a half feet high (plate 103).

When one first confronts this great sculpture in person, one is at once acutely aware of its sheer corporeality. It is very big and very bold, and in reality also very heavy. It dominates the room in which it stands. The great expanses of flat marble on the surface of the head create a marked simplicity of effect, which any surface treatment would diminish. The breasts are firmly shown in relief, much more pronouncedly so than in most other Cycladic figures. And the powerful simplicity of the pelvic area, where the top of the legs are delineated by careful modelling (but without any incision to emphasize the vulva) reinforces the impression.

The perception achieved when examining a straightforward photograph is a very different one. Unless the scale in the photograph is in some way effectively indicated (and it rarely is), this folded-arm figure is seen instead as of indeterminate size, for there is nothing in the proportions alone to give any indication of its colossal scale.

This figure follows fairly closely what in Chapter XI I termed the convention of "quintile modularity," where the head occupies one fifth of the total length of the figure and the distance from the tip of the toes to the knees is roughly another fifth. The widest point of the body is at the shoulders and the width there is the same modular unit, that is one fifth of the total length. The midpoint of the body, however, is not at a special, anatomically diagnostic point, falling instead some way below the lower (right) arm as it crosses the waist. These proportions are very much those seen in two very much smaller figures in the Goulandris Collection (plates 3 and 74). Many features of this exceptionally large sculpture thus correspond to those of more modest figures. Indeed there is only one detail that might lead the attentive observer to infer from photographs without a scale that this might be a figure of unusually large size: the presence of ears.

It is a curious feature of Early Cycladic folded-arm figures that (apart from the anomalous non-canonical examples with their fussy surface details) ears are shown only on pieces of exceptional size. Such figures will all have stood to a height of some two and a half feet or more. The impressive head from Amorgos in the National Museum in Athens (plate 72) offers one example, as does the beautiful head, also said to be from Amorgos, in the Louvre (plate 124).[5] Not all large figures show this feature, however: ears are notably lacking from the largest figure of all (height four feet ten inches) in the National Museum, Athens (plate 104) and from the impressive figure of the Dokathismata variety (height thirty inches) in the Ashmolean Museum in Oxford (plate 105).[6] But the pattern is nevertheless an undoubted one: ears correlate with monumental scale. They are not found on folded-arm figures of more modest size.

Why this should be we can only guess. It is noteworthy also that on the figure in plate 103 the ears have not been delineated with the same assurance as the rest of the body. Seen squarely from behind, the right ear is set more towards the back of the head than is the left one. This feature may possibly be related to the distinctly perceptible, if slight, turn of the head, which does not face directly to the front,

104

MONUMENTAL CANONICAL FIGURE
Amorgos, Keros-Syros culture
Marble, height 58½"
National Museum, Athens

105

CANONICAL FIGURE
Keros-Syros culture
Marble, height 29½"
Ashmolean Museum, Oxford

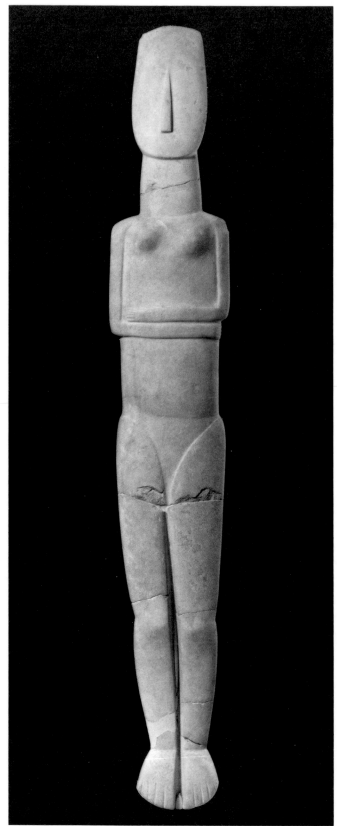

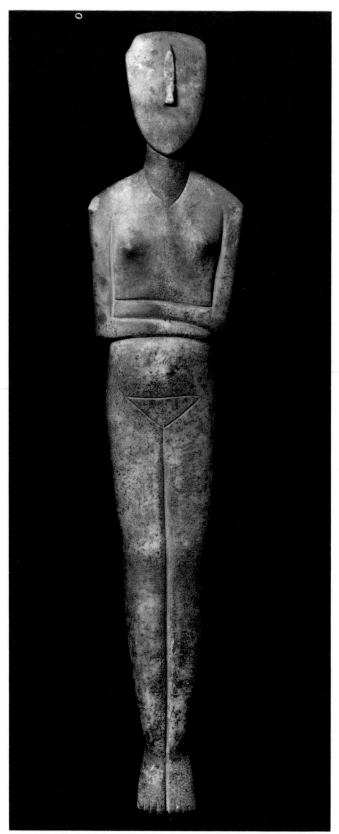

104

105

106
KORE
Athens, Archaic period, c. 560 B.C.
Marble, height 39⅛″
Acropolis Museum, Athens

Reproduced in color, plate 81

but appears to be looking slightly, perhaps by some ten degrees, to the right of center. It is not easy to say whether this effect is a deliberate one or not but it certainly helps to avoid any impression of stolidity in the sculpture, hinting instead at a certain mobility.

To do justice to this major work, a few further details may be noticed. In the first place, the left leg is missing from the knee (and has been replaced in plaster). There is a break also in the left upper thigh and at the right knee. As proposed in Chapter VIII, it is likely that such breakage was not deliberately caused simply to facilitate burial within a Cycladic grave. The alternative implication would be that these figures had a definite use-life before they were buried, as argued in Chapter VIII. And, of course, we have no reliable testimony that any of them in fact come from a grave (although this is perfectly likely): Some at least may have come from contexts of a different kind, such as the remarkable deposit, also discussed in Chapter VIII, found at Dhaskaleio Kavos on Keros.

The looters, however, whatever their competence, certainly perpetrated a barbarous act when, with the aid of a power saw, they cut up the figure, dividing it into five more-manageable pieces (head, upper torso, lower torso, left upper leg, right lower leg), presumably for ease of transport. The careless cut marks left by the saw when it was first applied in error above the waist to the lower part of the right arm are still clearly visible.

One important feature of this figure is the painted decoration that, as noted in Chapter X, may be discerned at the back of the head and neck. With some

difficulty a line may be traced on each side of the head, passing well to the back of the ear in each case. The distance between these lines narrows at the back of the neck and it ends in a curve at mid-neck. No trace of coloration is now visible: All that survives is a thin white line indicating the position of the edge of the once-painted surface. There are some differences also in the surface of the marble inside and outside the painted areas. There was evidently a central tress of hair that came down from the crown of the head (or from the headpiece, if the flat area be so interpreted, as suggested in Chapter x).

Whether there was any painted decoration on the face is now difficult to say. I have the impression that the two pale areas to be seen near the top of the nose, to right and left, may indicate that the eyes were painted in that position, but this is uncertain.

In expressing one's admiration for this monumental work, it is interesting to note how effectively the canon, which we have come to know so well for the smaller figures, works for this great sculpture, more than three times their height. The slight emphasis of the buttocks, the light hollowing indicating the backbone, the general lack of incised detail (other than the normal straight incisions to represent fingers and toes); all of this can also be seen on the smaller pieces, some of which share the same proportionality. They work equally well here, as do the well-modelled calves and thighs and the sweeping curve of the face and the nose. This figure is a *tour de force,* one of the great early sculptural achievements of humankind.

It is naturally appropriate to compare this piece, the second-largest complete figure known, with its counterpart in the National Museum, which is some three inches greater in height (plate 104). Both, of course, are absolutely canonical in posture, but the larger piece does not show the quintile modularity of the Goulandris figure. A different system is used, with the head again approximately one sixth the total length, and with the midpoint set at the line delimiting the lower abdomen. The width, however, is less than the head length. This makes the taller figure seem exceedingly narrow, attenuated almost. The same impression is conveyed in profile: The small head is also exceedingly thin, and it does not in profile convey the same robust presence as the Goulandris figure, which undoubtedly works more effectively as a sculpture in three dimensions.

If we bring into the discussion the large figure in the Ashmolean Museum in Oxford (plate 105), which is thirty inches in height and, as mentioned above, is assigned to the Dokathismata variety, the plastic qualities of the Goulandris figure are further emphasized.[7] For the Ashmolean piece has the flat planes and sweeping lines characteristic of that variety—the treatment of the back is particularly schematic and the effective separation of legs from torso is not achieved, nor indeed sought.

It is instructive also to compare this remarkable work with its most appropriate counterpart from the archaic period: Kore 593 in the catalogue of the Athenian Acropolis, the oldest of the Acropolis korai (plate 106).[8] This piece, already mentioned in Chapter x, is to be set some two thousand years later than the Cycladic one and there is, of course, no direct connection between them. She is

headless, unfortunately, but other archaic sculptures give us some insight into the possible form of the head, which was not like that of the Early Cycladic heads.

Kore 593 retains the material unity of the earliest archaic sculptures. Like the Goulandris figure, she is made from a single marble block and there is no protruding arm as in the later korai. The right arm is at the side holding a wreath. The left is folded across the waist and holds what Gisela Richter identifies as a pomegranate, intended, no doubt, as an offering to the goddess Athena. Indications of red coloring are preserved, as discussed in Chapter x: They are in no way garish, but will have added a crisp precision to the work. It is likely that we should imagine some comparable pigmentation on the face, at least, of the Goulandris figure, where, as noted earlier, the eyes may have been indicated in this way. The arrangement of the hair in Kore 593 is simple, a flat bundle of tresses hangs down upon her shoulders in a single squarish unit. Its form may owe something to the Egyptian hair arrangement, which was certainly the prototype for the hair in the kouros series. In the Goulandris figure the hair likewise hangs down in a single bundle, indicated originally by pigment.

The two pieces are best compared and contrasted when seen from the left, since from this position the arrangement of the arm is closely similar. In both the artist has to convey the bulk and form of the standing human body from a substantial block of marble, where heavy reliance upon surface detail is not appropriate. The backs of the two works present comparable solutions to the problem. In the Goulandris figure there is a slight extrusion at the rear which serves to indicate the position of the buttocks. There is also a flection of the legs at the knees, which gives a lighter effect in the Cycladic piece.

If one wished to characterize the two approaches, bearing in mind the successors to the archaic piece, one might say that the archaic Greek series is concerned with volumes, the Cycladic series also with planes. Some of the korai in Ionic style from the Eastern Aegean, with the whole body draped in a single chiton, are, in their lower part, almost cylindrical: They are like columns of marble. Kore 593, in contrast, is made from a rectangular block, but the body still represents a single mass. In the Cycladic piece, the light flexing of the legs and their separation, as well as the distinct isolation of the neck, contrives to produce a more complex effect. We are impressed as much by the echoing lines (of the tripartite arrangement of feet, calves, and thighs), when seen from the front and by the gentle sloping planes (the front of the thighs, the waist, the sloping forehead, the back, the backs of the thighs and calves) as we are by its mass and volume.

But any sculpture is a balance, a tension between these elements: mass and volume, line and plane. And volume is certainly emphasized in the Cycladic piece, most notably in the rounded breasts, while the drapery in the kore activates the surface and contrasts with the substantial bulk of this great marble block.

Seen in profile, these properties are even more evident. And the later development of each of these two sculptural forms serves further to emphasize the divergence. The later korai (plates 81 and 82) achieve their effects through the interplay of their bodily volumes with the active yet light rhythms of the drapery

on the body.[9] The Dokathismata figures or the large Ashmolean Museum example illustrated above emphasize further sweeping lines and planes. They still do have mass and volume, of course: It is these qualities that ensure their truly sculptural effects, but they are distinctly and successfully dominated by the graceful play of nearly straight lines and of slightly curving surfaces.

I have always thought Kore 593 to be the most beautiful, the most sculptural of all the Acropolis korai. The surface treatment of the robes is not exaggerated and the volume and sweep of the underlying body is keenly felt. She represents a turning point in the art of archaic Greece and a masterpiece of the period. It is interesting, therefore, to see how easily and naturally she accepts comparison with the fullest and most accomplished of our monumental Cycladic sculptures. Balance, harmony, and restraint are qualities possessed in ample measure by both pieces. Both achieve that near-miracle for which Pygmalion was celebrated by the ancient Greeks: the life-size representation of the human form. The block of marble, hewn from the quarry, takes on proportion and balance until the point is reached when it achieves a presence. *Alma presente!* Pygmalion, it is reported, fell in love with his own creation. What an achievement, to create in stone and in life-size scale and proportion, the human corporeal presence! Who can blame him?

CHAPTER XV

ACTION

AND

IMMOBILITY

THE MONUMENTAL DIGNITY OF some of the greatest of the Cycladic sculptures might lead one to the view that this was an art of hieratic (or divine) immobility. That everything is fixed, dignified, and intensely still, as is so often the case with Egyptian monumental sculpture. The impression could no doubt be reinforced by the dominance of the folded-arm canon, whereby the figures are nearly always shown in the same tranquil position.

To form this view could be to overlook some of the most delightful works of Cycladic sculpture, which offer an entirely new dimension to our appreciation of the Cycladic spirit.

All of these more vivacious works are small in size, generally less than ten inches high. There is no doubt one very good technical reason for choosing a position of immobility for a canonical form that is also to be applied to a large figure. This is the risk of breakage to the marble.

In her informative article "Risk and Repair in Early Cycladic Sculpture," Getz-Preziosi has emphasized the technical problems faced by the sculptor in carving these pieces, and has suggested that many were broken during the process of manufacture.[1] Hence, as discussed in Chapter VIII, the indications in many cases of repair. It may be, as I have argued, that many of these pieces were broken in use rather than during manufacture, yet the point is still a valid one. It was emphasized by Elizabeth Oustinoff's experience in making a canonical figure using ancient working materials: the figure broke at the head at an early stage.[2] This led her radically to reorganize her sculpture. What was to have been a figure ten inches long was reduced to six and a half inches, and the front and back were reversed for technical reasons.

These problems naturally face any artist producing monumental sculptures in stone. One of the reasons, no doubt, for the adoption by the Greeks of the Egyptian figure as a model for the kouros form was its effectiveness in representing the body within a coherent, economical, dense block of stone. Precisely the same may be said for the canonical folded-arm form: the arms hug the body, the legs are together, and there are no protruding limbs to be broken off. We saw in Chapter XI that the korai of the Acropolis, with their more ambitious position of the outstretched right forearm, were frequently subject to the damage and loss of this part.

Technical considerations, then, may have restricted the scale of the more active Early Cycladic figures with their outstretched arms or their separated legs. But accepting that these are all small in scale, they have a delightful freshness and immediacy of appeal.

One of the most charming is a seated figure in the Goulandris Collection (plate 1). The left forearm is across the stomach as in the folded-arm figures. But the right arm comes forward and the hand holds a cylindrical cup. There is no indication of sex: the breasts are not shown, and the figure may thus be male. He is seated upon a simple, four-legged stool. The head differs from those of the standing figures in that the chin comes much further forward from the neck. This is because the head is evidently conceived as tilted upwards while in the standing figures, despite the backward slope of the forehead, the head is upright, the face

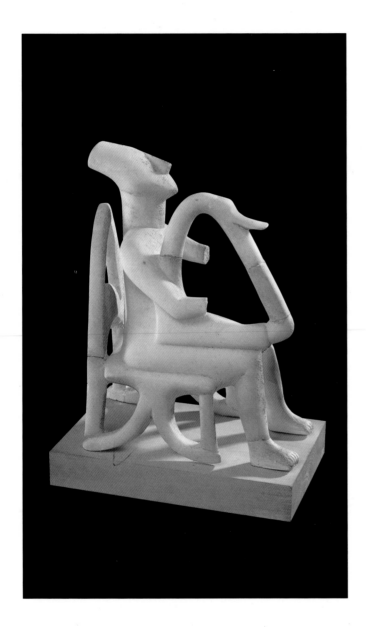

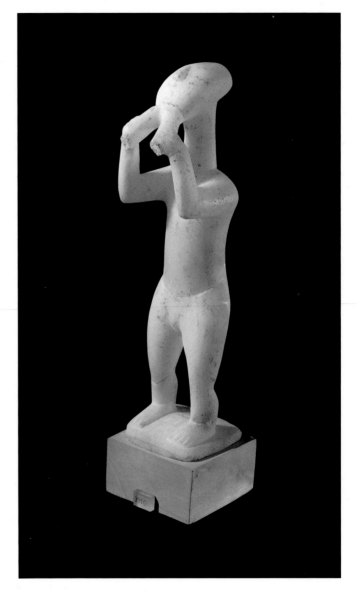

107
HARPIST
Keros, Keros-Syros culture
Marble, height 8⅞″
National Museum, Athens

108
FLAUTIST
Keros, Keros-Syros culture
Marble, height 7⅞″
National Museum, Athens

vertical. The gesture might be conceived as one of offering rather than of simple convivial drinking. In any case it is a sculpture of *gesture*. It has great dignity despite its small size (six inches).

It is of course the forward gesture of the right arm that carries with it the greatest risk of breakage. Remarkably the arm is undamaged: the only break is at the neck, repaired in recent times.

This delightful piece at once invites comparison with other known seated Cycladic sculptures, notably the harp players, of which there are several. The example in the National Museum, Athens, (plate 107) is said to have come from Keros, with its accompanying piece, a standing figure playing pipes (plate 108). As they were first documented in 1884 there is no reason to doubt their authenticity.[3] Both figures are male. The harpist again has the head tilted back so that one imagines he is singing. Two very comparable harp players in Karlsruhe were documented in 1838 and must likewise be genuine.[4] The form is thus, as so often in the Cyclades, established as a "type," which occurs in several versions. This in no way reduces the freshness of the composition: The impression is one of great alertness, with the figure seated bolt upright.

The accompanying piece from Keros is a standing male, the legs apart, each hand holding a pipe to the mouth. The form is again documented by several little marble bases from Dhaskaleio Kavos on Keros that may have supported figures very comparable to this, although they are, alas, broken at the foot.[5]

The realization that these figures also generally fall into well-defined types allows us to complete in our minds a broken piece in the Goulandris Collection that might otherwise be overlooked (plate 109). Inspection shows that the arms come forward from the torso: The form compares well with the Keros flautist, and this is probably what he was.

Together these musicians convey great vitality. As noted earlier, they might have been conceived as offering pieces for use in ritual ceremonies. Alternatively we might see them simply as sculptures. In any case they certainly convey an infectious *joie de vivre*.

Other seated figures are known. Some are simply seated in the folded-arm position upon a stool: One from Aplomata on Naxos is similar, but with one leg crossed over the other at the ankle.[6]

There are also double figures, standing side by side, each with an arm on the shoulder of the other. One such piece in the Goulandris Collection, already mentioned in Chapter x, has been broken, so that only one of the two figures is preserved: The arm of her companion is still clearly visible, however, extending across her back (plate 62). This may be compared with a larger piece in the British Museum.[7]

Another form of double figure, mentioned earlier, is particularly interesting: Here a smaller figure stands upon the head of the larger, both maintaining the canonical folded-arm position. A complete version of this type, first published in 1835, is preserved in the Badisches Landesmuseum in Karlsruhe.[8] A fragment of this type, just the head of the larger figure with the feet standing upon it, is in the Goulandris Collection (plate 60), and another is in Copenhagen (plate 59).[9] Quite

what these two standing figures are doing is a matter for speculation. The most plausible suggestion is that they are "acrobats," and that their acrobatic performance, like the sound of the pipes and the singing to the notes of the harp, may have formed a part of the rituals in which we have suggested the canonical figures were used, and which they may in such cases also reflect.

Beyond the human form, one might have expected the keen eye and liveliness of expression of the sculptors to have resulted in a major series of vivacious animal sculptures. Such is not the case, however. Animal sculptures are rare in Early Cycladic art. A container in the form of a pig (plate 110) in the Goulandris Collection may be compared with another marble quadruped in the Ashmolean Museum.[10] These are the only marble animals we have. There are also several small beads in various colored stones from the Grotta-Pelos culture: some are in the form of animals, mostly birds. The outstanding work that incorporates living forms is a handsome marble flat-based dish containing a perch straight across the interior upon which sit sixteen doves, the whole carved from a single piece of marble (plate 112). Some of the doves are broken, and a further broken dove, which does not belong to this almost complete bowl (plate 111), shows at least one other vessel in this form must have existed. Originally eight of the doves faced in one direction and eight in the other, in such a way that all were facing in a counterclockwise direction. When one realizes this — and it is far from obvious, since most of the doves are badly damaged — the whole sculpture takes on a restrained circular movement. Further broken doves have been recovered from the site of Dhaskaleio Kavos on Keros, suggesting that this almost complete piece may also have been taken from that site.[11] In John Taylor's photograph the vessel is shown containing barley at which the doves are pecking: This reflects its likely original use as an offering vessel.

Marble was the preferred medium for representing the human figure at this time: There are no terra-cotta figures from the Cycladic Early Bronze Age. Animal figures of clay are also exceedingly rare. As noted in Chapter XI, the charming pottery bear from Syros (plate 83) is not simply a "one-off" spontaneous creation, for it is matched by a fragment from the settlement of Aghia Irini on Kea and by another from Naxos (plate 84).[12]

Some of the small marble "action" sculptures are indeed masterpieces. While the "acrobats" are, to our eyes, a little stiff and scarcely succeed in conveying movement (if such was their intention), the harpists from Thera and Keros and the seated cup-bearer are triumphantly successful. In each case the movement is a tranquil one: This is not the exuberant physicality that emerged later in fifth-century Athens (for instance with the Discobolus) nor the frenzied tension of the succeeding Hellenistic period (for instance in the Laocoön). It is the gentle play of the harpist's hand, the rhythm of the flautist, the timeless gesture of greeting or offering of the seated figure.

Pleasing and admirable in themselves, they offer a new dimension to our understanding of the standing figures. Against a background of such vitality, their immobility may be seen as intentional. It is not the stiffness and rigidity of the inexpert craftsmen: It is something deliberate within the Cycladic canon.

109
FRAGMENT (TORSO) OF A FLAUTIST
Keros–Syros culture
Marble, height 5″

110
VESSEL IN THE FORM OF A PIG
Grotta–Pelos culture
Marble, length 5″

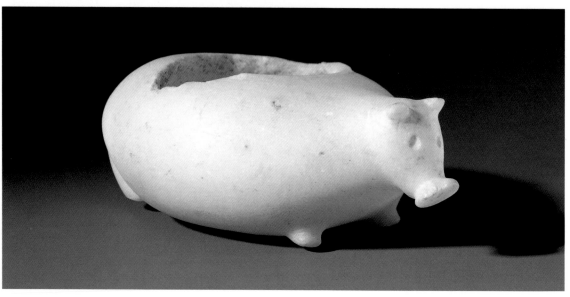

III
DOVE
Keros-Syros culture
Marble, height 1⅝″

This dove appears to have been broken
from a bowl like that in plate 112

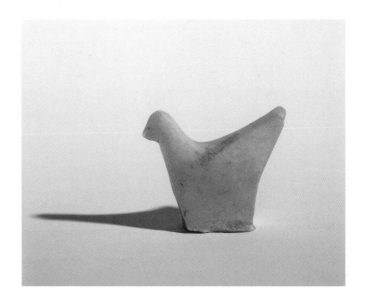

112
DOVE BOWL
Keros-Syros culture
Marble, diameter 15⅜″

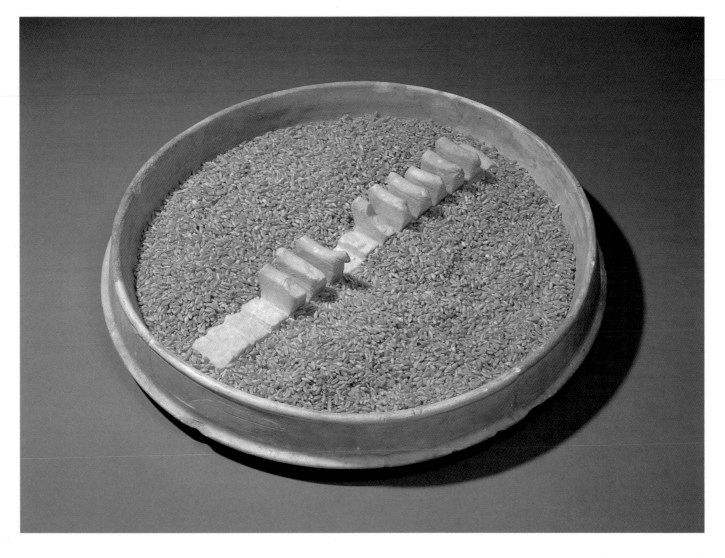

CHAPTER XVI

THE
EYE
OF
THE
BEHOLDER:
CYCLADIC
ART
AND
MODERN
TASTE

All art originates in the human mind,
in our reactions to the world rather than in the visible world itself,
and it is precisely because art is "conceptual"
that all representations are recognizable by their style.

E.H. GOMBRICH, *Art and Illusion*

WHEN PAUL WOLTERS REPORTED in 1891 the discovery of an almost life-size head on the island of Amorgos, he described it as "dieser abstossend hässliche Kopf" ("this repulsively ugly head")—a judgment most of his contemporaries surely would have endorsed.[1] Today it is one of the treasures of the National Museum in Athens (plate 113) and we can admire it for the qualities that it shares with other Cycladic works as well as for its unusually well-preserved painted decoration.

So rapid a reverse in taste is at first sight rather astonishing. How is it that in less than a century something that is first seen as "repulsively ugly" comes to be acclaimed as a masterpiece, commanding the respect and admiration of artists and of the general public? Wolters's head would certainly command more than a million dollars on the art market of the early 1990s.

To answer this question will go a long way towards solving for us the Cycladic enigma presented in Chapter I: How is it that these works from the dawn of European civilization compete for our attention and respect with the most sophisticated works of contemporary art?

Wolters's statement demonstrates for us, if demonstration were necessary, that there are no universals in aesthetics. But there are, nonetheless, wide areas of agreement as well as fashions of taste that command considerable assent. Today there are few people in the Western world among those who take an interest in the visual arts who fail to respond to Impressionist and Post-impressionist painting, while Van Gogh found it difficult ever to sell a painting in his lifetime.

To make better sense of Wolters's view, and our own, it is germane to focus upon the very concept of a "work of art" as a thing in itself. It is obvious to us that there are some objects of particular worth, the creations of exceptional, almost godlike persons, that are often set within a showcase or on a pedestal in a museum. They are singled out for our respect as something special, remote, apart. They are invested with a mysterious worth. It is pertinent to examine our relationship to these works and to ask how much of our reaction to them is due to ourselves and our perceptions; how much to qualities that are actually inherent in the work, set there deliberately by the artist.

At the outset one should record the obvious point that the craftsmen who made these sculptures probably had no concept whatever of the "work of art." The notion of an object, aestheticly pleasing in its own right, and to be admired in isolation, quite possibly with no other function, may well have been quite foreign to them, just as it is in many communities outside the Western world today.

It is necessary therefore to examine our own response and that of our time to works that we esteem as seriously interesting or beautiful—as worthy of our contemplation. In doing so, we may identify some of the preconceptions that may

have barred others, as they did Wolters, from enjoying such works. At the same time, such an exercise could lead us to conclude that we are placing great emphasis upon qualities that their original makers may not greatly have valued.

These two steps may open the way for a further consideration of how the Cycladic canonical figures communicate their message. For while that message may never be available to us — the *meaning* of these works, as understood within their own society, can never completely be recovered — it may well be possible to give some closer appreciation of how it was conveyed. This may bring us nearer to seeing what it is that we most admire in them.

OVERCOMING THE TYRANNY OF THE RENAISSANCE

"There is no excellent beauty," said Francis Bacon, "that hath not some strangeness in the proportion." This observation, while reasonable enough in itself, carries with it assumptions so pervasive that it took the whole modern movement to question them. For Bacon, while conceding the virtue of "some strangeness," is clearly assuming that there are widely accepted norms of representation.

That "right way" was very much a creation of the Italian Renaissance, drawing upon the Classical ideal formulated in ancient Greece and propagated by the Romans. For the Greeks in the fifth century B.C. achieved a special kind of perfection in representing the human body, notably in sculpture, such that any other approach, any other style, came to look odd and ill-shapen to the cultured eye (that is to say, to the eye enculturated by the Greek vision). There is no doubt that the Greek way of viewing the world, especially the human body, is still part of the visual inheritance of most of us, "our own Greek training" as the art historian E. H. Gombrich puts it.[2] For most readers of this book, almost the only illustration that looks naturalistic will be the Kritios Boy, a statue from the early Classical period (plate 91). It was carved at just the point that Greek sculptors achieved that classical, ideal vision of the human form that has ever since appeared the norm.

The Classical world declined in the fourth century A.D., and visual conventions with it. During the period of Byzantine art that followed, different ideals operated (and there were at this time almost no representations in stone of the human body). For precisely this reason — the departure of Byzantine art from the Classical norm — the Byzantine style fell, for a long period, into low esteem when Classical art was being rediscovered and reestablished by the sculptors and painters of the Italian Renaissance.

The discovery of such "classic marbles" as the Apollo Belvedere, now in the Vatican museums, encouraged Renaissance artists to create a visual world that could accommodate the Classical norm. And they did more: By developing a coherent system of perspective (raised to an end in itself by painters such as Uccello) they established a new convention of seeing, or at least of representing what was seen, so that any other seemed archaic, or barbaric, or primitive.

So while Bacon might permit "some strangeness" in the proportion, he would no doubt have been horrified, as were most critics of the day, when the early exponents of the modern movement, such as Picasso in 1907 with *Les*

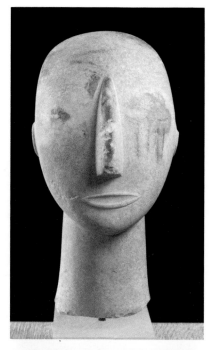

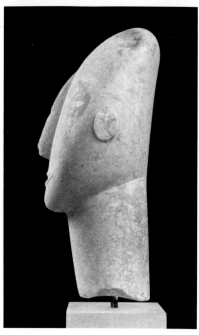

113
HEAD OF A CANONICAL FIGURE
Amorgos, Keros-Syros culture
Marble, height 11⅜"
National Museum, Athens

This is Wolters's "repulsively ugly head"
Reproduced in color, plate 72

114
BAKOTA GUARDIAN FIGURE
Gabon, West Africa, late 19th century A.D.
Wood, copper, and brass, height 21″
University of California Museum of Cultural History, Los Angeles

115
BAKOTA GUARDIAN FIGURE
Gabon, West Africa, late 19th century A.D.
Wood, copper, and brass, height 30″
Ethnographic Museum, Geneva

Demoiselles d'Avignon (Museum of Modern Art, New York), deliberately broke with the conventions of the traditional norm and set out to establish new conventions of their own.

Paul Wolters, writing in 1891, was under the spell, the tyranny of the Renaissance and Classical Greece, and for him, any self-respecting head would not look too different from that of the Kritios Boy, or a sculpture by Michelangelo or Bernini.[3] For nearly all of his generation, as for many still in ours, the work of most other cultures was "barbaric." The sculptures of Africa could be classified as "primitive art," and those of the early Cyclades could be set along with them and valued little.

Yet if we look at Dogon or Bambara heads from West Africa, we see in them today several kinds of elegance and readily recognize the expressive force within them. They are not in any very meaningful sense "primitive": The use of such a term simply implies the judgment, perfectly correct in itself, that they do not form part of the Greek-to-Renaissance tradition of the West.

The Bakota reliquary figures of Gabon (plates 114 and 115) offer an instance where the style, although remote from Western experience, clearly had a coherence of its own, with a formal language as sophisticated as in any Greek work.[4] In each Bakota reliquary the body is shown by an open lozenge and the head indicated by a central oval sheet, flanked on each side by a flat sheet of metal, and with a crescent of metal above. The schematization of the face is notable, yet the convention left plenty of room for variation in the facial features.

Picasso owned two Bakota reliquary figures (in his very extensive collection of African art). That he was influenced by African art in 1907 when he painted *Les Demoiselles d'Avignon* cannot be doubted, but this does not imply that his work was in any significant sense derivative of it. He himself stated that "the African sculptures that hang almost everywhere in my studio are more witnesses than models."[5] It can be argued that it was the liberation from traditional Western conventions that these pieces collectively offered rather than specific individual motifs that played the significant role, as "primitive" art had for other artists before him, most notably Paul Gauguin. Picasso's rupture, in the early years of the century, of the prevailing conventions of representation, which he had been content to follow in the "rose" and "blue" periods of his youthful work, is one of the most crucial in the history of Western art.

Amedeo Modigliani, although we may think of him as a painter, considered himself first a sculptor.[6] His elegant, elongated heads (plates 116 and 117) have earned a secure place in the Western tradition. As he carved in stone, his use of the notion of the caryatid supporting a considerable mass on top of the head inevitably has for us resemblances with Classical Greek precursors. But he too was liberated from the tyranny of the Renaissance, in part by his experience of the "primitive art" of other cultures. Like the Bakota reliquaries discussed above, his sculptured heads conform to an apparently well-defined internal convention that, along with the emphasis on the nose and the general absence of surface detail, gives them elements in common with Cycladic heads.

Constantin Brancusi explored the purest forms—a male torso made of cylinders of brass, the human head as an ellipse.[7] That the liberating influence of

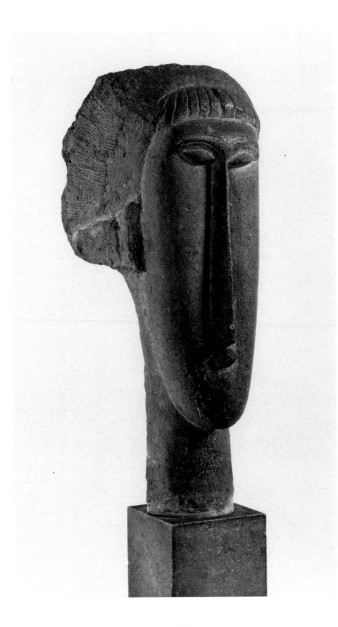

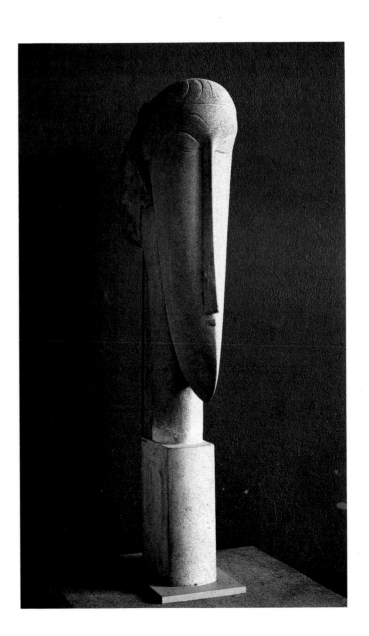

116

HEAD OF A WOMAN

Amedeo Modigliani, c. A.D. 1911

Limestone, height 25½″

National Gallery of Art, Washington, D.C.

117

HEAD

Amedeo Modigliani, A.D. 1913

Limestone, height 24¹¹⁄₁₆″

Victoria and Albert Museum, London

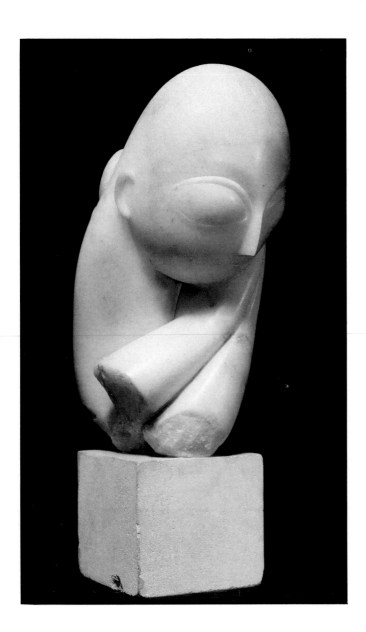

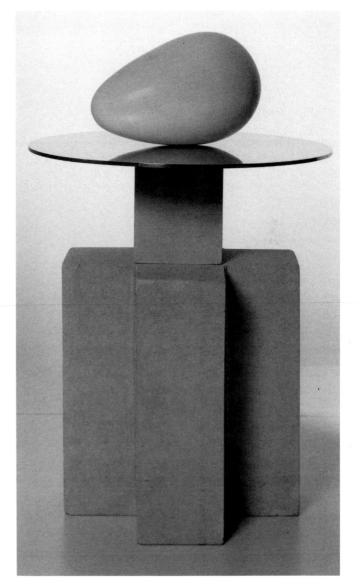

118
MADEMOISELLE POGANY
Constantin Brancusi, A.D. 1913
Marble, height 17¼″
Philadelphia Museum of Art

119
THE BEGINNING OF THE WORLD
Constantin Brancusi, c. A.D. 1920
Marble, height 7″
Dallas Museum of Art, Texas

African art was felt in his work is also well documented.[8] Several of his heads, notably some of the versions of *Mlle. Pogany* (plate 118) are, in their sweeping lines and extensive plane surfaces, reminiscent of Cycladic heads, including the head from Amorgos so castigated by Wolters. Indeed Henry Moore wrote, "I'm sure the well-known Cycladic head at the Louvre [plate 124] influenced Brancusi and was the parent of his sculpture, that simple oval egg-shaped form he called *The Beginning of the World* [plate 119]."[9] It was Brancusi's genius to discover and evoke the underlying structure of the living world in the simplest of forms. The Cycladic sculptors had a view of the world that was in some ways analogous.

Today, of course, it is easy for us to observe that a work by Brancusi resembles a Cycladic sculpture. But we may just as easily feel that a Cycladic work looks like a Brancusi.

THE IDEA OF THE WORK OF ART

In 1910, at the Armory Show in New York, that strange genius of our century, Marcel Duchamp, struck what was intended as a blow against the pretensions of the contemporary art world, which places "art" upon a pedestal and proceeds to deal in it as a valuable and potentially profitable commodity. He purchased two commonplace, everyday objects, both of rather striking form, and placed each upon a pedestal, presenting it in this way as a work of art, as a work entered for the exhibition. One was a bottle rack of angular design, the other a urinal. These were Duchamp's famous ready-mades.

Today his action seems one of the most interesting and revealing artistic acts of the modern movement, for it opens in a profound way the whole question of the nature of the work of art.[10] Duchamp's act forever changed the accepted definition of a work of art, and that change has a direct relevance, I think, for our perception of Cycladic art and indeed for other prehistoric symbolic expressions as well. For it is *we* who place these objects upon the pedestal within the museum, and classify them as works of art. An everyday pyxis, even simple tools of obsidian, become artworks presented for our contemplation, just like the bottle rack and the urinal in the Armory Show. As Duchamp put it, "It is the *observers* who make pictures."[11]

It was André Malraux, in his illuminating work *Le Museé Imaginaire,* who drew a useful distinction.[12] He discussed those objects that are works of art *by destination*, that is to say were made to be works of art, destined for the art world, like all the easel paintings and most of the sculptures in the Western world since the eighteenth century. And he contrasted with these those pieces that were works of art *by metamorphosis.* That is to say, they were made with some quite different purpose in mind. By placing them in the art gallery, upon their pedestals, we have *transformed* them into works of art. Clearly there could be no more apt description of the fate of Cycladic sculpture.

It is perhaps not very widely appreciated today that the concept of "work of art" is of relatively recent origin. The ancient Greeks accorded no particularly high status to artists, although they admired their works. They were merely artisans. As Plutarch put it in his *Life of Pericles*: "No gifted young man, upon

seeing the Zeus of Pheidias at Olympia ever wanted to be Pheidias nor, upon seeing the Hera at Argos, ever wanted to be Polykleitos. . . . For it does not necessarily follow that, if a work is delightful because of its gracefulness, the man who made it is worthy of our serious regard."[13] Or as Lucian put it: "All will praise your art, but not one of those who see your art, if he were in his right mind, would pray to be like you. For this is what you will be: a common workman, a craftsman, one who makes his living with his hands."

In medieval times the artist was a craftsman, and his work could certainly be admired just as one might admire a well-made piece of furniture. The "master-piece" was simply the special piece of work by which an apprentice craftsman showed that he had reached the necessary professional standard, not very different perhaps from the diploma work in a modern art school. There was no suggestion of sublime excellence. Jean Gimpel, in his illuminating tract against commercialism, *The Cult of Art,* has shown that the notion of the artist as a person of special, sometimes almost divine, status is very much a creation of the Italian High Renaissance.[14] From then on the artist was a special figure: Michelangelo was called "divine" in his lifetime. The romantic notion of the *"peintre maudit"* supported this idea that art was a special creation of *"la vie de Bohème."* The notion of "Art for Art's sake" was fully developed only in the nineteenth century. It is pertinent to realize how recent a phenomenon the cult of the artist is, even if there have been other cultures also (ancient Rome, Imperial China) where notable works have been very highly valued.

We must be careful then in admiring Cycladic works, not to imagine that they enjoy any independent or unchallengeable status as works of art. It is *we* who classify them as such. The work of art is defined by the observer, in that act of metamorphosis that, by setting it apart for contemplation, confers upon it a special status.

Today, in defining the work of art as an artifact that is set aside for contemplation, we assign a special and very much more active role to the viewer, for it is by his or her deliberate contemplation that the object becomes a work of art. The sculpture does not transmit its ideal and timeless qualities to us and they are in no sense *inherent* in the work; it is *we* who find them there.

SIMPLICITY
AND
SEVERITY
IN
WESTERN
ART

O seule et sage voix
Qui chantes pour les yeux!

PAUL VALÉRY, *Cantique Des Colonnes*

IF WE CONTEMPLATE THE large Cycladic head in the Goulandris Collection (plate 120), we may gradually come to feel what Paul Wolters could not, that we are in the presence of what is for us a major achievement, a very considerable work of art. The simplicity of the form does not become trite as we look, nor do the elements separate themselves in such a way that they might adequately be described in words and so dismissed. The qualities appear to us to be immanent ones, residing tranquilly and with authority within the marble.

As I have said, it is the deliberate activity of contemplation of the work by the observer that produces meaning and aesthetic pleasure. Meaning is constructed in the mind now, in the present, at the time it is experienced. It is not predetermined, or not entirely so, by the form of the work. We must be careful then not to project into the object of contemplation or to assign to it all of those qualities that are present in our minds at the moment of contemplation.

Thus when we find that these works of more than four thousand years ago seem to speak to us deeply about the human condition, we need not suppose that they provoked the same patterns of thought in the minds of their makers. Their "meaning" then, as it was consciously intended and perceived, may have been very much more straightforward, practical, and prosaic. What did those early sculptors care for the long span of human history? And what did they know of it? Far more likely that they firmly believed in some creation myth, some early yet detailed cosmogenic narrative, just as did most thinkers in the Western world until the development of evolutionary thought in the nineteenth century.

For the creators, and for the first viewers who saw these works, the most remarkable achievement that they embodied must surely have been the very act of *poesis*, of creation, of producing an image, an icon, a likeness of near-natural scale in this enduring, flesh-white material. No doubt in each culture that comes to produce life-size sacred images, their first production must in the same way have carried with it something of the marvelous, almost of the miraculous. For us today, with the cross-cultural perspective afforded to us by the perusal of our personal *museé imaginaire*, something more is implied. We situate them early in the history of sculpture and are impressed by their precocity. It comes as a shock that these products of the sculptor's craft should have achieved with such authority that very simplicity that we may feel is the culmination of our own twentieth century tradition in art.

It takes great sureness of hand and mind in a work of art to simplify: to pare away, until almost nothing is left, and yet at the same time to leave the essential, the basic form, the key idea, still present and undiminished. In broaching this topic, it is difficult to avoid using the language of the Greek philosophers, notably of Plato, who was one of the first to develop the distinction between the outward form of things and their deeper significance. As he conceived of things, there is a

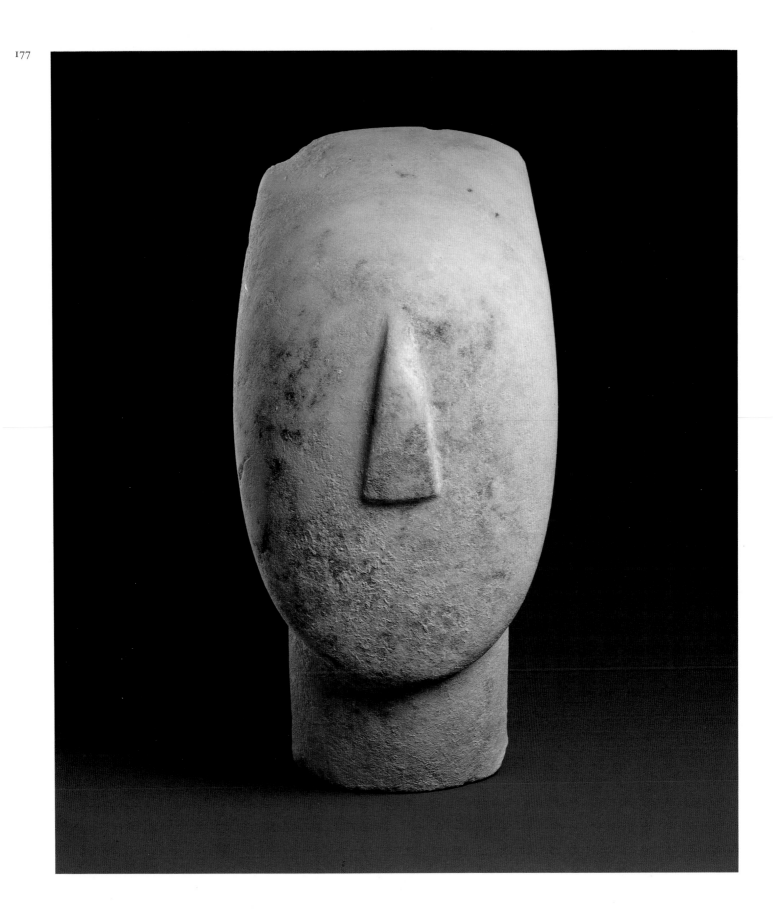

deeper reality underlying the imperfection of the forms of the real world. But this
concept of the ideal was not directed primarily towards aesthetic issues in the
visual arts that we have now begun to discuss. It arose from his more general wish
to penetrate, as a philosopher, beneath the superficiality of appearances.

There is perhaps a tendency for us today to link in our minds the Greek quest
for *symmetria*, the principle of balance and proportionality in visual art discussed
in Chapter XI, with this broader Platonic notion. The Platonic approach is in
sympathy with the Pythagorean view that numerical regularities and harmonies
underlie many of the basic properties of the natural world. This in turn antici-
pated many of the developments of the scientific revolution of more recent times,
from Newton to Einstein. The notion that mathematics is the queen as well as the
servant of science sustains much of modern theoretical physics. But while
Pythagoras himself was indeed concerned with the physical aspects of sound and
of harmony in music, there is little evidence that Greek artists were seeking to
achieve in their work the expression of any especially meaningful simplicities of
form, other than those proportionalities in architecture or the representation of
the parts of the body that were discussed in Chapter XI. So it may be a mistake to
see in the Greek preoccupation with canonical proportion (or its Cycladic prede-
cessor) any desire to reach some ultimate simplicity of form. They certainly did
not attribute to the process of abstraction the same values as we do today. Indeed
the notion of abstraction in art may have been foreign to Greek thought.

The deeper and wider notion that the infinite variety of shapes in the visible
world can be reduced to a limited number of simple forms now in popular
currency was instead very much the creation of some of the most influential critics
who promoted the modern movement early in this century, such as Roger Fry
and, later, Herbert Read. In those early years of modernism, it became common
to believe that it was the role of the painter or the sculptor in creating the work of
art to capture the pure forms underlying the complexity of things. Great artists,
from Raphael, with his balanced compositions, to Brancusi, with his harmonious
and simplified shapes, were felt by such critics to have succeeded particularly well
in giving expression to these significant forms. Such ideas as these naturally
encouraged an interpretation of the meaning of the simplification and abstraction
of form that would be quite foreign to Greek art in the Classical period.

We tend to see such abstraction as a notable tendency in Early Cycladic
sculpture, and not without reason. As noted earlier, something of the same
quality is apparent to us in archaic Greek art and in the same way, for many people
the work of the so-called "Italian primitives" is more appealing than that of their
successors in the High Renaissance. But the subsequent development of Greek art
was away from the elemental simplicity of the archaic period, towards a natu-
ralism that itself at times gave way to mannerism, just as the Baroque succeeded
the Renaissance. Within the chronological development of Cycladic art, there
appears to have been a movement away from naturalism. The folded-arm figures
of the Kapsala and then the Spedos varieties probably succeeded the Plastiras form
with its greater attention to detail. It is believed that the early Spedos variety was
followed in turn by the Dokathismata variety, which represents Cycladic sculp-

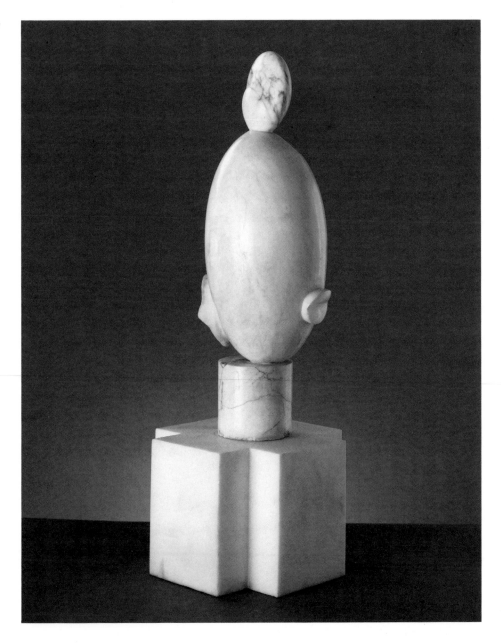

121
WHITE NEGRESS
Constantin Brancusi, A.D. 1924
Marble, height 19″
Philadelphia Museum of Art

ture at its most "stylized," that is to say, with the greatest emphasis upon sweeping line and simple, planar surfaces.

One of the major developments in the art of our own century has indeed been the acceptance of abstraction as an autonomous form of expression. The notion that an artist might deliberately choose not to represent visually any specific scene or object in the real world was one of the great intellectual steps of the early years of our century. In the paintings of Wassily Kandinsky, for instance, in the years from 1905 to 1912, one can see the vigor of line and color increasing while the figurative element of the composition becomes more and more difficult to discern, until finally there is no such component. Suddenly we find ourselves

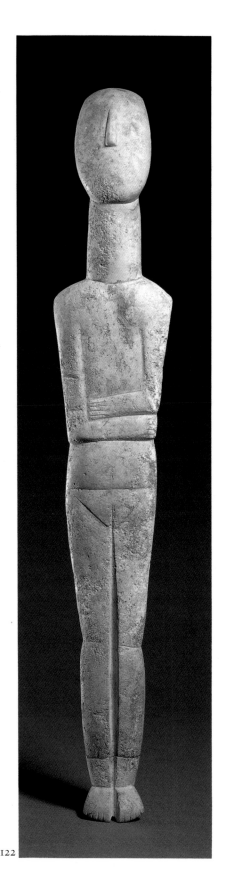

free, cast off from the constraints and conventions of figuration. This was a process of abstraction, in which the underlying forms, which had indeed first been perceived through the visual experience of the real world, were allowed to dominate, until the actual configurations of that world were lost altogether.

As Herbert Read once pointed out, there is an opposite approach in non-representational art to the process of gradual abstraction just described. He termed it "parthenogenetic," implying that the forms are, as it were, the product of a virgin birth. They come into being without the mediation of shapes learnt from the external world; they are constructed. For example Kazimir Malevich, the Russian Constructivist, was an early exponent of this approach, and in his work the lines and squares are used to create a pattern that does not mimic the objects or landscapes of the real world.

Such a conceptual approach as this was however the exception among the early masters who heralded or who introduced the modern movement. Paul Cézanne, for instance, although he remarked that all art aspires to the circle, the sphere, and the cube — a very appropriate statement for the great precursor of the cubists — was certainly not an advocate of the parthenogenetic in this sense. His work sought to distill the superfluous from reality to leave the essence. Even Piet Mondrian, whose later art, with its rectangular grid and primary colors, certainly appears parthenogenetic, developed his style through the progressive dissection and simplification of the real world.

Interestingly, the pure mathematical forms, the sphere itself, the cylinder, and the cone — the Euclidian bodies — have not usually proven helpful when they have been directly incorporated within sculptures, just as compilations of circles and triangles in geometric configurations have not made good paintings. In themselves they seem cold and mechanical. So far those sculptors and painters who have used them systematically and logically for visual effect have achieved few compositions that are not visually rather obvious and ultimately trivial.

Turning again to our Cycladic head in the light of these issues of abstraction and representation, we see that it is indeed reduced to essentials. But these essentials are not simple geometrically definable forms: spheres, ellipsoids, or cylinders. There is nothing parthenogenetic about the way the forms are arrived at.

The neck, then, is not a cylinder, nor can the head easily be described in some geometrical formulation. Yet it is of considerable simplicity: a single topological surface with the addition of the straightforward triangular nose. That nose is an uncomplicated protuberance, a flat plane, roughly parallel to but raised above the plane of the face and demarcated by three straight lines.

Seen from the front the face makes a beautifully smooth, elliptical curve, with just the faintest out-turning at the crown. We have then what comes close in appearance to an ellipsoidal surface, with smooth curves, but which never quite achieves that degree of regularity. On it is set firmly but not aggressively the clear triangle of the nose.

It is highly likely that eyes were painted onto the face, although no trace survives of them now. They would have been part of the finished work. But we

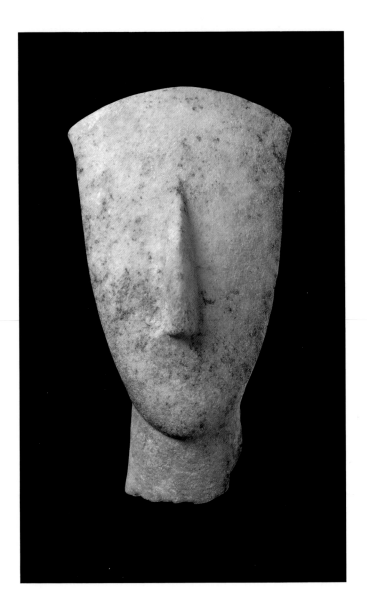

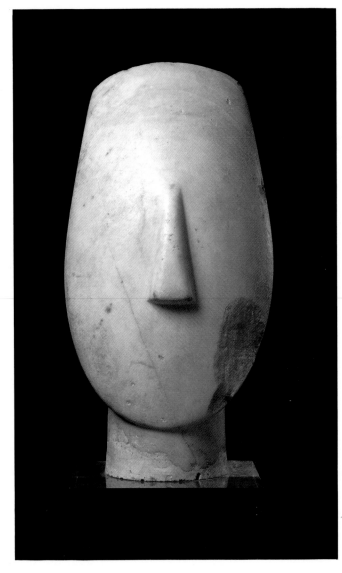

123

HEAD OF A CANONICAL FIGURE

Keros-Syros culture

Marble, height 3¹¹⁄₁₆″

124

HEAD OF A CANONICAL FIGURE

Keros-Syros culture

Marble, height 10⅝″

The Louvre, Paris

122

CANONICAL FIGURE

Keros-Syros culture

Marble, height 28⁵⁄₁₆″

may at this point disregard them, for they were not part of the primary work for the sculptor (even if he personally may have added them at a later stage). When he was actually carving and smoothing this head there were no eyes, just as there are none now.

In profile the head has a wonderful, sweeping grace achieved largely by means of its flowing uninterrupted lines. At the back of the neck there is a straight vertical sweep that curves rather suddenly at the crown. The face has a simple open surface that curves more steeply at the forehead than lower down: The progress of this curved surface is transformed, when seen from the side, into a sinuous profile line, or edge, that marks the join of the flat face where it intersects with the flattish curve of the rear of the head.

From the rear, we note the almost imperceptible merging of the columnar neck with the fuller and more rounded volume of the head, and in the silhouette that is delineated by the outline of the curved face and straight neck.

The subtlety and understatement of the form of this striking head may profitably be compared with that of a celebrated and notably simple Brancusi head, *White Negress* (plate 121). There Brancusi came close, as he did on other occasions, to using the Euclidian forms. His sculpture has an ellipsoidal head with an additional shape plonked upon it for lips. It is perhaps a deliberate *reductio ad absurdum*. Yet while its boldness is arresting, it cannot sustain the same prolonged contemplation as can our Cycladic head: The geometric precision of the form is ultimately inimical.

Part of the absorbing interest in looking at Cycladic sculpture comes from the experiencing of the range of solutions that the sculptors found in response to the problem of setting the fuller volume of the head upon the narrow column of the neck. They had to present that rounded shape in such a way that the front (the face) was to some extent flat: It had therefore to be defined by some sort of edge in order to delimit the face and to separate it from the intersecting curve of the back of the head. This intersection thus generated an outline, symmetrical when seen from the front, whose line, seen in profile, was one of the most characteristic features of the head. It is instructive to compare some of the solutions offered.

One solution might be a globular form (plate 122), very much an ellipsoid upon a broad cylinder, employing very much the same simplification later used by Brancusi. Or it might be flat, an almost plain triangular surface (plate 55), a solution usually used for the Chalandriani variety, near the end of the Early Cycladic period. Or it might be some especially satisfying adjustment, where plane and volume and line come together with particular effect (plate 123), and where for once the nose does not seem a superfluous addition but somehow relates well to the outline of the face.

These qualities are brought together to particularly good effect in the very large head now in the Louvre (plate 124), which has always seemed to me to deal with the human head even more subtly and unself-consciously than any work by Brancusi. Now some ten and a half inches in height, it originally formed part of a monumental sculpture (although not quite of the same scale as the life-size

Goulandris figure or the very large figure in the National Museum in Athens). In conformity with the slightly odd convention for the very large figures it shows the ears in relief. The flat surface of the face has a particularly pleasing rounded outline, and seen in profile, that same flat surface forms a subtly sinuous edge, from the well-proportioned chin to the sloping crown. While it has much in common with the head with which we began this discussion, each head is expressive in its own way and perfectly distinct as a sculpture in its own right.

Cycladic sculpture thus offers, as these examples amply demonstrate, a whole range of consummately accomplished solutions to the perennial problem of the sculptor, the representation of the human head in a manner that uses form rather than surface detail to impart vitality and dignity.

We have distinguished as one underlying current in Western art, a movement towards simplicity and reduction. As we saw in Chapter XVI, it has been a salient feature in much of the painting and sculpture of our century, from Picasso, Modigliani, and Brancusi down to the present. It was not a dominant tendency during the Italian Renaissance when, as in fifth-century Athens, the prime emphasis was rather upon verisimilitude and came ultimately to depend upon increasing elaboration. The tendency towards simplicity may be contrasted with its polar opposite, complexity and elaboration, two of the guiding principles of the Baroque. Simplicity, we may assert, is generally effective in the expression of stillness and calm, and in sculpture is evoked by masses and volumes. Its opposite (and counterpart) quality embodies movement and expressive energy, and often uses dramatic surface effects.

Here of course we are close to restating an old opposition often drawn in the past between Classical and Baroque tendencies in art; between Classicism and Romanticism. These distinctions may be linked to those made long ago by Nietzsche in comparing the Apollonian and the Dionysian in art and in literature.

While the reduction to essence of which we are speaking sets out to achieve its effects by minimal means, it is important to grasp that the Apollonian tendency that we are distinguishing here is not at all the same as what has recently come to be termed "minimal art." For that designation has been preempted by a number of contemporary conceptual artists, such as Sol LeWitt and Donald Judd, for whom the actual task of producing a material shape or form is secondary to the production and elaboration of an explicit and well-defined concept. As Edward Lucie Smith says of this kind of minimal art, it is "generally an art of ideas, and the works of art, instead of coexisting with the idea . . . are purely subsequent to it."[1] That kind of minimal art stands close in this respect to the Constructivist approach, although it goes well beyond it. In our consideration of an Early Cycladic sculpture we are talking rather of the contemplative reduction that is perfectly in harmony with the kind of approach towards painting adopted by Cézanne.

Setting aside that very cerebral approach inherent in such minimal art, and looking now to some of the greatest visual achievements of recent decades, the two major trends that we have been discussing, calm simplicity versus expressive energy, were both evident, at least superficially, in the New York School painting

of the 1950s and 1960s, which represents some of the most accomplished work of our century. (The term "Abstract Expressionism" is best avoided, for it emphasizes the Dionysian tendency at the expense of the Apollonian.) There we may contrast the vigorous surface activity of Jackson Pollock, certainly an Abstract Expressionist, with what has been called the "quietism" of Mark Rothko or of Barnett Newman.

It is with Newman's work in particular that I should like to compare our Cycladic head (plates 120 and 125). Of course the comparison of painting with sculpture can only take us so far. This may be a somewhat superficial undertaking, especially when the artists are separated by more than four millennia, and particularly when the sculpture remains a representational one and the painting is

125

THE GATE

Barnett Newman, A.D. 1954

Oil on canvas, 94 x 76″

Stedelijk Museum, Amsterdam

essentially and parthenogenetically abstract. But it is perhaps permissible to offer a personal response to these works — there is, after all, no other way — and to note how Newman sometimes, with consummate skill, achieved what seems close to an absolute. For it is in this quality of near perfection, at the extremes of simplicity, that the resemblance lies. He consistently reduced his paintings to just a few vertical lines of color, set in or at the intersection of plain fields of color. It must be added that unless one has stood in front of a few of these paintings one cannot really appreciate that they actually *work*. No mere reproduction can convince one that the Presence is really there, yet with all superfluity removed, pared down to the essential, so that there is no more to eliminate.

There is great unity and evident simplicity in each of the mature works of Newman, along with a quality of dignity that seems to derive in part from his fixity of purpose, reflected in his statement that "the self, terrible and constant, is for me the subject matter of painting."[2] It took him many years and much struggle until he found for himself his own artistic convention, his own canon if you like, that required large canvasses upon which were deployed those broad areas of uniform color, and on which occur the separation or intersection of those vertical lines of color, often very narrow vertical lines, that are a principal focus for the attention of the viewer.

Of course this is pure abstraction, parthenogenetic: There is nothing in the painting to identify with a specific visual experience in the world. Nonetheless, the very verticality that we associate with life and energy takes part of its meaning, as no doubt with Mondrian, from the experience of living and standing upright in the world. Abstract works too are the product of concrete experience.

The Cycladic head, and no doubt the figure of which it originally formed a part, both shares and prefigures some of those qualities that have been attained by the most eminent artists of our own time. As we have seen, some of these qualities are apparent too in the archaic sculptures of the Greeks and they surface in the works of a few masters of the Renaissance, who were not averse to simplification, such as Masaccio and Piero della Francesca. As the tyranny of the Renaissance was thrown off, new opportunities arose for such works. We see their fulfillment throughout the modern school. Cycladic sculpture of the third millennium B.C. achieves what many artists in our century have sought to emulate: the art of refining complex forms while retaining the quality of presence that pervades all great works of art.

EPILOGUE: THE BIRTH OF APOLLO

Ils reviendront, ces Dieux, que tu pleures toujours!
Le temps va ramener l'ordre des anciens jours.
La connais tu, Daphné, cette ancienne romance,
Au pied du sycomore, ou sous les lauriers blancs,
Sous l'olivier, le myrthe, ou les saules tremblants,
Cette chanson d'amour qui toujours recommence?

GÉRARD DE NERVAL, *Delphica*

IN THE PRECEDING PAGES I have tried to consider some of the issues and problems that these remarkable Cycladic sculptures raise in the contemporary mind.

Despite the little that we know about the Cycladic people and their world, we can at least be very clear that theirs were small-scale societies. None of their settlements could have numbered more than a few dozen inhabitants. No island could have supported more than a couple of thousand. No chief or ruler could have had more than a few thousand souls within his dominion, if indeed these societies were already, despite their small scale, centrally organized.

We may infer that the Cycladic islanders of the time were united by a common belief system (as well, no doubt, as a common language). It is likely that this belief system integrated the various island societies into a wider community.

I have suggested that the inhabitants of several islands may have met together at special sanctuaries. These meetings would have been not unlike such festivals in Classical times as the famous meeting dedicated to Apollo on the island of Delos. And these in turn find echoes in the *panigyri* of modern times, notably the great celebration of the Assumption of the Panaghia, the Blessed Virgin, on Tenos (and also on Paros), which takes place annually on the 15th of August. These meetings may have involved rituals showing respect for the ancestors. At such meeting places the larger sculptures may have figured prominently: One sanctuary may be represented by the sadly looted site at Dhaskaleio Kavos on Keros.

It was in this context that Early Cycladic sculpture developed, aided in part by the plentiful supplies of marble in the islands, especially on Naxos and Paros.

Cycladic sculpture, and Cycladic crafts in general, possessed certain features that we have discussed at length: It adhered to a canon, it was proportional, and it was simple. These qualities were also exemplified by the art of early Egypt, and they emerged again, probably as a result of Egyptian influence, in the art of Greece in the archaic period.

The order that was to characterize the art and architecture of Greece — the canon, the proportionality — was thus already present in the islands in the third millennium B.C. Apollo, of course, was the Greek god of reason and of order. Simplicity and calm, canon, and proportion are supremely Apollonian attributes, in contrast to the riotous exuberance and unbridled expression of the Dionysian. It is appropriate therefore that the birthplace of Apollo in Greek myth (and of his sister Artemis, the virgin huntress) was the Cycladic island of Delos.

The Cycladic style anticipates by many centuries the sense of order that gave rise, for instance, to the kouros and the kore. The Greeks however had a much

clearer sense of progress, so that only a century after the kouros of Melos we find the Kritios Boy, the latest in that series, employing many of the features of mature Classical sculpture.

But with the development of the Classical ideal of beauty, which the Kritios Boy so well embodies, came the adoption of that naturalism in art that by Roman times had become repetitive. Its rediscovery in the fourteenth and fifteenth centuries in Italy was one of the great moments in the development of the visual art of the west. But the reawakened tradition again became a stifling convention.

It took the modern movement of the twentieth century to return us to that important and long-overlooked quality in art, simplicity arrived at through the abstraction of form. The Cycladic spirit reemerged. The directness and simplification that a century ago seemed "repulsively ugly" are now felt to reflect a coherence of vision and a sensitivity of form that we greatly admire.

The Cycladic spirit may well embody great freshness of vision, but implicit within it is a sense of order. This order involved a keen awareness of tradition. There is no doubt to my mind that in the field of art, rules and discipline — constraints if you prefer — offer opportunities as much as they impose burdensome restrictions. In music the sonata form or the symphony offers a structure within which the composer may operate and the listener follow with a greater effective freedom than in the uncharted fields of amorphous and atonal sound characteristic of some modern compositions, as it may appear to many of us who feel rather lost among them. That we feel lost is often because we have neither learnt nor recognized the self-imposed rules within which the composer is operating. In the same way, regularities of meter and the sonnet form offered Shakespeare scope enough and provided a framework that allowed the listener or reader to follow, without being bewildered by too many simultaneous variables. For complete freedom, unrestrained, can be overwhelming. As T. S. Eliot put it: "Humankind cannot bear very much reality."

In the Cyclades there developed also, for the first time in Europe, a concern for underlying regularities of proportion. This quest for visual harmony was taken up again by the sculptors of archaic and Classical Greece; it paralleled the philosophers' search for the underlying principles of the natural world, a search that, when resumed in the Renaissance, sparked the scientific revolution that called the modern world into being.

It is not necessary to seek to trace these later developments back to the Cycladic islands of nearly five thousand years ago in order to recognize that we encounter there, in these relics of the dawn of European civilization, something that was new and fresh and original. Through these remarkable sculptures, which anticipate in several ways much that we value in our own era, we can still catch today the echo of that originality.

NOTES

CHAPTER I (pages 18–24)

1. Finn 1981, 13.
2. Renfrew C. 1972a; Doumas 1977b; See also Barber 1987 for recent finds and bibliography.
3. Doumas 1983; See also Doumas 1968.
4. Zervos 1957; Majewski 1935; Renfrew C. 1969; Thimme (ed.) 1977; Getz-Preziosi 1987a.
5. Renfrew C. 1973, 93.
6. Renfrew C. 1987; 1964.
7. Caskey M. E. 1986; Renfrew C. (ed.) 1985.
8. See pages 99–101 for a discussion of Dhashaleio Kavos, Keros. Recent investigations conducted for the Ephorate of Antiquities for the Cyclades by Christos Doumas, Lila Marangou, and Colin Renfrew have documented the extent of the looting at the site.
9. Grimes 1989.

CHAPTER II (pages 25–30)

1. Kirk 1974, 50–51.
2. Ibid., 52.
3. Thimme (ed.) 1977, 497.
4. Walpole 1818, 324.
5. See, for example, Furtwängler 1892, 102; Reichel 1897, 81, 84; Walpole 1818, 324; Reinach 1888, III.
6. Daniel 1981, 48ff.
7. Bent 1884; Köhler 1884.
8. Duemmler 1886.
9. Edgar 1897, 46.
10. Tsountas 1898; 1899.
11. Stephanos 1903; 1904; 1906; 1908; 1909; 1910.
12. Atkinson et al. 1904.
13. Ibid., 246.
14. Varoucha 1926.
15. Bossert 1965; Doumas 1977a, 18–20.
16. Pryce 1928, 1.
17. Karo 1930, 135.
18. Seager 1910; 1912; Xanthoudides 1915; 1916; 1918; Mylonas 1930; 1934.
19. Majewski 1935.
20. Kontoleon 1949; 1950.
21. Zapheiropoulos 1960, 246–47.
22. Evans and Renfrew 1968.
23. Caskey J.L. 1962; 1964a; 1966; 1967.
24. Alexiou 1951; 1958; Caskey J.L. 1954; 1956; 1957; 1958; 1959; Yalouris 1957; Mylonas 1959.
25. Zervos 1957.
26. Bossert 1967; Doumas 1962; 1963; 1964; Evans and Renfrew 1968; Papadopoulou 1965; Tsakos 1967; Zapheiropoulos 1960; 1965; Zapheiropoulou 1966; 1967; 1968a; 1968b; 1970a.
27. Kontoleon 1961; 1963; 1965; 1967; 1969; Bossert 1967; Evans and Renfrew 1968; Caskey J.L. 1962; 1964a; 1966; 1967; 1971c; 1972; Coleman 1977.
28. Alexiou 1960; Sakellarakis 1967; Tzedakis 1967; 1968; Harding, Cadogan, and Howell 1969; Marinatos 1970b.
29. Levi 1962; 1966; Pecorella 1984.
30. Papathanasopoulos 1962; Budde and Nicholls 1965; Doumas 1968; Jacobsen 1969; Preziosi 1966.
31. Blance 1961; Bossert 1960; Caskey J.L. 1960; Cavalier 1961; Renfrew C. 1964; Charles 1967; Doumas 1970; Marinatos 1962; Renfrew, Cann, and Dixon 1965; Renfrew and Peacey 1968.
32. Bossert 1965; Hïckmann 1968; Doumas 1968; Erlenmeyer 1965; Schefold 1965; Thimme 1965.
33. Renfrew C. 1969.
34. Doumas 1965; 1967; Korres 1965.
35. Doumas 1976b; Zapheiropoulou 1970a; 1970b; 1975; Sakellarakis 1972; Marinatos 1970b.
36. Archaeological Reports 1974–75, 23–25; 1975–76, 25–26; 1977–78, 52–54.
37. Marinatos 1968; 1969; 1970a; 1971; 1972; 1974; 1976; Doumas (ed.) 1978, 777–78; Sotirakopoulou 1986.
38. Davaras 1972; Doumas 1977a; 1979; Sakellarakis 1972, 350–51; 1977a.
39. Papavasileiou 1910; Theocharis 1949, 292.
40. Sampson 1985, 320; 1988.
41. Ibid., 327.
42. Touchais 1981, 156–59; Tzavella-Evjen 1984.
43. Thimme (ed.) 1977.
44. Doumas (ed.) 1978.
45. Getz-Preziosi 1987b.
46. Marangou (ed.) 1990.
47. Renfrew C. 1972a.
48. Barber 1987; Ekschmitt 1986; Doumas 1972a; 1972b; 1976b; 1977a; Fitton 1989; Getz-Preziosi 1985; 1987a; Höckmann 1975.
49. Branigan 1971; Caskey 1971b; 1974; Davis J.L. 1984; Doumas 1976a; Fitton 1984; Getz-Preziosi 1972; 1975; 1977; 1979; 1981; 1982a; 1982b; 1984; Preziosi

189 and Weinberg 1970; Renfrew 1986a; 1986b; Thimme 1975; Broodbank 1989; Craig and Craig 1972; Doumas 1970; Gale and Stos-Gale 1981; 1984; Gropengiesser 1986; Renfrew and Aspinall, forthcoming; Torrence 1979; 1986; Caskey 1979; Coleman 1974; 1979; Doumas 1988; Macgillivray 1983; 1984; Rutter 1979; 1983; 1984.

50. See, for example, Davis and Cherry (eds.) 1979; Macgillivray and Barber (eds.) 1984; Rougemont (ed.) 1983; Fitton 1984.

CHAPTER III (pages 31–34)

1. Torrence 1986.
2. Doumas 1990.
3. Renfrew J.M. 1982.
4. Gamble 1982.
5. Renfrew J.M. 1973, 125–31; Renfrew C. 1972a, 281–85.
6. Renfrew J.M. 1973, 131–34; Renfrew C. 1972a, 285–87; but see Runnels and Hansen 1986.
7. Renfrew, Greenwood, and Whitehead 1968; Shackleton 1968.

CHAPTER IV (pages 35–51)

1. Atkinson et al. 1904.
2. Edgar 1897.
3. Evans A.J. 1905.
4. Warren and Hankey 1989, 169.
5. Renfrew C. 1972a, 539; Doumas 1977b, chapter 1.
6. Renfrew C. 1965; 1972a, 152.
7. Caskey 1971a. See also Coleman 1974; 1979.
8. Renfrew C. 1972a, 221. See also Warren and Hankey 1989, 169.
9. Renfrew C. 1972a, 165.
10. Graves with Middle Minoan finds at Aila on Naxos (Papathanasopoulos 1962, pl. 64); Middle Helladic at Aghios Loukas on Syros (Barber 1981); Middle Cycladic at Arkesine on Amorgos (Bossert 1954).
11. Bossert 1967; Renfrew C. 1972a, 533–34; Doumas 1977b, 22.
12. Macgillivray 1980.
13. Caskey 1972, 370; Wilson and Eliot 1984.
14. See Rutter 1983; 1984; Wilson and Eliot 1984; Macgillivray 1984.
15. Evans and Renfrew 1968.
16. Renfrew and Aspinall, forthcoming.

17. Cherry 1979.
18. Renfrew 1987, 175.
19. Personal communication from Dr. Sandor Bökönyi.
20. Weinberg 1951.
21. Renfrew C. 1986a.
22. Cherry 1979, 33.
23. Coleman 1977.
24. Caskey 1970, 340.
25. Tsountas 1899.
26. Doumas 1964, III.
27. Renfrew J.M. 1982; Runnels and Hansen 1986.
28. Cherry 1982; Cherry, Davis, and Mantzourani, forthcoming.
29. Gale and Stos-Gale 1981; 1984.
30. Papathanasopoulos 1962, 114.
31. Tsountas 1898, 154.
32. Tsountas 1899, pl. 10, 1.
33. Torrence 1986.
34. Broodbank 1989.
35. Höckmann 1977; Renfrew C. 1967b.
36. See note 29.
37. Renfrew C. 1982.

CHAPTER V (pages 54–65)

1. Renfrew C. 1972a, 526–27; Doumas 1977b, 17–18.
2. Renfrew, Cann, and Dixon 1965; Torrence 1986.
3. Evans and Renfrew 1968, pl. XLIII.
4. Renfrew 1969, pl. 9, e; Thimme (ed.) 1977, pl. 314, no. 281.
5. Coleman 1977, pl. 67.
6. Papathanasopoulos 1962, pl. 66, g.

CHAPTER VI (pages 66–73)

1. Bossert 1960; Coleman 1985.
2. Renfrew 1967a.
3. Ibid., pl. 6.
4. Charles 1967.
5. Fiedler 1841.
6. Renfrew C. 1972a, fig. 12.2, 1.
7. Thimme (ed.) 1977, pls. 333–38.
8. Renfrew 1972a, 533; Doumas 1977b, 22.
9. Caskey 1972; Wilson and Eliot 1984; Macgillivray 1980.
10. Renfrew 1972a, 534; Doumas 1977b, 23.

CHAPTER VII (pages 74–94)

1. Thimme 1975; Renfrew C. 1969, 9.
2. Renfrew C. 1969, 15–20.

3. The late Professor J.L. Caskey and Professor Saul Weinberg have both expressed doubts about the validity of the classifications offered in my 1969 article (Caskey J.L. 1971b, 125–26; Weinberg 1977, 142). In this matter, however, I am unrepentant.
4. Fitton 1989.
5. Getz-Preziosi 1972.
6. Tsountas 1898.
7. Getz-Preziosi 1987b, 156–57.
8. Renfrew C. 1969, 28.
9. Tsountas 1898.
10. Zervos 1957, fig. 162.
11. Tsountas 1899; Zervos 1957, fig. 245. See also Zervos 1957, figs. 247, 250.
12. Renfrew C. 1969, 18–19; Sakellarakis 1977a; 1977b.
13. Papathanasopoulos 1962, pl. 46.
14. Fitton 1989, 41.
15. Renfrew 1969, 13.
16. Atkinson et al. 1904, pl. XXXIX, 1 and 2; Caskey J.L. 1971b.
17. Davis 1984, 17.
18. Thimme 1975.
19. Getz-Preziosi 1984, 20.
20. Thimme (ed.) 1977, 419.
21. Getz-Preziosi 1981, 6.
22. Fitton 1989, 40, 67.
23. Renfrew C. 1969, pl. 9, a; Getz-Preziosi 1987a, 61, fig. 30.
24. Thimme (ed.) 1977, pl. 304, no. 258.
25. Renfrew C. 1969, pl. 9, c; Riis, Moltesen and Guldager 1989, 26–27; Zervos 1957, fig. 319; Thimme (ed.) 1977, pl. 303, no. 257.

CHAPTER VIII (pages 95–105)

1. Weinberg 1965, 192.
2. Doumas 1968, 88–94.
3. Schefold 1965; Thimme 1965.
4. Goodison 1989, 4–49.
5. Ucko 1968; Fleming 1969.
6. Tsountas 1898, pl. 8, 1.
7. Tsountas 1899, pl. 10, 1.
8. Getz-Preziosi 1982a.
9. Renfrew C. 1984a.
10. Davis 1984.
11. Caskey J.L. 1986.
12. Renfrew C. (ed.) 1985.
13. Renfrew C. 1965, pl. 42, d.
14. Doumas 1964; Zapheiropoulou 1968a; 1968b; 1975.
15. Renfrew C. 1984a, 27–28.

16. Zapheiropoulou 1970b; Kontoleon 1971, 178–79; 1972b, 150–53.
17. Doumas 1977b, 100–119.
18. Getz-Preziosi 1981.
19. Getz-Preziosi 1979; Fitton 1984.
20. Goodison 1989, 11.
21. Richter 1968, 3.
22. Thimme (ed.) 1977, pl. 261, no. 153.

CHAPTER IX (pages 108–116)
1. Oustinoff 1984.
2. Getz-Preziosi 1977; 1987a.
3. Tsountas 1898, 195.
4. Of those from T. 103, eleven are illustrated by Zervos 1957, pl. 57; of those from T. 117, eight by Zervos 1957, pl. 58. The find groups are illustrated by Getz-Preziosi 1987a, pl. 2.
5. Doumas 1977b, pl. XXXV, a, b, c, d; Getz-Preziosi 1987a, pl. 4b.
6. Doumas 1977b, pl. XXXV, a, c, d; Getz-Preziosi 1987a, pl. 4b, 1–3.
7. Papathanasopoulos 1962, pl. 70; Getz-Preziosi 1987a, pl. 3a.
8. Papathanasopoulos 1962, pl. 46; Getz-Preziosi 1987a, pls. 5, 6; Renfrew C. 1969, pl. 3, d, e.
9. Getz-Preziosi 1987a, 64.
10. Ibid., 65.
11. Ibid., 67.
12. Ibid., pl. 44, 1; Zervos 1957, 218, fig. 296.
13. Getz-Preziosi 1987a, pls. 1a, 1b; Thimme (ed.) 1977, pl. 303, no. 257.
14. Zapheiropoulou 1979, pl. 243.

CHAPTER X (pages 117–125)
1. Tsountas 1898, 195; Getz-Preziosi 1987a, pl. VIIa
2. Getz-Preziosi 1987a, 53.
3. Tsountas (1898, 195) does mention coloring, not necessarily paint, between

the breasts of one of the figures from Grave 14 at Dokathismata on Amorgos.
4. Preziosi and Weinberg 1970.
5. Richter 1968.

CHAPTER XI (pages 126–141)
1. Zervos 1957, pl. 180–81, no. 238.
2. Caskey 1972, pl. 77b.
3. Zapheiropoulou 1988, 39, no. 2.
4. Graziosi 1960, pl. 1–3, 9–12.
5. Ucko 1968; Renfrew 1969, pls. 3, b.
6. Vitruvius, *De Architectura,* IV.
7. Ibid. 1970.
8. Richter 1970.
9. Panofsky 1955.
10. Schäfer 1986, 333.
11. Iversen 1975, pl. 3; Davis 1989, 23.
12. Schäfer 1986, 334.
13. Adam 1966; Guralnick 1978.
14. Diodorus Siculus I.98.5–9, quoted by Pollitt 1965, 19–20.
15. Pollitt 1965, 89.
16. Getz-Preziosi 1987a, 37–38.
17. Thom 1967.
18. Getz-Preziosi 1987a, pl. 26; compare the head sizes of nos. 2 and 3; Getz-Preziosi 1987a, pl. 28; compare the head sizes of nos. 5 and 6.

CHAPTER XIV (pages 154–161)
1. Kemp 1989, 79–82; Baumgartel 1948; Giedion 1964, 84.
2. Evans 1971, pl. 19, 5; Renfrew C. 1972b.
3. Giedion 1964, 104.
4. Carlyle 1888, 25.
5. Zervos 1957, 146–47, no. 178; Wolters 1891.
6. Zervos 1957, 219, no. 297; 136, no. 162.
7. Ibid., 136, no. 162.
8. Richter 1968, 40, no. 43, figs. 147–50.
9. Ibid., 72, figs. 359–64 and 70, figs. 341–44.

CHAPTER XV (pages 162–167)
1. Getz-Preziosi 1982a.
2. Oustinoff 1984.
3. Köhler 1884.
4. Thimme (ed.) 1977, 300–301, nos. 254, 255.
5. Zapheiropoulou 1968a, 99.
6. Getz-Preziosi 1987a, 61, fig. 30.
7. Renfrew 1969, pl. 9, d; Thimme 1977 (ed.), 306, no. 259. See also Thimme 1977, 304–5, no. 258.
8. Thimme (ed.) 1977, 308, no. 257.
9. Renfrew 1969, pl. 9, c.
10. Zervos 1957, 247, no. 332.
11. Doumas 1983, 134.
12. Zervos 1957, pl. 180–81, no. 238; Caskey 1972, pl. 77b; Zapheiropoulou 1988, 39, no. 2.

CHAPTER XVI (pages 168–175)
1. Wolters 1891.
2. Gombrich 1960, 123.
3. Renfrew 1962.
4. Rubin 1984, pp. 260, 266, 268, 270, 301, 302.
5. Quoted in Rubin (ed.) 1984, 17.
6. Werner 1965.
7. Giedion-Welcker 1968.
8. Geist 1984.
9. Finn 1981, 13. See Sachini 1984, 86.
10. Alexandrian 1977.
11. Ibid. 84.
12. Malraux 1967, 10. See also Macquet 1979, 9.
13. Pollitt 1965, 226–27.
14. Gimpel 1969.

CHAPTER XVII (pages 176–185)
1. Lucie-Smith 1974.
2. Rosenberg 1978, 21.

BIBLIOGRAPHY

Adam, S. 1966
 The Technique of Greek Sculpture. London:
 British School of Archaeology at Athens.
Alexandrian 1977
 Marcel Duchamp. Naefels: Bonfini Press.
Alexiou, S. 1951
 Protominoikai taphai para to Kanli Kastelli
 Irakleiou. *Kretika Chronika* 5: 275–95.
——. 1958
 Ein frühminoisches Grab bei Lebena auf
 Kreta. *Archäologischer Anzeiger* 1958: 1–10.
——. 1960
 Anaskaphe Lebenos. *Archaiologikon Deltion*
 16, Chronika: 257–58.
Atkinson, T.D., Bosanquet, R.C., Edgar,
 C.C., Evans, A.J., Hogarth, D.G., Mac-
 kenzie, D., Smith, C., and Welch, F.B. 1904
 Excavations at Phylakopi in Melos. Society
 for the Promotion of Hellenic Studies:
 Supplementary Paper no. 4.
Ayrton, E. 1961
 The Doric Temple. London: Thames and
 Hudson. (Photographs by Serge
 Moulinier.)

Barber, R.L.N. 1981
 A tomb at Ayios Loukas, Syros: some
 thoughts on Early-Middle Cycladic chro-
 nology. *Journal of Mediterranean Anthro-
 pology and Archaeology* 1: 167–79.
——. 1987
 The Cyclades in the Bronze Age. London:
 Duckworth.
Baumgartel, E.J. 1948
 The three colossoi from Keptos and their
 Mesopotamian counterparts. *Annales
 du Service des Antiquités de l'Égypte* 48:
 433–53.
Bent, J.T. 1884
 Researches among the Cyclades. *Journal
 of Hellenic Studies* 5: 42–59.
Blance, B. 1961
 Early Bronze Age colonists in Iberia.
 Antiquity 35: 192–202.
Bossert, E.-M. 1954
 Zur Datierung der Gräber von Arkensine
 auf Amorgos. In *Festschrift für Peter
 Goessler,* pp. 23–34. Tübinger Beiträge zur
 Vor- und Frühgeschichte. Stuttgart:
 Kohlhammer.
——. 1960
 Die gestempelten Verzierungen auf
 frühbronzezeitlichen Gefässen der Agäis.
 *Jahrbuch des Deutschen Archäologischen
 Instituts* 75: 1–16.

——. 1965
 Ein Beitrag zu den frühkykladischen Fund-
 gruppen. *Anadolu Araştirmalari* 2: 85–100.
——. 1967
 Kastri auf Syros. *Archaiologikon Deltion* 22,
 Meletai: 53–76.
Branigan, K. 1971
 Cycladic figurines and their derivatives in
 Crete. *Annual of the British School of Archae-
 ology at Athens* 66: 57–78.
Broodbank, C. 1989
 The longboat and society in the Cyclades
 in the Keros-Syros culture. *American Jour-
 nal of Archaeology* 93: 319–37.
Budde, L., and Nicholls, R. 1965
 *A Catalogue of the Greek and Roman Sculp-
 ture in the Fitzwilliam Museum, Cambridge.*
 Cambridge: Cambridge University Press.

Carlyle, T. 1888
 *On Heroes, Hero-Worship, and the Heroic in
 History.* London: Chapman Hall. (Lectures
 delivered in May 1840.)
Caskey, J.L. 1954
 Excavations at Lerna 1952–53. *Hesperia* 23:
 3–30.
——. 1955
 Excavations at Lerna 1954. *Hesperia* 24:
 25–49.
——. 1956
 Excavations at Lerna 1955. *Hesperia* 25:
 147–73.
——. 1957
 Excavations at Lerna 1956. *Hesperia* 26:
 142–62.
——. 1958
 Excavations at Lerna 1957. *Hesperia* 27:
 125–44.
——. 1959
 Excavations at Lerna 1958–59. *Hesperia* 28:
 202–7.
——. 1960
 Lerna, the Cyclades, and Crete. *American
 Journal of Archaeology* 64: 183.
——. 1962
 Excavations in Keos 1960–61. *Hesperia* 31:
 263–83.
——. 1964a
 Excavations in Keos 1963. *Hesperia* 33:
 314–35.
——. 1964b
 Greece, Crete, and the Aegean islands in
 the early Bronze Age. *Cambridge Ancient
 History.* Vol. 1, part 2, chap. 26a. Fascicle.
 Cambridge: Cambridge University Press.

———. 1966
Excavations in Keos 1964–65. *Hesperia* 35: 363–76.

———. 1967
Excavations in Keos. *Archaiologikon Deltion* 22: 470–79.

———. 1970
The early Bronze Age at Ayia Irini in Keos. *Archaeology* October 1970: 339–42.

———. 1971a
Greece, Crete, and the Aegean islands in the Aegean early Bronze Age. In I.E.S. Edwards, C.J. Gadd, and N.G.L. Hammond (eds.) *Cambridge Ancient History.* Vol. 1, part 2, pp. 771–807. Cambridge: Cambridge University Press.

———. 1971b
Marble figurines from Ayia Irini in Keos. *Hesperia* 40: 113–26.

———. 1971c
Investigations in Keos. Part 1: excavations and explorations 1966–70. *Hesperia* 40: 359–96.

———. 1972
Investigations in Keos. Part 2: a conspectus of the pottery. *Hesperia* 41: 357–401.

———. 1974
Addendum to the marble figurines from Ayia Irini. *Hesperia* 43: 77–79.

———. 1979
Ayia Irini in Keos: the successive periods of occupation. *American Journal of Archaeology* 83: 412.

Caskey, M.E. 1986
Keos II, Part I, The Temple at Ayia Irini: The Statues. Mainz: Von Zabern.

Cavalier, M. 1961
Les cultures préhistoriques des îles éoliennes et leur rapport avec le monde égéen. *Bulletin de Correspondance Hellénique* 84 (1960–61): 319–46.

Charles, J.A. 1967
Early arsenical bronzes: a metallurgical view. *American Journal of Archaeology* 71: 21–27.

Cherry, J.F. 1979
Four problems in Cycladic prehistory. In J.L. Davis and J.F. Cherry (eds.) *Papers in Cycladic Prehistory,* pp. 22–47. Los Angeles: UCLA Institute of Archaeology.

———. 1982
A preliminary definition of site distribution on Melos. In C. Renfrew and M. Wagstaff (eds.) *An Island Polity: The Archaeology of Exploitation in Melos,* pp. 10–23. Cam-

bridge: Cambridge University Press.

Cherry, J.F., Davis, J.L., and Mantzourani, E. (forthcoming)
The Landscape of Northern Keos in the Cyclades: An Archaeological and Ethnographic Survey from the Earliest Settlement Until Modern Times. Los Angeles: UCLA Institute of Archaeology.

Coleman, J.E. 1974
The chronology and interconnections of the Cycladic islands in the Neolithic period and the early Bronze Age. *American Journal of Archaeology* 78: 333–44.

———. 1977
Keos I: Kephala, a Late Neolithic Settlement and Cemetery. Princeton: American School of Classical Studies.

———. 1979
Chronological and cultural divisions of the early Cycladic period: a critical appraisal. In J.L. Davis and J.F. Cherry (eds.) *Papers in Cycladic Prehistory,* pp. 48–50. Los Angeles: UCLA Institute of Archaeology.

———. 1985
"Frying pans" of the Early Bronze Age Aegean. *American Journal of Archaeology* 89: 191–219.

Craig, H., and Craig, V. 1972
Greek marbles: determination of provenance by isotopic analysis. *Science* 176: 401–3.

Daniel, G. 1981
A Short History of Archaeology. London: Thames and Hudson.

Davaras, C. 1972
Archaiotetes kai Mnemeia Anatolikes Kretes. *Archaiologikon Deltion* 27, Chronika: 648–50.

Davis, J.L. 1984
A Cycladic figure in Chicago and the non-funereal use of Cycladic marble figures. In J.L. Fitton (ed.) *Cycladica: Studies in Memory of N.P. Goulandris.* London: British Museum Publications.

Davis, J.L., and Cherry, J.F. (eds.) 1979
Papers in Cycladic Prehistory. Monograph 14. Los Angeles: UCLA Department of Archaeology.

Davis, W. 1989
The Canonical Tradition in Ancient Egyptian Art. Cambridge: Cambridge University Press.

Doumas, C. 1962
Archaiotetes kai Mnemeia Kykladon.

Archaiologikon Deltion 17, Chronika: 272–74.

———. 1963
Archaiotetes kai Mnemeia Kykladon. *Archaiologikon Deltion* 18, Chronika: 275–79.

———. 1964
Archaiotetes kai Mnemeia Kykladon 1963. *Archaiologikon Deltion* 19, Chronika: 409–12.

———. 1965
Korphi t'Aroniou. *Archaiologikon Deltion* 20, Meletai: 41–64.

———. 1967
Le incisioni rupestre di Nasso nelle Cicladi. *Bollettino del Centro Camuno di Studi Preistorici* 3: 111–32.

———. 1968
The N.P. Goulandris Collection of Early Cycladic Art. Athens

———. 1970
Remarques sur la forme du bateau égéen a l'âge du bronze ancien. In E. Anati (ed.) *Valcamonica Symposium.* Capo di Ponte, 285–90.

———. 1972a
Early Bronze Age settlement patterns in the Cyclades. In P.J. Ucko (ed.) *Man, Settlement, and Urbanism,* 227–30. London: Institute of Archaeology.

———. 1972b
Notes on Early Cycladic architecture. *Archäologischer Anzeiger* 1972: 151–70.

———. 1976a
Les idoles cycladiques. *Archéologia* 100 (November 1976): 26–34.

———. 1976b
Protokykladike Kerameike apo ta Christiana Theras. *Archaiologike Ephemeris* 1976: 1–11.

———. 1977a
Proistorikoi Kykladites sten Krete. *Athens Annals of Archaeology* IX: 69–80.

———. 1977b
Early Bronze Age Burial Habits in the Cyclades. Studies in Mediterranean Archaeology 48. Göteberg: Paul Astroms Förlag.

———. 1979
Proistorikoi Kykladites sten Krete II. *Athens Annals of Archaeology* XII: 105–7.

———. 1983
Cycladic Art: The N.P. Goulandris Collection. London: British Museum Publications.

———. 1988
EBA in the Cyclades: continuity or discon-

193

tinuity? In E.B. French and K.A. Wardle (eds.) *Problems in Greek Prehistory*, pp. 21–29. Bristol: Bristol University Press.

———. 1990.
The elements at Akrotiri. In D.A. Hardy, C. Doumas, J.A. Sakellarakis, and P.M. Warren (eds.) *Thera and the Aegean World III.* Vol. 1, *Archaeology*, pp. 24–30. London: Thera Foundation.

Doumas, C. (ed.) 1978
Thera and the Aegean World I. London: Thera Foundation.

Doumas, C. and Marangou, L. 1978
Ancient Greek Art: The N.P. Goulandris Collection. Athens.

Duemmler, F. 1886
Mitteilungen von den Griechischen Inseln. *Athenische Mitteilungen* 11: 15–46.

Eco, U. 1962
Opera Aperta. Milan: Bompiani.

Edgar, C.C. 1897
Prehistoric tombs at Pelos. *Annual of the British School of Archaeology at Athens* 3: 35–51.

Ekschmitt, W. 1986
Kunst und Kultur der Kykladen. *Kulturgeschichte der antiken Welt.* Band 28.1. Mainz: Von Zabern.

Erlenmeyer, M.-L. and H. 1965
Von der frühen Bildkunst der Kykladen. *Antike Kunst* 8: 59–71.

Evans, A.J. 1905
La classification des époques successives de la civilisation minoënne. In *Comtes Rendus du Congrès International de l'Archéologie, Athènes 1905,* pp. 209–13.

Evans, J.D. 1971
Prehistoric Antiquities of the Maltese Islands; a Survey. London: Athlone.

Evans, J.D., and Renfrew, C. 1968
Excavations at Saliagos near Antiparos. British School of Archaeology at Athens: Supplementary Volume 5. London: Thames and Hudson.

Fiedler, K.G. 1841
Reise durch alle Theile des Königrieches Griechenland in den Jahren 1834 bis 1837 II. Leipzig.

Finn, D. 1981
Henry Moore at the British Museum. London: British Museum. (Photographs by David Finn.)

Fitton, J.L. 1984
Perditus and Perdita: two drawings of Cycladic figurines in the Greek and Roman Department of the British Museum. In J.L. Fitton (ed.) *Cycladica: Studies in Memory of N.P. Goulandris,* pp. 76–87. London: British Museum Publications.

———. 1989
Cycladic Art. London: British Museum Publications.

Fleming, A. 1969
The myth of the Mother Goddess. *World Archaeology* 1: 247–61.

Furtwängler, A. 1892
Erwerbungen der Antikensammlungen in Deutschland. *Archaologischer Anzeiger* 1892: 102.

Gale, N.H., and Stos-Gale, Z.A. 1981
Cycladic lead and silver metallurgy. *Annual of the British School of Archaeology at Athens* 76: 169–224.

———. 1984
Cycladic metallurgy. In J.A. Macgillivray and R.L.N. Barber (eds.) *The Prehistoric Cyclades,* pp. 255–76. Edinburgh: Department of Classical Archaeology.

Gamble, C. 1982
Animal husbandry, populations, and urbanisation. In C. Renfrew and M. Wagstaff (eds.) *An Island Polity: The Archaeology of Exploitation in Melos,* pp. 161–71. Cambridge: Cambridge University Press.

Geist, S. 1984
Brancusi. In W. Rubin (ed.) *"Primitivism" in Twentieth-Century Art,* pp. 345–68. New York: Museum of Modern Art.

Getz-Preziosi, P. 1972
Traditional Canon and Individual Hand in Early Cycladic Sculpture. Ph.D. dissertation, Harvard University.

———. 1975
An Early Cycladic sculptor. *Antike Kunst* 18: 47–50.

———. 1977
Cycladic sculptors and their methods. In J. Thimme (ed.) *Art and Culture of the Cyclades,* pp. 71–91. Karlsruhe: C.F. Müller.

———. 1979
The Hunter/Warrior figure in Early Cycladic marble sculpture. In J.L. Davis and J.F. Cherry (eds.) *Papers in Cycladic*

Prehistory, pp. 87–96. Los Angeles: UCLA Institute of Archaeology.

———. 1981
The male figure in Early Cycladic sculpture. *Metropolitan Museum Journal* 15: 5–33.

———. 1982a
Risk and repair in Early Cycladic sculpture. *Metropolitan Museum Journal* 16: 5–32.

———. 1982b
"The Keros Hoard": introduction to an Early Cycladic enigma. In D. Metzler and B. Otto (eds.) *Antidoron: Festschrift für Jürgen Thimme,* pp. 37–44. Karlsruhe: C.F. Müller.

———. 1984
Nine fragments of Early Cycladic sculpture in Southern California. *The J. Paul Getty Museum Journal* 12: 5–20.

———. 1985
Early Cycladic Sculpture: An Introduction. Malibu: J. Paul Getty Museum.

———. 1987a
Sculptors of the Cyclades: Individual and Tradition in the Third Millennium B.C. Ann Arbor: University of Michigan Press.

———. 1987b
Early Cycladic Art in North American Collections. Richmond: Virginia Museum of Fine Arts.

Giedion, S. 1964
The Eternal Present II: The Beginnings of Architecture. London: Oxford University Press.

Giedion-Welcker, C. 1958
Constantin Brancusi. Neuchâtel: Éditions du Griffon.

Gimpel, J. 1969
The Cult of Art. New York: Stein and Day.

Gombrich, E.H. 1960
Art and Illusion: A Study in the Psychology of Pictorial Representation. London: Phaidon.

Goodison, L. 1989
Death, Women, and the Sun. Bulletin Supplement 53. London: Institute of Classical Studies.

Graziosi, P. 1960
Palaeolithic Art. London: Faber.

Grimes, W. 1989
The antiquities boom: who pays the price? *The New York Times Magazine,* July 16, 1989, pp. 17–29.

Gropengiesser, H. 1986
Siphnos, Kap Agios Sostis: Keramische prähistorische Zeugnisse aus dem Gruben- und Huttenrevier. *Athenische Mitteilungen* 101: 1–39.

Guralnick, E. 1978
The proportions of kouroi. *American Journal of Archaeology* 82: 461–72.

Harding, A., Cadogan, G., and Howell, R. 1969
Pavlopetri: an underwater Bronze Age town in Laconia. *Annual of the British School of Archaeology at Athens* 64: 113–42.

Höckmann, O. 1968
Zu Formenschatz und Ursprung der schematischen Kykladenplastik. *Berliner Jahrbuch für Vor- und Frühgeschichte* 8: 45–75.

———. 1975
Zu dem Kykladischen Gebäudemodel von Melos. *Istanbuler Mitteilungen* 35: 269–99.

———. 1977
The Cyclades and the Western Mediterranean. In J. Thimme (ed.) *Art and Culture of the Cyclades,* pp. 163–72. Karlsruhe: C.F. Müller.

Iversen, E. 1975
Canon and Proportions in Egyptian Art. 2d ed. Warminster: Aris and Phillips.

Jacobsen, T.W. 1969
A group of Early Cycladic vases in the Benaki Museum in Athens. *Archäologischer Anzeiger* 1969: 233–42.

Karo, G. 1930
Archäologische Funde. *Archäologischer Anzeiger* 1930: 135–38.

Kemp, B.J. 1989
Ancient Egypt: Anatomy of a Civilization. London: Routledge.

Kirk, G.S. 1974
The Nature of Greek Myths. Harmondsworth: Pelican Books.

Köhler, U. 1884
Praehistorisches von den griechischen Inseln. *Athenische Mitteilungen* 9: 156–59.

Kontoleon, N.M. 1949
Anaskaphe en Naxo. *Praktika tes en Athenais Archaiologikes Etaireias* 1949: 112–22.

———. 1950
Anaskaphe en Naxo. *Praktika tes en Athenais Archaiologikes Etaireias* 1950: 269–80.

———. 1961
Anaskaphe Naxou. *Praktika tes en Athenais Archaiologikes Etaireias* 1961: 191–200.

———. 1963
Anaskaphe Naxou. *Praktika tes en Athenais Archaiologikes Etaireias* 1963: 148–55.

———. 1965
Anaskaphe Naxou. *Praktika tes en Athenais Archaiologikes Etaireias* 1965: 167–82.

———. 1967
Anaskaphe Naxou. *Praktika tes en Athenais Archaiologikes Etaireias* 1967: 112–23.

———. 1969
Anaskaphe Naxou. *Praktika tes en Athenais Archaiologikes Etaireias* 1969: 139–46.

———. 1970
Anaskaphe Naxou. *Praktika tes en Athenais Archaiologikes Etaireias* 1970: 146–55.

———. 1971
Anaskaphe Naxou. *Praktika tes en Athenais Archaiologikes Etaireias* 1971: 172–80.

———. 1972a
Anaskaphe Naxou. *To Ergon tes Archaiologikes Etaireias Kata to* 1972: 88–100.

———. 1972b
Anaskaphe Naxou. *Praktika tes en Athenais Archaiologikes Etaireias* 1972: 143–55.

Korres, G.S. 1965
Epi tes chronologeseos ton marmarinon plakon tes "Korphes t" Aroniou Naxou. *Archaiologike Ephemeris* 1965: 1–6.

Lambrinoudakis, B. 1976
Anaskaphe Naxou. *Praktika tes en Athenais Archaiologikes Etaireias* 1976: 295–308.

———. 1977
Anaskaphe Naxou. *Praktika tes en Athenais Archaiologikes Etaireias* 1977: 378–86.

Levi, D. 1962
Le due prime campagne dia scavi a Iasos. *Annuario della Scuola Archeologica Italiana de Atene* 39–40 (1961–62): 550–71.

———. 1966
Le campagne 1962–1964 a Iasos. *Annuario della Scuola Archeologica Italiana de Atene* 43–44 (1965–66): 401–546.

Lucie-Smith, E. 1974
Minimal art. In T. Richardson and N. Stangos (eds.) *Concepts of Modern Art,* pp. 243–55. New York: Ica Books.

———. 1981
Pop art. In N. Stangos (ed.) *Concepts of Modern Art,* pp. 225–38. London: Thames and Hudson.

Macgillivray, J.A. 1980
Mount Kynthos in Delos: the Early Cycladic settlement. *Bulletin de Correspondance Hellénique* 104: 3–45.

———. 1983
On the relative chronologies of Early Cycladic IIIA and Early Helladic III. *American Journal of Archeology* 87: 81–83.

———. 1984
The relative chronology of Early Cycladic III. In J.A. Macgillivray and R.L.N. Barber (eds.) *The Prehistoric Cyclades: Contributions to a Workshop on Cycladic Chronology,* pp. 70–77. Edinburgh: Department of Classical Archaeology.

Macgillivray, J.A., and Barber, R.L.N. (eds.) 1984
The Prehistoric Cyclades: Contributions to a Workshop on Cycladic Chronology. Edinburgh: Department of Classical Archaeology.

Mackay, E. 1917
Proportion squares on tomb walls in the Theban necropolis. *Journal of Egyptian Archaeology* 4: 74–85.

Macquet, J. 1979
Introduction to Aesthetic Anthropology. Malibu: Undenor.

Majewski, K. 1935
Figuralna Plastyka Cycladzka. Lwow.

Malraux, A. 1967
Museum Without Walls. London: Secker and Warburg.

Marangou, L. 1984
Evidence for the Early Cycladic period on Amorgos. In J.L. Fitton (ed.) *Cycladica: Studies in Memory of N.P. Goulandris,* pp. 99–115. London: British Museum Publications.

Marangon, L. (ed.). 1990
Naxos in the Third Millennium B.C. Athens: Goulandris Foundation.

Marinatos, S. 1962
Ai Kyklades os paragon tou Mesogeiakou politismou. *Epeteris tes Etaireias Kykladikon Meleton* 2: 234–43.

———. 1968
Excavations at Thera I, 1967. Athens: Archaiologike Etaireia.

———. 1969
Excavations at Thera II, 1968. Athens: Archaiologike Etaireia.

———. 1970a
Excavations at Thera III, 1969. Athens: Archaiologike Etaireia.

———. 1970b
Further news from Marathon. *Athens Annals of Archaeology* III: 154–55.

———. 1971
Excavations at Thera IV, 1971. Athens: Archaiologike Etaireia.

195 ———. 1972
Excavations at Thera V, 1971. Athens:
Archaiologike Etaireia.
———. 1974
Excavations at Thera VI, 1972. Athens:
Archaiologike Etaireia.
———. 1976
Excavations at Thera VII, 1973. Athens:
Archaiologike Etaireia.

Mylonas, G. 1930
Anaskaphai para ton Ayion Kosman.
Praktika tes Akademias Athenon 5 (1930):
319–23.
———. 1934
Excavations at Haghios Kosmas. *American
Journal of Archaeology* 38 (1934): 258–79
———. 1959
*Aghios Kosmas: An Early Bronze Age Settle-
ment and Cemetery in Attica.* Princeton,
N.J.: Princeton University Press.

Oustinoff, E. 1984
The manufacture of Cycladic figurines: a
practical approach. In J.L. Fitton (ed.)
*Cycladica: Studies in Memory of N.P.
Goulandris,* pp. 38–47. London: British
Museum Publications.

Panofsky, E. 1955
The history of the theory of human pro-
portions as a reflection of the history of
styles. In E. Panofsky *Meaning in the Visual
Arts,* pp. 82–138. New York: Doubleday.

Papadopoulou, Ph. 1965
Archaiotetes kai Mnemeia Kykladon.
Archaiologikon Deltion 20, Chronika:
508–14.

Papathanasopoulos, G. 1962
Kykladika Naxou. *Archaiologikon Deltion*
17, Meletai: 104–51.

Papavasileiou, G. 1910
Peri ton en Euvia Archaion Taphon.
Athens.

Pecorella, P.E. 1984
La cultura preistorica di Iasos in Caria.
Rome.

Pollitt, J.J. 1965
*The Art of Greece 1400–31: Sources and
Documents.* Englewood Cliffs, N.J.:
Prentice Hall.

Preziosi, P. 1966
Cycladic objects in the Fogg and Farland
collections. *American Journal of Archaeology*
70: 105–11.

Preziosi, P.G., and Weinberg, S.S. 1970

Evidence for painted details in Early
Cycladic sculpture. *Antike Kunst* 13: 4–12.

Pryce, F.N. 1928
*Catalogue of Sculpture in the Department of
Greek and Roman Antiquities of the British
Museum.* Vol. 1, Part I: *Prehellenic and Early
Greek.* London: British Museum.

Reichel, W. 1897
Über vorhellenische Götterkulte. Wien:
Alfred Hölder.

Reinach, S. 1888
*Voyage Archéologique en Grèce et en Asie
Mineure.* Paris: Firmin-Didot.

Renfrew, C. 1962
The tyranny of the Renaissance. *Cambridge
Review* 83: 219–23.
———. 1964
Crete and the Cyclades before Rhada-
manthus. *Kretika Chronika* 18: 107–41.
———. 1965
*The Neolithic and Early Bronze Age Cultures
of the Cyclades and Their External Relations.*
Ph.D. dissertation, Cambridge University.
———. 1967a
Cycladic metallurgy and the Aegean Early
Bronze Age. *American Journal of Archae-
ology* 71: 1–20.
———. 1967b
Colonialism and megalithismus. *Antiquity*
41: 276–88.
———. 1969
The development and chronology of the
Early Cycladic figurines. *American Journal
of Archaeology* 73: 1–32.
———. 1972a
*The Emergence of Civilization. The Cyclades
and the Aegean in the Third Millennium* B.C.
London: Methuen.
———. 1972b
Malta and the calibrated radiocarbon chro-
nology. *Antiquity* 46: 141–45.
———. 1973
*Before Civilization: The Radiocarbon Revolu-
tion and Prehistoric Europe.* London: Cape.
———. 1982
Polity and power: interaction, intensifica-
tion, and exploitation. In C. Renfrew and
M. Wagstaff (eds.) *An Island Polity: The
Archaeology of Exploitation in Melos,* pp.
264–89. Cambridge: Cambridge Univer-
sity Press.
———. 1984a
Speculations on the use of Early Cycladic
sculpture. In J.L. Fitton (ed.) *Cycladica:*

Studies in Memory of N.P. Goulandris,
pp. 24–30. London: British Museum
Publications.
———. 1984b
From Pelos to Syros: Kapros Grave D and
the Kampos group. In J.A. Macgillivray
and R.L.N. Barber (eds.) *The Prehistoric
Cyclades: Contributions to a Workshop on
Cycladic Chronology,* pp. 41–54. Edinburgh:
Department of Classical Archaeology.
———. 1986a
A neolithic head from the Cyclades. *Antiq-
uity* 60: 134–35.
———. 1986b
A new Cycladic sculpture. *Antiquity* 60:
132–34.
———. 1987
*Archaeology and Language: The Puzzle of
Indo-European Origins.* London: Cape.

Renfrew, C. (ed.) 1985
*The Archaeology of Cult: The Sanctuary at
Phylakopi.* British School of Archaeology
at Athens: Supplementary vol. 18.
London: Thames and Hudson.

Renfrew, C. and Aspinall, A. (forthcoming)
Aegean obsidian and Franchthi Cave. In
C. Perles (ed.) *Les Industries Lithiques Tail-
lées de Franchthi (Argolide),* II. Franchthi
Fascicle 5. Bloomington: Indiana Univer-
sity Press.

Renfrew, C., Cann, J.R., and Dixon, J.E. 1965
Obsidian in the Aegean. *Annual of the
British School of Archaeology at Athens* 60:
225–47.

Renfrew, C., and Peacey, J.S. 1968
Aegean marble: a petrological study.
*Annual of the British School of Archaeology
at Athens* 63: 45–66.

Renfrew, J.M. 1973
*Palaeoethnobotany: The Prehistoric Food
Plants of the Near East and Europe.* London:
Methuen.
———. 1982
Early agriculture in Melos. In C. Renfrew
and M. Wagstaff (eds.) *An Island Polity:
The Archaeology of Exploitation in Melos,* pp.
156–60. Cambridge: Cambridge Univer-
sity Press.

Renfrew, J.M., Greenwood, P.H., and
Whitehead, P.J. 1968
The fish bones. In J.D. Evans and C.
Renfrew (eds.) *Excavations at Saliagos near
Antiparos,* pp. 118–21. British School of
Archaeology at Athens: Supplementary
volume 5. London: Thames and Hudson.

Richter, G. 1968
Korai: Archaic Greek Maidens. London: Phaidon.

———. 1970
Kouroi: Archaic Greek Youths. London: Phaidon.

Riis, P.J., Moltesen, M., and Guldager, P. 1989
Catalogue of Ancient Sculptures I: Aegean, Cypriote, and Graeco-Phoenician. Copenhagen: National Museum of Denmark.

Rosenberg, H. 1978
Barnett Newman. New York: Abrams.

Rougemont, G. (ed.) 1983
Les Cyclades: Matériaux pour une Étude de Géographie Historique. Paris: Centre National de Recherches Scientifiques.

Rubin, W. 1984
Picasso. In W. Rubin (ed.) *"Primitivism" in Twentieth-Century Art,* pp. 241–343. New York: Museum of Modern Art.

Rubin, W. (ed.) 1984
"Primitivism" in Twentieth-Century Art. New York: Museum of Modern Art.

Runnels, C.N., and Hansen, J. 1986
The olive in the prehistoric Aegean. *Oxford Journal of Archaeology* 5: 299–308.

Rutter, J.B. 1979
Ceramic Change in the Aegean Early Bronze Age. Occasional Paper no. 5. Los Angeles: UCLA Institute of Archaeology.

———. 1983
Some observations on the Cyclades in the later third and early second millennium. *American Journal of Archaeology* 87: 69–76.

———. 1984
The "Early Cycladic III gap." In J.A. Macgillivray and R.L.N. Barber (eds.) *The Prehistoric Cyclades: Contributions to a Workshop on Cycladic Chronology,* pp. 95–107. Edinburgh: Department of Classical Archaeology.

Sachini, A. 1984
Prehistoric Cycladic Figurines and Their Influence on Early Twentieth-Century Sculpture. M. Litt. dissertation, University of Edinburgh.

Sakellarakis, J. 1967
Anaskaphe Archanon. *Praktika tes en Athenais Archaiologikes Etaireias* 1967: 151–61.

———. 1972
Anaskaphe Archanon. *Praktika tes en Athenais Archaiologikes Etaireias* 1972: 310–53.

———. 1977a
Ta kykladika stoicheia ton Archanon. *Athens Annals of Archaeology* X: 93–113.

———. 1977b
The Cyclades and Crete. In Thimme, J. (ed.) *Art and Culture of the Cyclades,* pp. 145–54. Karlsruhe: C. F. Müller.

Sampson, A. 1985
Manika: mia protoelladike poli sti Chaldika I. Athens.

———. 1988
Early Helladic contacts with the Cycladese during the EBA 2. *Aegaeum* 2: 5–10.

Schäfer, H. 1986
Principles of Egyptian Art. Oxford: Griffith Institute. (First published Leipzig, 1919.)

Schefold, K. 1965
Heroen und Nymphen in Kykladengräbern. *Antike Kunst* 8: 87–90.

Seager, R.B. 1910
Excavations at the Island of Pseira, Crete. Philadelphia: University Museum.

———. 1912
Explorations in the Island of Mochlos. Boston: American School of Classical Studies at Athens.

Shackleton, N.J. 1968
The Mollusca, the Crustacea, the Echinodermata. In J.D. Evans and C. Renfrew (eds.) *Excavations at Saliagos near Antiparos,* pp. 122–38. British School of Archaeology at Athens: Supplementary volume 5. London: Thames and Hudson.

Sotirakopoulou, P. 1986
Early Cycladic pottery from Akrotiri on Thera and its chronological implications. *Annual of the British School of Archaeology at Athens* 81: 297–312.

Stephanos, K. 1903; 1904; 1906; 1908; 1909; 1910
Kykladika Naxou. *Praktika tes en Athenais Archaiologikes Etaireias* 1903: 22–27; 1904: 57–61; 1906: 86–90; 1908: 114–17; 1909: 209–10; 1910: 270–73.

Stos-Gale, Z.A., Gale, N.H., and Gilmore, G.R. 1984
Early Bronze Age Trojan metal sources and Anatolians in the Cyclades. *Oxford Journal of Archaeology* 3: 23–43.

Theocharis, D.R. 1949
Ek tes proistorikes Euvias kai Skyrou. *Archeion Euvoikon Meleton:* 279–329.

Thimme, J. 1965
Die religiöse Bedeutung der Kykladenidole. *Antike Kunst* 8: 72–86.

———. 1975
Ein monumentales Kykladenidol in Karlsruhe. *Jahrbuch der Staatlichen Kunstsammlungen in Baden-Würtemburg* 12: 7–20.

———. (ed.) 1977
Art and Culture of the Cyclades. Karlsruhe: C.F. Müller.

Thom, A. 1967
Megalithic Sites in Britain. Oxford: Clarendon Press.

Torrence, R. 1979
A technological approach to Cycladic blade industries. In J.L. Davis and J.F. Cherry (eds.) *Papers in Cycladic Prehistory,* pp. 66–86. Monograph 14. Los Angeles: UCLA Department of Archaeology.

———. 1986
Production and Exchange of Stone Tools: Prehistoric Obsidian in the Aegean. Cambridge: Cambridge University Press.

Touchais, J. 1981
L'antre corycien I. *Bulletin de Correspondance Hellénique* Supplement 7: 154–59.

Tsakos, C. 1967
Archaiotetes kai Mnemeia Kykladon. *Archaiologikon Deltion* 22, Chronika: 464.

Tsountas, C. 1898
Kykladika. *Archaiologike Ephemeris* 1898: 137–212.

———. 1899
Kykladika II. *Archaiologike Ephemeris* 1899: 73–134.

Tzavella-Evjen, C. 1984
Lithares. Athens

Tzedakis, J. 1967
Archaiotetes kai Mnemeia Dytikes Kretes. *Archaiologikon Deltion* 22, Chronika: 504–6.

———. 1968
Anaskaphe Spelaiou Platyvolas. *Archaiologikon Deltion* 23, Chronika: 415–16.

Ucko, P.J. 1968
Anthropomorphic Figurines of Predynastic Egypt and Neolithic Crete. Royal Anthropological Institute: Occasional Paper no. 24. London: Andrew Szmidla.

Varoucha, I.A. 1926
Kykladikoi Taphoi tes Parou. *Archaiologike Ephemeris* 1925–26: 98–114.

Wagstaff, M., and Cherry, J.F. 1982
Settlement and population change. In C.

197 Renfrew and M. Wagstaff (eds.) *An Island Polity: The Archaeology of Exploitation in Melos,* pp. 136–55. Cambridge: Cambridge University Press.

Walpole, R. 1818
Memoirs Relating to European and Asiatic Turkey and Other Countries of the East. London.

Warren, P., and Hankey, V. 1989
Aegean Bronze Age Chronology. Bristol: Bristol Classical Press.

Weinberg, S.S. 1951
Neolithic figurines and Aegean interrelations. *American Journal of Archaeology* 55: 121–33.

———. 1965
Ceramics and the supernatural. In F.R. Matson (ed.) *Ceramics and Man.* Chicago: Aldine.

———. 1977
The Cyclades and Mainland Greece. In J. Thimme (ed.) *Art and Culture of the Cyclades.* Karlsruhe: C.F. Müller.

Werner, A. 1965
Modigliani the Sculptor. London: Peter Owen.

Wilson, S.E., and Eliot, M. 1984
Ayia Irini III: the last phase of occupation at the EBA settlement. In J.A. Macgillivray and R.L.N. Barber (eds.) *The Prehistoric Cyclades,* pp. 78–87. Edinburgh: Department of Classical Archaeology.

Wolters, P. 1891
Marmorkopf aus Amorgos. *Athenische Mitteilungen* 16: 46–58.

Xanthoudides, S. 1915
Archaiologikon Deltion 1, Parartema: 60–62.

———. 1916
Archaiologikon Deltion 2, Parartema: 25–27.

———. 1918
Megas Protominoikos Taphos Pyrgou. *Archaiologikon Deltion* 4, Chronika: 136–170.

Yalouris, N. 1957
Dokimastikai Erevnai eis ton Kolpon tes Pheias. *Archaiologike Ephemeris* 1957: 31–43.

Zapheiropoulos, N.S. 1960
Archaiotetes kai Mnemeia Kykladon. *Archaiologikon Deltion* 16, Chronika: 246–47.

———. 1965
Archaiotetes kai Mnemeia Kykladon. *Archaiologikon Deltion* 20, Chronika: 505–8.

Zapheiropoulou, Ph. 1966
Archaiotetes kai Mnemeia Kykladon. *Archaiologikon Deltion* 21, Chronika: 386.

———. 1967
Archaiotetes kai Mnemeia Kykladon. *Archaiologikon Deltion* 22, Chronika: 465–67.

———. 1968a
Cycladic finds from Keros. *Athens Annals of Archaeology* 1968: 97–100.

———. 1968b
Kyklades, anaskaphikai erevnai—periodeiai. *Archaiologikon Deltion* 23, Chronika: 381.

———. 1970a
Archaiotetes kai Mnemeia Kykladon. *Archaiologikon Deltion* 25, Chronika: 428–29.

———. 1970b
Protokykladika evremata ex Ano Kouphonisi. *Athens Annals of Archaeology* 3: 48–51.

———. 1975
Ostraka ek Kerou. *Athens Annals of Archaeology* 8: 79–85.

———. 1979
Protokykladika eidolia tes Naxou. *Stele, Tomos eis Mnemen Nikolaou Kontoleontos,* pp. 532–40. Athens.

———. 1984
The chronology of the Kampos group. In J.A. Macgillivray and R.L.N. Barber (eds.) *The Prehistoric Cyclades: Contributions to a Workshop on Cycladic Chronology,* pp. 31–40. Edinburgh: Department of Classical Archaeology.

———. 1988
Naxos: Monuments and Museums. Athens: Krene.

Zervos, C. 1957
L'Art des Cyclades. Paris: Éditions Cahiers d'Art.

CONCORDANCE

This concordance includes Early Cycladic and archaic and Classical Greek works. Numbers in the left column refer to plates in this book. Plate numbers in parentheses are cross-references to other illustrations of the same piece in this book.

G indicates the catalogue number of the exhibition of the N.P. Goulandris Collection at the British Museum in 1983 (Doumas 1983).

Coll. indicates the inventory number of each item in the N.P. Goulandris Collection.

DG indicates the page reference to the publication of the piece in *The N.P. Goulandris Collection of Early Cycladic Art* (Doumas 1968).

30. "Frying pan." — Coll. 971; Thimme (ed.) 1977, 532, no. 402.
31. Bottle. — G 61; Coll. 223; DG 39.
32. Bottles. — G 60, 86, and 112; Coll. 218, 196, and 219; DG 36.
33. Louros figurines. — G 41 (pl. 96.1) and 42; Coll. 344 and 345.
34. Footed jar. — G 192; Coll. 235; DG 45.
35. "Frying pan." — Athens, National Museum 4974; Zervos 1957, pl. 223.
36. "Sauceboat." — Athens, National Museum 6107; Papathanasopoulos 1962, pl. B.
37. Cylindrical pyxis. — Athens, National Museum 5225; Zervos 1957, pl. 234.
38. Chisel, daggers, and needle. — G 202; Coll. 224; DG 161. G 199; Coll. 223a; DG 161. G 196; Coll. 242; DG 162. G 193; Coll. 267; DG 163.
39. Bowl. — G 59; Coll. 215; DG 72.
40. Pyxides. — G 151; Coll. 263; DG 76. G 102; Coll. 58; DG 55.
41. "Palette." — G 55; Coll. 89; DG 66.
42. Footed vessel with four cups. — Coll. 970; Thimme (ed.) 1977, 510, no. 310.
43. Spouted bowl. — G 130; Coll. 592.
44. Footed cup. — G 52; Coll. 279.
45. Footed cup. — G 111; Coll. 210; DG 67.
46. Pyxis. — G 128; Coll. 542.
47. Pyxis. — Athens, National Museum 5358; Zervos 1957, fig. 30.
48. Spouted jug. — G 179; Coll. 195; DG 29.
49. Tankard. — Athens, National Museum 4943; Zervos 1957, pl. 183.
50. Footed jar. — G 191; Coll. 232; DG 44.
51. Canonical figure. — G 70; Coll. 654.
52. Figure of the Kapsala variety. — Athens, National Museum 6140.12; Getz-Preziosi 1987a, pl. 21,1 (pl. 102:1).
53. Canonical figure. — G 131; Coll. 595.
54. Figure of the Dokathismata variety. — G 178; Coll. 206 (pls. 2, 66, 96:6, 11, 14, 100:2, 102:3, fig. 11 right).
55. Figure of the Chalandriani variety. — G 107; Coll. 102; DG 96 (pls. 96:7, 12, 15, 100:5, 101:4, 102:4).
56. Figure of the Koumasa variety. — Ashmolean Museum AE 172; Renfrew 1969, pl. 6a.
57. Figure of the Spedos variety. — G 173; Coll. 282; DG 136 (pls. 96:5, 18, 100:1, 101:2, fig. 10 right).
58. Non-canonical figures. — G 162; Coll. 312; DG 154 (pl. 100:6). G 161; Coll. 308; DG 146 (pls. 2, 96:16).
59. Fragment of a double standing figure. — Copenhagen, National Museum ABb 139; Renfrew 1969, pl. 9,c.

60. Fragment of a double standing figure. — G 167; Coll. 339.
61. Violin figurine. — G 20; Coll. 337.
62. Double figure. — G 165; Coll. 330; DG 184.
63. Canonical figure. — G 174; Coll. 257 (pl. 96:4).
64. Canonical figure (detail). — G 95; Coll. 310; DG 151.
65. Canonical figure. — G 94; Coll. 309; DG 150.
66. Canonical figure. — G 178; Coll. 206 (pls. 2, 54, 96:6, 11, 14, 100:2, 102:3, fig. 11 right).
67. Unfinished figure. — G 87; Coll. 209; DG 115.
68. Two canonical figures. — National Museum 4722 and 4733; Renfrew 1969, pl. 5, b and c.
69. Two canonical figures. — Ashmolean Museum 1929.27 and 1929.28; Renfrew 1969, pl. 3, d and e.
70. Two canonical figures and the head of a third. — G 2; Coll. 251; DG 121 (pl. 100:4). G 63; Coll. 256; DG 127. G 64; Coll. 281; DG 135 (pls. 73, 100:3, 101:5, fig. 7).
71. Head. — Copenhagen, National Museum 4697; Renfrew 1969, pl. 8a.
72. Head. — Athens, National Museum 3909; Zervos 1957, pl. 177–8 (pl. 113).
73. Canonical figure (detail). — G 64; Coll. 281; DG 135 (pls. 70, 100:3, 101:5, fig. 7).
74. Canonical figure. — G 172; Coll. 280; DG 132 (pls. 96:13, 98 right, 101:6, 102:2).
75. Canonical figure. — G 122; Coll. 311; DG 152 (pls. 99 left, fig. 9 right).
76. Head. — G 67; Coll. 701.
77. Canonical figure (detail). — G 66; Coll. 252; DG 122 (fig. 10 left).
78. Canonical figure (detail). — G 211; Coll. 724 (pls. 2, 96:20, 100:8, 103).
79. Lady of Auxerre. — Paris, Louvre 3098; Richter 1968, no. 18.
81. Kore. — Athens, Acropolis Museum 593; Richter 1968, no. 43 (pl. 106).
82. Kore. — Athens, Acropolis Museum 670; Richter 1968, no. 119.
83. Bear. — Athens, National Museum 676; Zervos 1957, pl. 238.
84. Bear. — Naxos, Archaeological Museum 4728; Zapheiropoulou 1988, 39,2.
85. Non-canonical figure. — G 144; Coll. 328; DG 156.
89. Kouros. — Athens, National Museum 1558; Richter 1970, no. 86.
90. Kouros. — Athens, National Museum, 1906; Richter 1970, no. 63.
91. Late kouros ("the Kritios Boy"). — Athens, Acropolis Museum 698; Richter 1970, no. 190.
92. Kore. — Athens, Acropolis Museum 679; Richter 1968, no. 113.
93. Kore. — Athens, Acropolis Museum 671; Richter 1968, no. 111.

96. Cycladic heads.
1. G 41; Coll. 344 (pl. 33).
2. G 138; Coll. 113; DG 107.
3. G 92; Coll. 255; DG 126 (pl. 96:10).
4. G 174; Coll. 257 (pl. 63).
5. G 173; Coll. 282; DG 136 (pls. 57, 96:18, 100:1, 101:2, fig. 10 right).
6. G 178; Coll. 206 (pls. 2, 54, 66, 96:11, 96:14, 100:2, 102:3, fig. 11 right).
7. G 107; Coll. 102; DG 96 (pls. 55, 96:12, 15, 100:5, 101:4, 102:4).
8. G 150; Coll. 259; DG 130–1.
9. G 147; Coll. 462 (pl. 96:19).
10. G 92; Coll. 255; DG 126 (pl. 96:3).
11. G 178; Coll. 206 (see pl. 96:6 for refs.).
12. G 107; Coll. 102; DG 96 (see pl. 96:7 for refs.).
13. G 172; Coll. 280; DG 132 (pls. 74, 98 right, 101:6, 102:2).
14. G 178; Coll. 206 (see pl. 96:6 for refs.).
15. G 107; Coll. 102; DG 96 (see pl. 96:7 for refs.).
16. G 161; Coll. 308; DG 146 (pls. 2, 58).
17. G 171; Coll. 284; DG 140 (pl. 120).
18. G 173; Coll. 282; DG 136 (see pl. 96:5 for refs.).
19. G 147; Coll. 462 (pl. 96:9).
20. G 211; Coll. 724 (pls. 2, 78, 100:8, 103).

97. Canonical male figure. Coll. 969; Getz-Preziosi 1981, no. 10.

98. Cycladic anatomy.
left: G 177; Coll. 598 (pls. 2, 100:9, 122, fig. 11 left).
right: G 172; Coll. 280; DC 132 (pls. 74, 96:13, 101:6, 102:2).

99. Differing proportionality.
left: G 122; Coll. 311; DG 152 (pl. 75, fig. 9 right 101:3).
right: G 118; Coll. 283; DG 138 (pl. 101:1).

100. Cycladic torsos.
1. G 173; Coll. 282; DG 136 (pls. 57, 96:5, 96:18, 101:2, fig. 10 right).
2. G 178; Coll. 206 (pls. 2, 54, 66, 96:6, 11, 14, 102:3, fig. 11 right).
3. G 64; Coll. 281; DG 135 (pls. 70, 73, 101:5, fig. 7).

4. G 62; Coll. 251; DG 121 (pl. 70).
5. G 107; Coll. 102; DG 96 (pls. 55, 96:7, 12, 15, 101:4, 102:4).
6. G 162; Coll. 312; DG 154 (pl. 58).
7. G 175; Coll. 304; DG 145 (pls. 2, 3, fig. 9 left).
8. G 211; Coll. 724 (pls. 2, 78, 96:20, 103).
9. G 177; Coll. 598 (pls. 2, 98 left, 122, fig. 11 left).

101. Waists and abdomens.
1. G 118; Coll. 283; DG 138 (pl. 99 right).
2. G 173; Coll. 282; DG 136 (pls. 57, 96:5, 18, 100:1, fig. 10 right).
3. G 122; Coll. 311; DG 152 (pls. 75, 99 left, fig. 9 right).
4. G 107; Coll. 102; DG 96 (pls. 55, 96:7, 12, 15, 100:5, 102:4).
5. G 64; Coll. 281; DG 135 (pls. 70, 73, 100:3, fig. 7).
6. G 172; Coll. 280; DG 132 (pls. 74, 96:13, 98 right, 102:2).

102. Feet.
1. Athens, National Museum 6140.12 (pl. 52).
2. G 172; Coll. 280; DG 132 (pls. 74, 96:13, 98 right, 101:6).
3. G 178; Coll. 206 (pls. 2, 54, 66, 96:6, 11, 14, 100:2, fig. 11 right).
4. G 107; Coll. 102; DG 96 (pls. 55, 96:7, 12, 15, 100:5, 101:4).

103. Monumental canonical figure. G 211; Coll. 724 (pls. 2, 78, 96:20, 100:8).

104. Monumental canonical figure from Amorgos. Athens, National Museum 3978; Zervos 1957, fig. 297.

105. Canonical figure. Ashmolean Museum AE 176; Zervos 1957, pl. 162.

106. Kore. Acropolis 593; Richter 1968, no. 43 (pl. 81).

107. Harpist. Athens, National Museum 3908; Zervos 1957, pl. 302.

108. Flautist. Athens, National Museum 3910; Zervos 1957, pl. 333.

109. Torso of a flautist. G 149; Coll. 246; DG 117.

110. Vessel in the form of a pig. G 34; Coll. 285; DG 78.

111. Dove. G 160; Coll. 305; DG 169.

112. Dove bowl. G 164; Coll. 329; DG 171.

113. Head. Athens, National Museum 3909; Zervos 1957, pls. 177–8 (pl. 72).

120. Head. G 171; Coll. 284; DG 140 (pl. 96:17).

INDEX

PHOTOGRAPH CREDITS

All of the photographs in this book are by John Bigelow Taylor, with the exception of the following:

page 92, National Museum, Copenhagen
page 128 (right), Archaeological Museum, Naxos
page 130 (all), Hirmer Fotoarchiv, Munich
page 136 (left), National Gallery of Art, Washington, D.C. Mellon Collection
page 136 (right), Benaki Museum, Athens
page 170 (left) University of California Museum of Cultural History, Los Angeles. Gift of the Wellcome Trust
page 170 (right), © Hugo P. Herdeg's Erben, Zurich

page 172 (left), National Gallery of Art, Washington, D.C. Chester Dale Collection
page 172 (right), Victoria and Albert Museum, London
page 173 (left), Philadelphia Museum of Art. Louise and Walter Arensberg Collection
page 173 (right), Dallas Museum of Art, Foundation for the Arts Collection, Gift of Mr. and Mrs. James H. Clark
page 179, Philadelphia Museum of Art. Louise and Walter Arensberg Collection
page 184 (bottom), Stedelijk Museum, Amsterdam

The publisher would like to thank the University of Michigan Press for permission to use the following diagrams from Patricia Getz-Preziosi, *Sculptors of the Cyclades:* figure 7, page 122 (by Eugenia Joyce Fayen) and figure 8, page 138 (by Patricia Getz-Preziosi).

Editor: Eric Himmel
Designer: Maria Miller

Library of Congress Cataloging-in-Publication Data

Renfrew, Colin, 1937–
The Cycladic spirit: masterpieces from the Nicholas P. Goulandris
collection/Colin Renfrew; introduction by Christos Doumas;
photographs by John Bigelow Taylor.
p. cm.
Includes bibliographical references and index.
ISBN 0–8109–3169–9 ISBN 0–8109–2500–1 (pbk.)
1. Sculpture, Cycladic. 2. Goulandris, N. P. — Art collections. 3.
Sculpture — Private collections — Greece — Athens. 4. Mouseio
Kykladikēs Technēs. I. Taylor, John Bigelow. II. Hidryma Nikolaou
P. Goulandrē. III. Mouseio Kykladikēs Technēs. IV. Title.
NB130.C78R4 1991
732′.3′093915 — dc20 91–9537
CIP